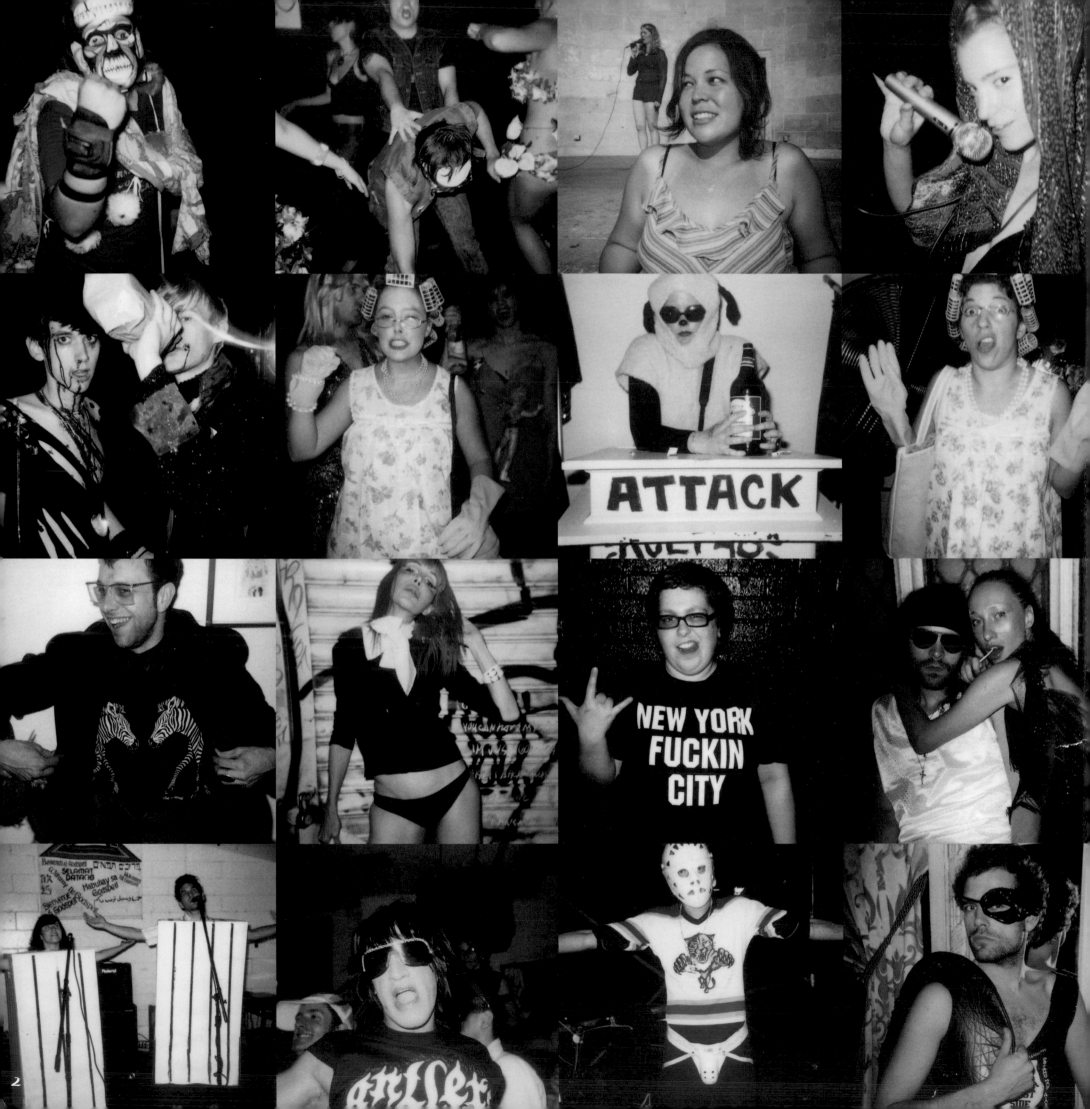

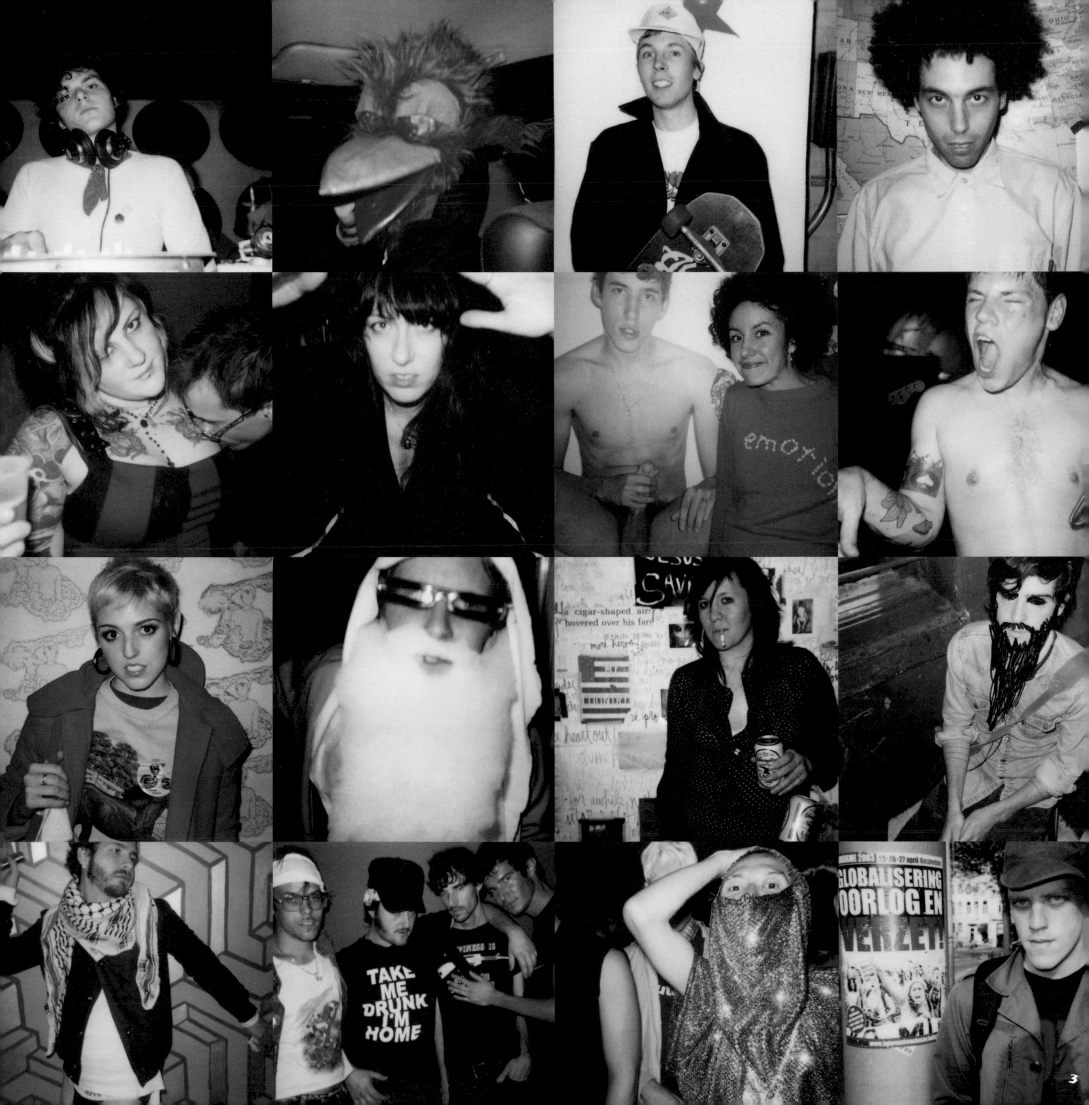

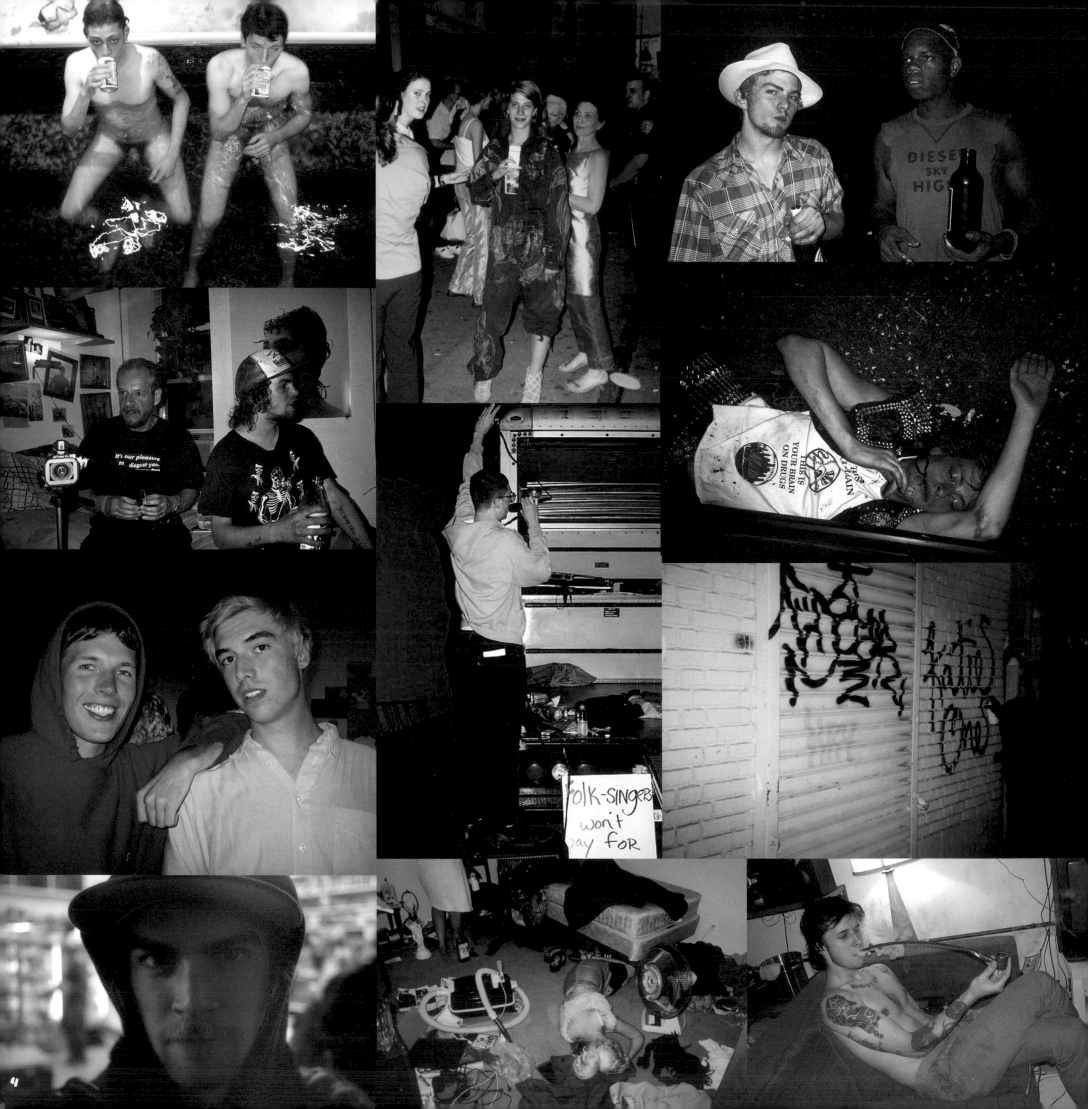

2004
biennial
exhibition

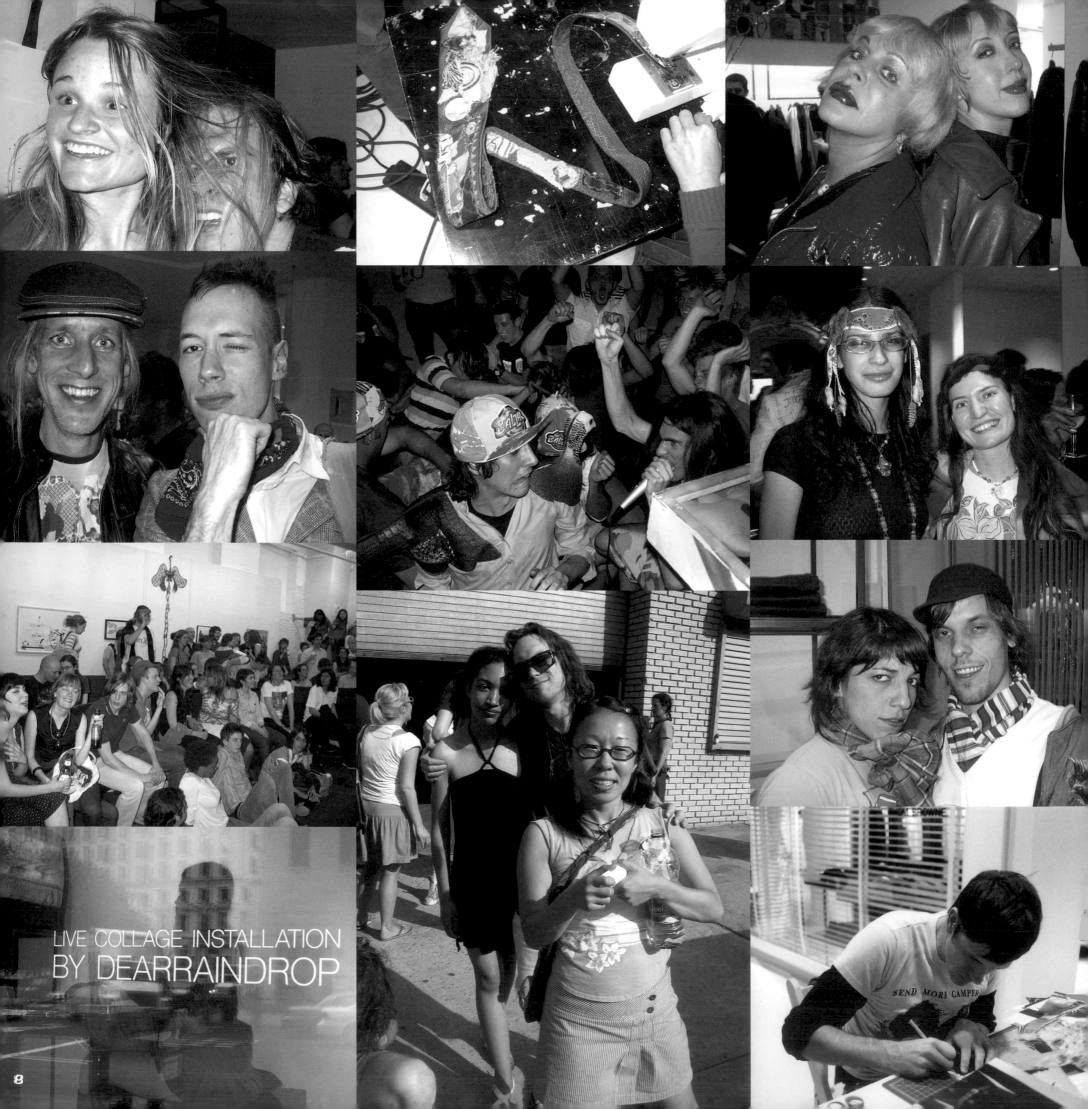

LIVE COLLAGE INSTALLATION
BY DEARRAINDROP

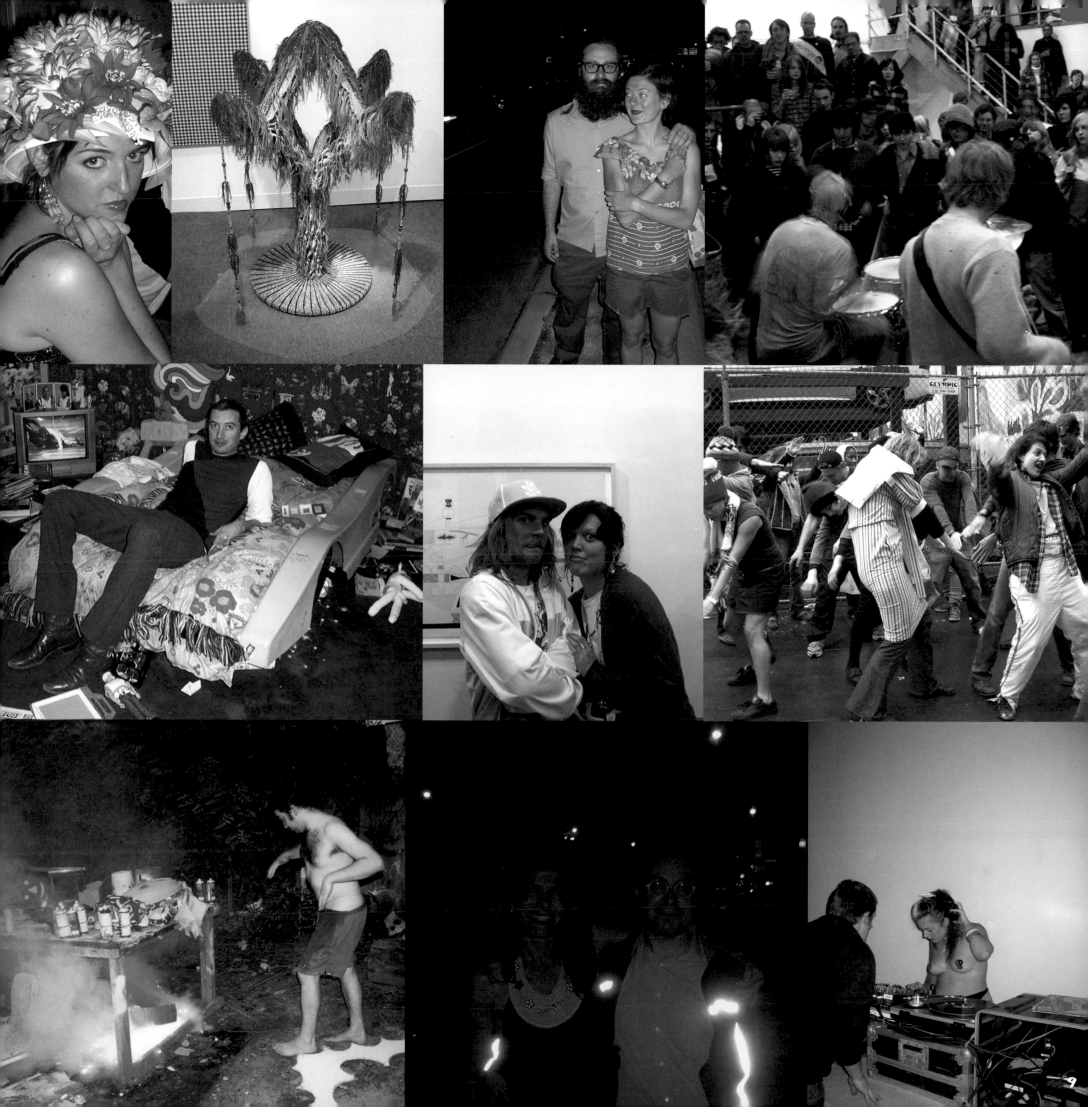

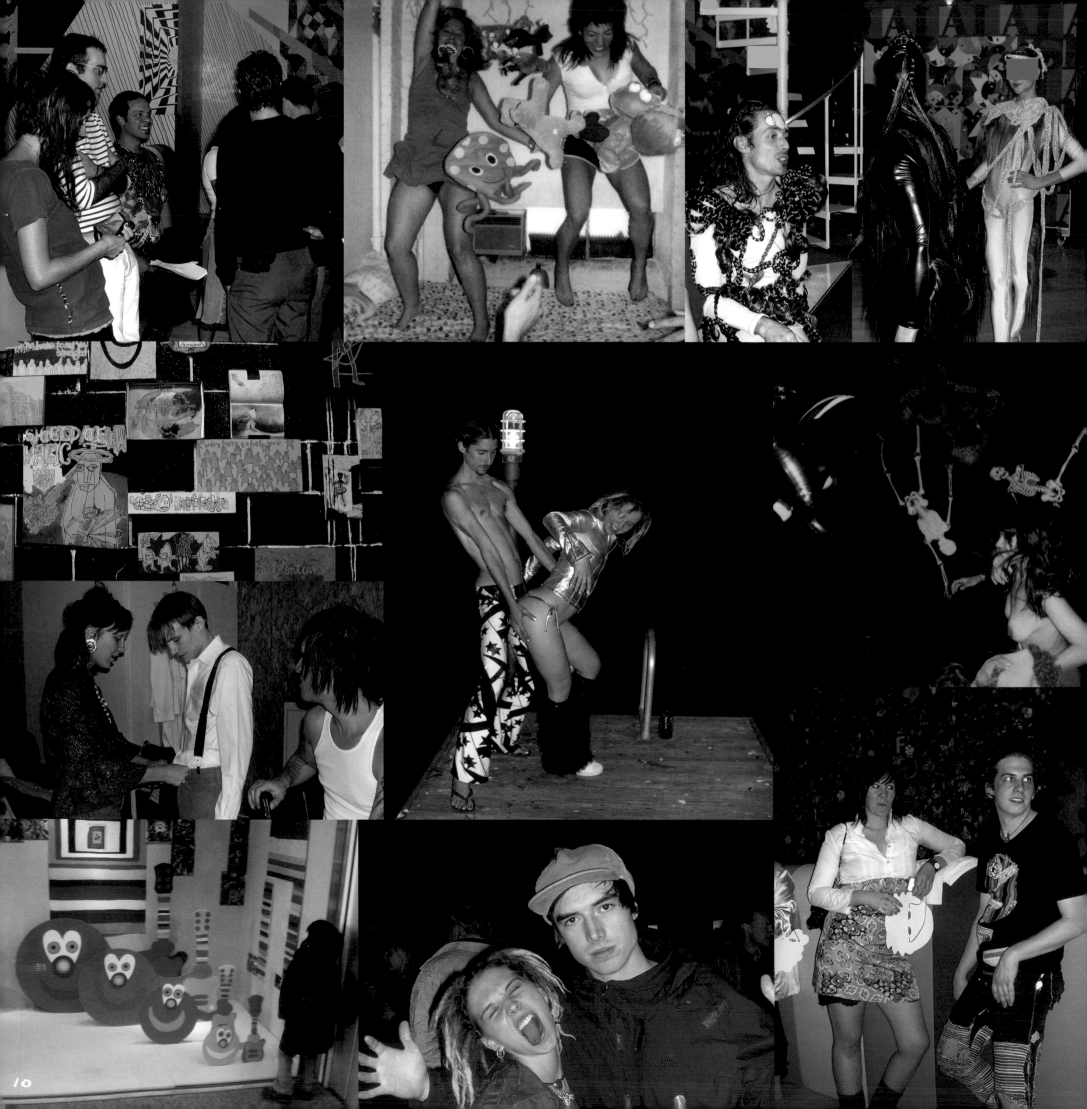

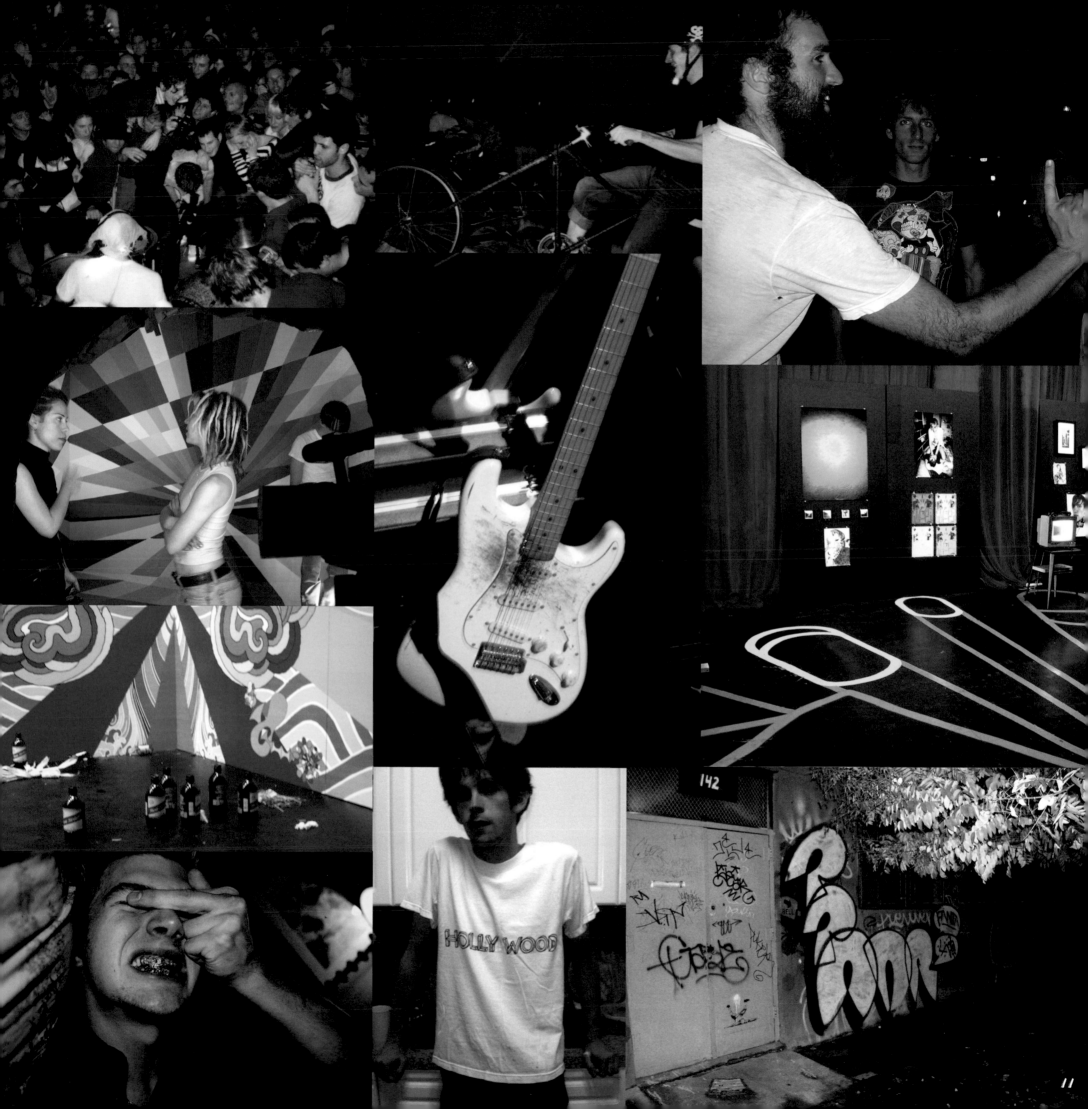

Le Tigre

JIM DRAIN

ARA PETERSON

HISHAM Bharoocha

MAT

JUSTIN SAMSON

RY FYAN

Erik Parker

LI

JULES DE BALINCOURT

BARR

TH

KEEGAN MCHARGUE

T

Misaki Kawai

JD SAMSON

Ryan McGinley

Scott Hug

AVENUE D

Cory A

EDITED BY JEFFREY DEITCH AND KATHY GRAYSON. ESSAYS BY CORY ARCHANGEL,

PHILLIP GUICHARD, LAWRENCE RINDER, JEFFREY DEITCH, AND KATHY GRAYSON.

CONTENTS

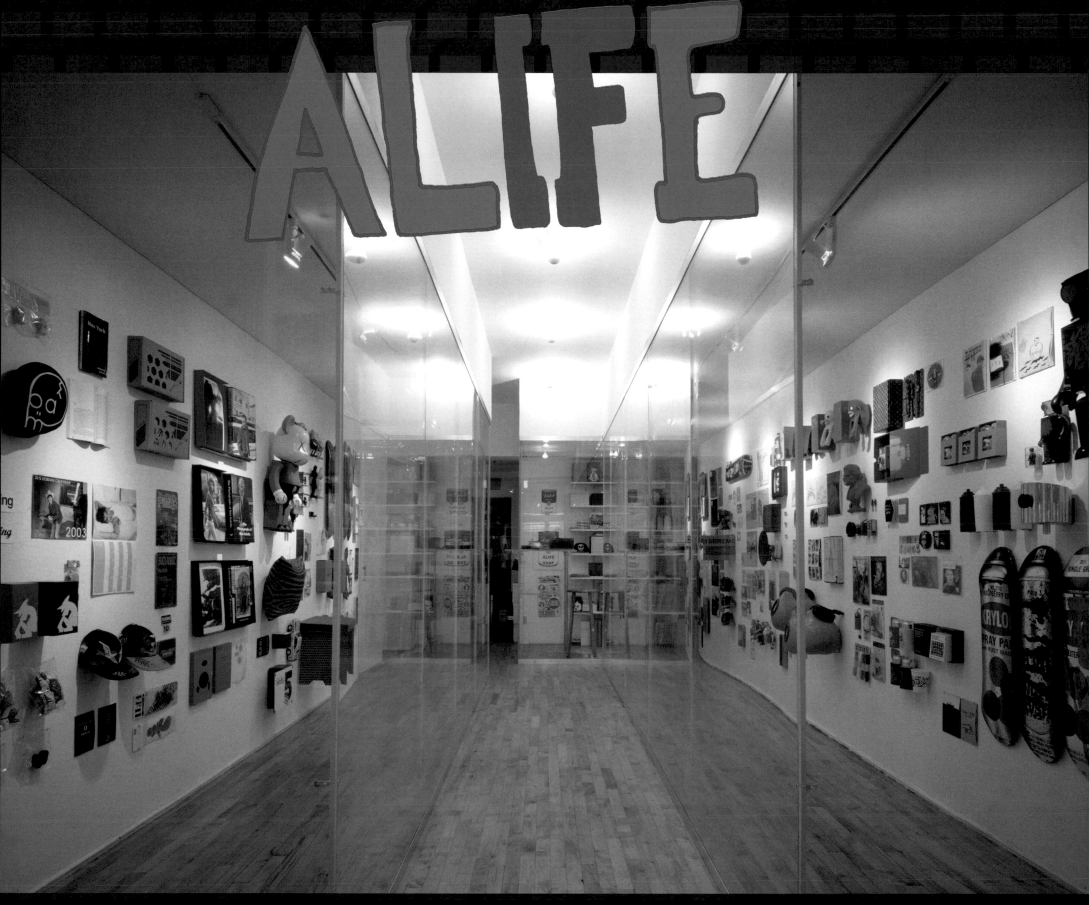

Arnaud Delecolle, Tony Arcabascio, and Rob Cristofaro started alife in 1999 with a storefront on Orchard Street, offering their creative services. What began as a creative studio and retail space has since turned into a fixture of New York street culture, a sometime-gallery and meeting place for the Lower East Side art community. In the winter of 2003, they installed a mini-alife outpost at Deitch Projects and later in Roberts and Tilton in LA. This original, art-based traveling store was the ultimate place ▇▇▇ find specialty art ▇▇▇ hard-to-find z▇▇▇, limited production of ▇▇▇▇ toys, and awesome art books. ▇▇▇▇es the curated ▇▇ produ▇t store on Or▇▇▇d, they also built the Alife Riv▇▇ton Club: tucked ▇▇▇t Clinton Street, it was the first limited edition, super sneaker shrine in America. While their stores are meticulously organized and design-conscious, their office walls are three inches deep with photos, art, tags, and collected errata that make up the broad

community alife has connected with. The alife guys are amazing schemers who know how to hustle and can get over on just about anyone who is fucked enough to cross them. Helping many young artists do the same, they have been integral to linking young talent with different collaborative opportunities outside the art world proper. Multi-talented entrepreneurs, the alife guys also produce their own footwear line "RTFT", publish books, and have recently collaborated with Levi's Strauss on the first ever co-branded line of 501s. FYI: ▇▇▇s also a ▇▇▇at writer and hismagazine contributor have instructed many young people ▇▇ the important topics of how to steal things, fight, and burn ▇▇▇s successfully.

Above: installation view, Deitch Projects alife store, December 14, 2002– January 10, 2003, photo Tom Powel Imaging.

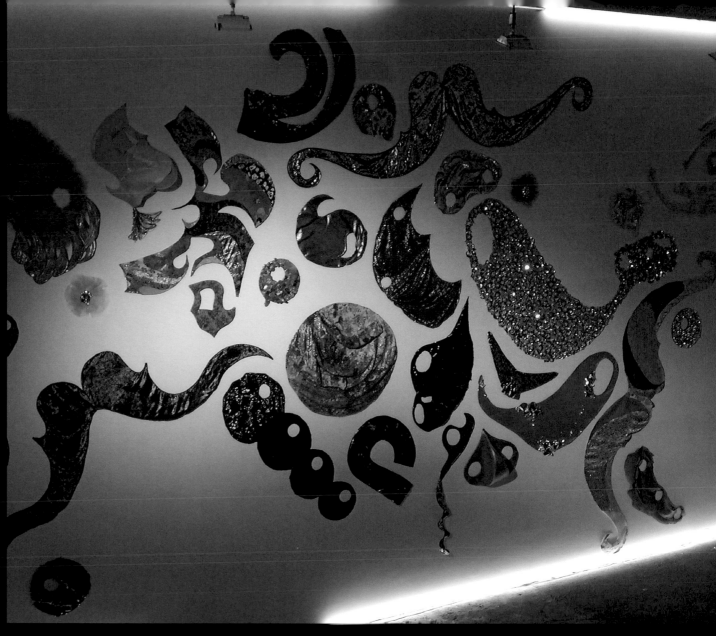

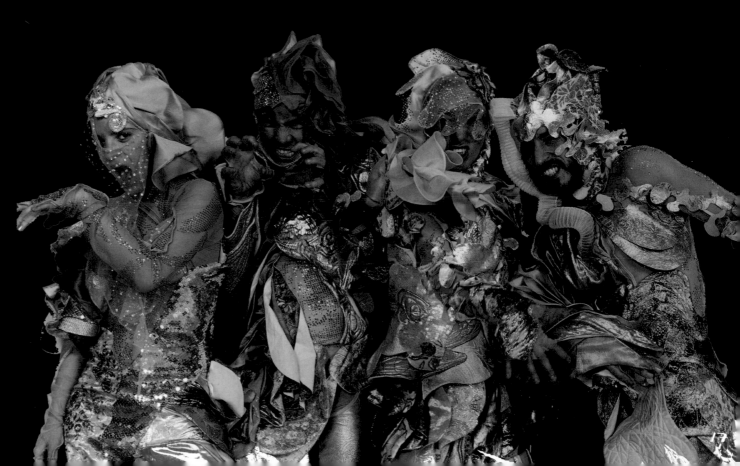

As Four are a four-person art, fashion, and performance group that came together in New York four years ago. After stunning runway shows that were more spectacular performance interventions than fashion runway, Adi, Ange, Gabi, and Kai's very unique blend of glitter and grit is now central to New York's fashion scene. With interstellar mollusk forms and sci-fi drag queenie glamour, the group gained huge popularity for their elegant Disk Bag and for their experimental lines that use billows of glitter, tulle, and sparkle spandex to play with transgender (and trans-animal) body morphing. Projects at Deitch have included a striking performance on the roof of the 76 Grand gallery in 2002, and a 2003 fall fashion week extravaganza installation at 18 Wooster Street. Their dog Powder is often on the receiving end of their creative outfitting talents as well, as is their silver-encrusted, Factoryesque Lower East Side studio. Both these, and the group members themselves, are instantly-recognisable icons of downtown style. Imbued with an almost deranged insistence on group identity, As Four's collaborative syncretism and quest for hybrid vigor have helped to take the overblown pretentiousness out of the New York fashion world, making it a more exciting, down-to-earth, (and intergalactic) place.

All images courtesy the artists. Opposite page: *Spiral*, digital photo collage, 2004. This page: Deitch invitation to *As Four* exhibition, September 5 - 21, 2002; installation view of Deitch exhibition, photo Tom Powel Imaging; As Four *Self-portrait*, 2004.

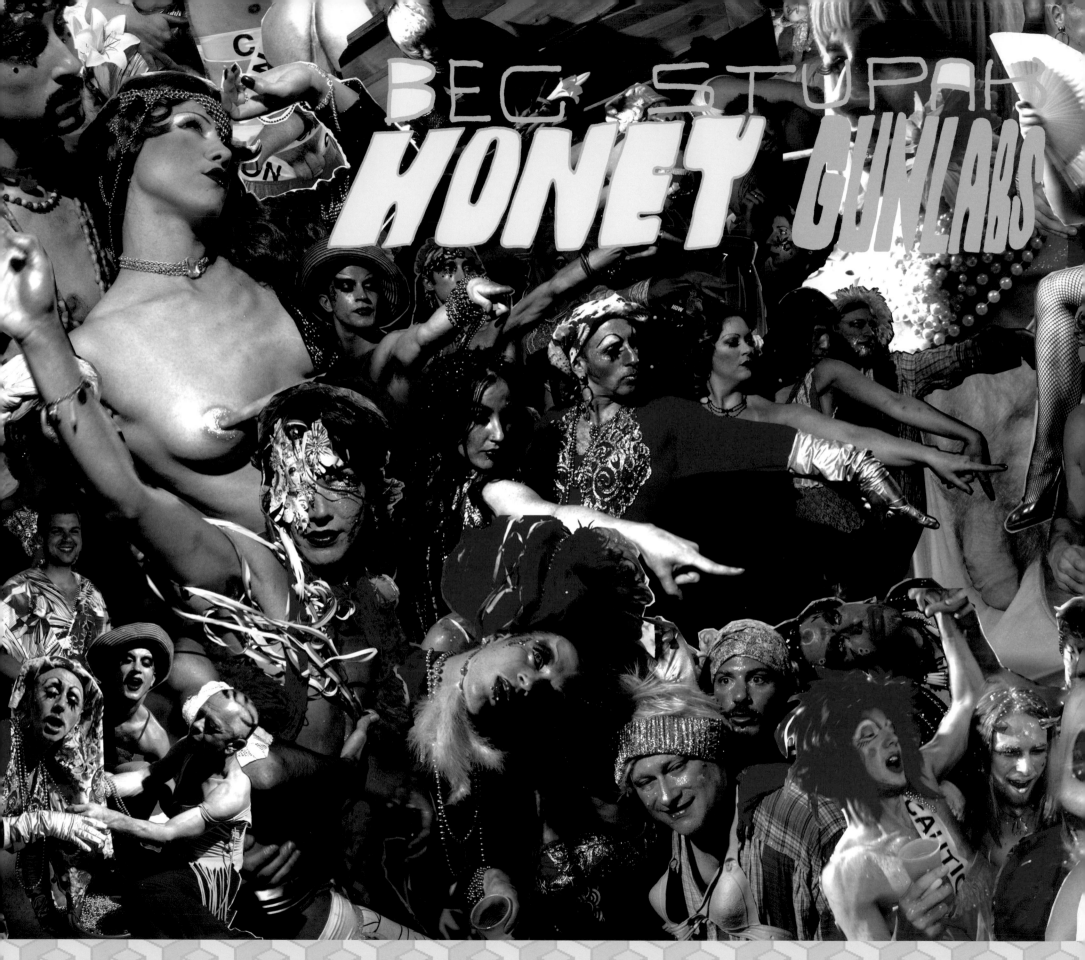

BEC STUPAK
HONEY GUNLABS

Bec learned how to use video to make people psyched on the rigorous training ground of early-90s raves. The five thousand teens packed into the DC Armory, pupils the size of dinner plates, wanting to see her visual synthesis of all they were feeling and listening to-- for ten hours straight-- were her first art audience. These sorts of field tests in the US and Europe eventually became Honeygun Labs, an experimental video project that, after a few years, has blossomed into a collaborative effort that at any given time includes several people creating and experimenting with different styles and techniques. In 2002, Honeygun Labs began to create work with the NYC-based art collective

Assume Vivid Astro Focus. Their first project, Freebird, was an animation set to an endless loop of Leonard Skynard's Freebird guitar solo. It led to further collaboration on Walking On Thin Ice, an unofficial music video for Yoko Ono's song of the same name, presented at Deitch Projects and Peres Projects in San Francisco. In 2004, H.G.L. collaborated again with A.V.A.F. to create a piece for the Whitney Biennial (Garden 8), which combined the band Los Super Elegantes, an LED lighting component to make the walls breathe and a site-specific video piece that was created using live mixing techniques. As an off-shoot to the Whitney project, Bec started a DVD zine called Scissorfriends,

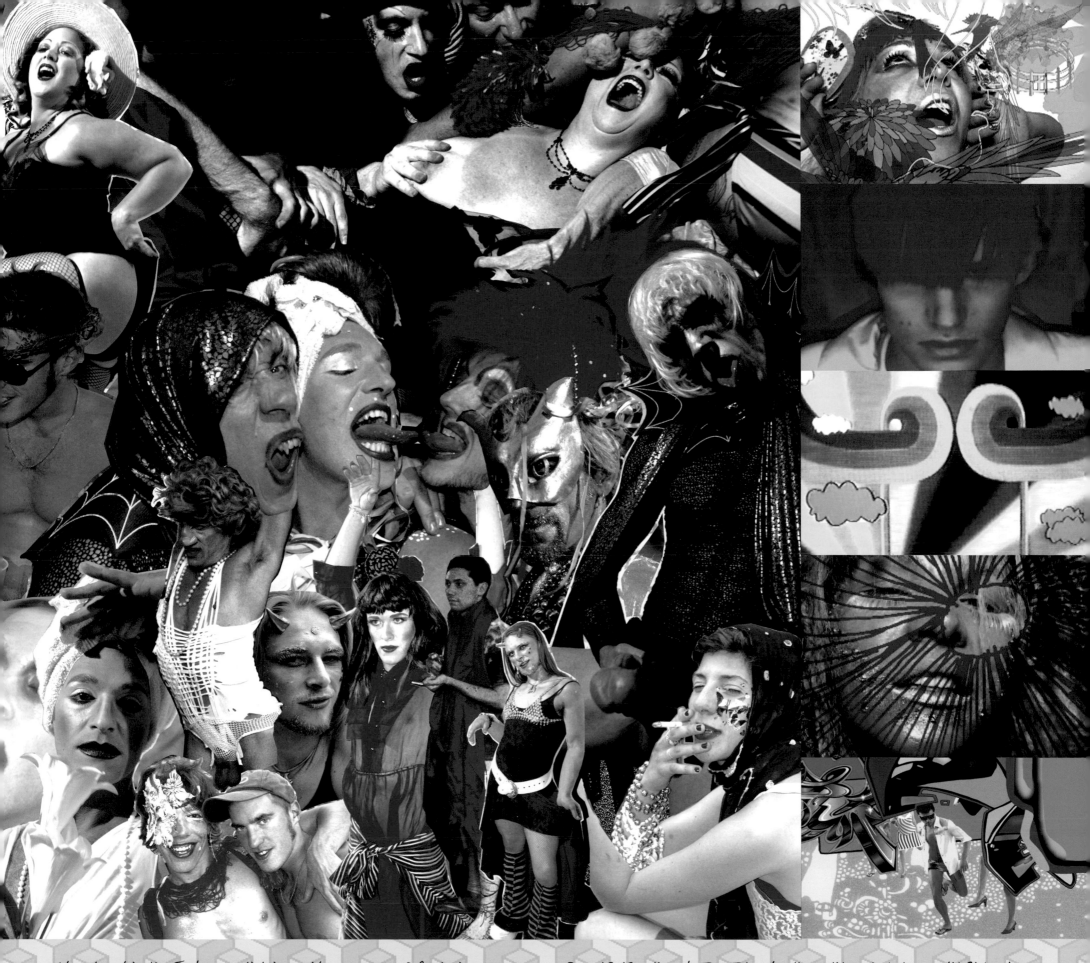

(developed in the Eyebeam artist-in-residence program) featuring every-
thing from little dogs dancing, to cough-syrup induced music, to a deranged
lady exhibiting her queefing skills. Her phenomenal video made in collaboration
with Phiiliip for his song, Elemental Childe was the standout piece in Phiiliip's
Divided By Lightning show at Deitch and was definitively radder than any-
thing you might happen to see on MTV. Never content with just one project,
Bec also plays guitar in the band Saint Eve, and hula-hoops with the precision
hula-hoop troupe, Groovehoops. The cover of this book, along wtih the patterns
on the inside flap and the title page, use artwork Bec developed in conjunc-
tion with A.V.A.F.

Page 18-19: collage by Bec Btupak, all constituent photos credit Richard
Mitchell and A.V.A.F. Above right: still from Walking on Thin Ice, video in con-
junction with A.V.A.F. show at Peres Projects and Deitch Projects, 2003; still
from Elemental Childe, video for Phiiliip, 2004; still from Freebird, video in
conjunction with A.V.A.F. show at Bellwether, 2002; still from Walking on Thin
Ice, video in conjunction with A.V.A.F. show at Peres Projects and Deitch
Projects, 2003; still from Walking on Thin Ice, video in conjunction with A.V.A.F.
show at Peres Projects and Deitch Projects, 2003; still from Garden 8,
Whitney Biennial of American Art, 2004, featuring Los Super Elegantes.

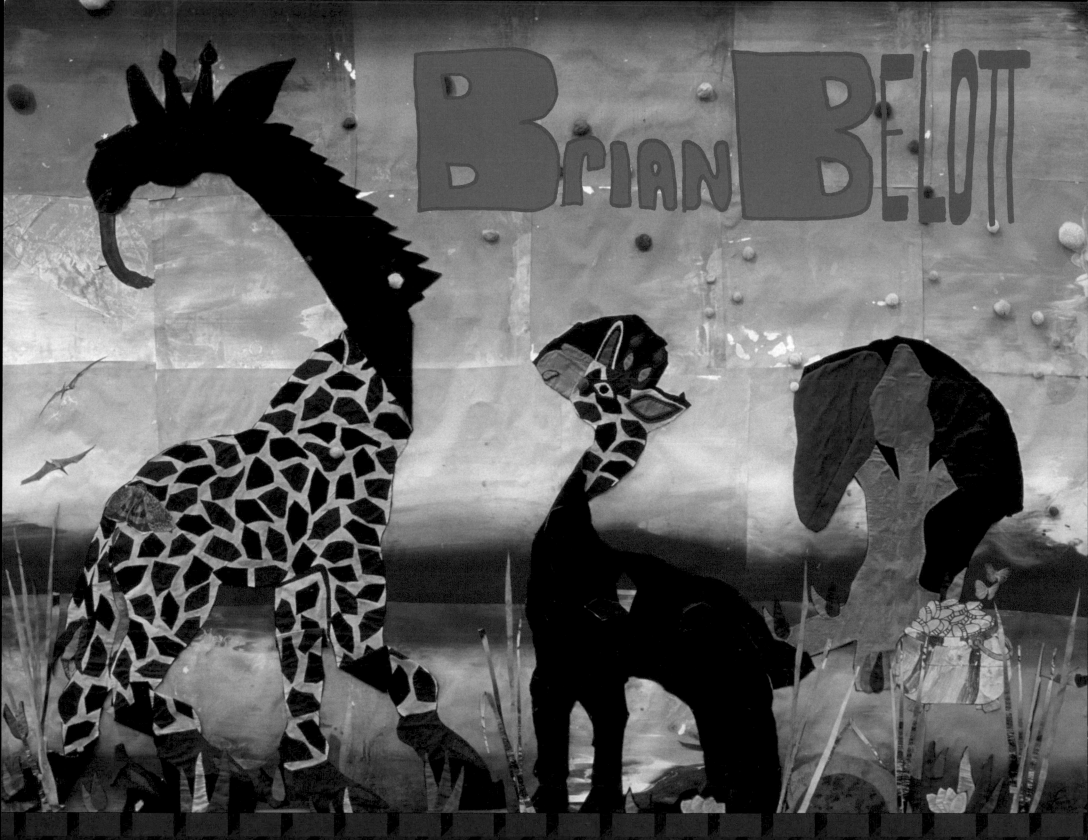

Brian BELOTT

Of all the artists currently experimenting in a collage medium, Brian's work stands out for its sophistication and inventiveness. His 2003 debut at Canada in *You are my sunshine/ you is my sunshine* showed what the medium can really be about. A moonscape of proliferating octagon high rises elevate jangly, 8-bit beings over a patchwork earth; fabric giraffes bend their accordion necks before a rainbow poofball sunset. In another work from that show, a reconfigured Citibank ad spells instead "Fuck YBAers NJ artists rule". The wood-grained blue screen prints that decorated the *Nautical Waste* party thrown at his loft became the inspirattion for a beautiful collage synthesized out of the decorations, in which majestic barks are thrashed in the choppy, wood-grained surf. His collage books, filled to the gills, also serve as elegant static freeze frames of his exploded multimedia living environment. Collaborations are more frequent than not, but a solo endeavor at Kenny Schachter conTEMPorary last summer showed how his expansive, free-form vision could be sandwiched into glit-

tery glass interlayer paintings- *très weird*. Found sounds and found objects keep Brian's artmaking in galleries as unpredictable as the impromptu performance pieces you will catch if you run into him in the right place at the right time. He has an uncanny ability to sound like an old radio on the fritz and is a stand-up comedian type performer weirdo, Slo-Jams improviser, and all around kook.

Above: *Jersey Landscape*, 2003, mixed media, 6 x 4' aprox., courtesy Canada Gallery, NYC. Opposite: *Boombox #73rd*, 2003, glass interlayer painting, 15 x 18"; *The Clock Eyed Cats*, series of three, detail, glass interlayer painting, 2004; *Glitter Boombox*, 2003, glass interlayer painting, 18.5 x 24"; *Candy Cane Boombox*, 2003, glass interlayer painting, 12 x 17", all courtesy Kenny Schachter conTEMPorary; installation view from *What's Going On?* May 2004, Kenny Schachter conTEMPorary; *Untitled (robot)*, 2003, mixed media collage, 36 x 21", courtesy Canada Gallery.

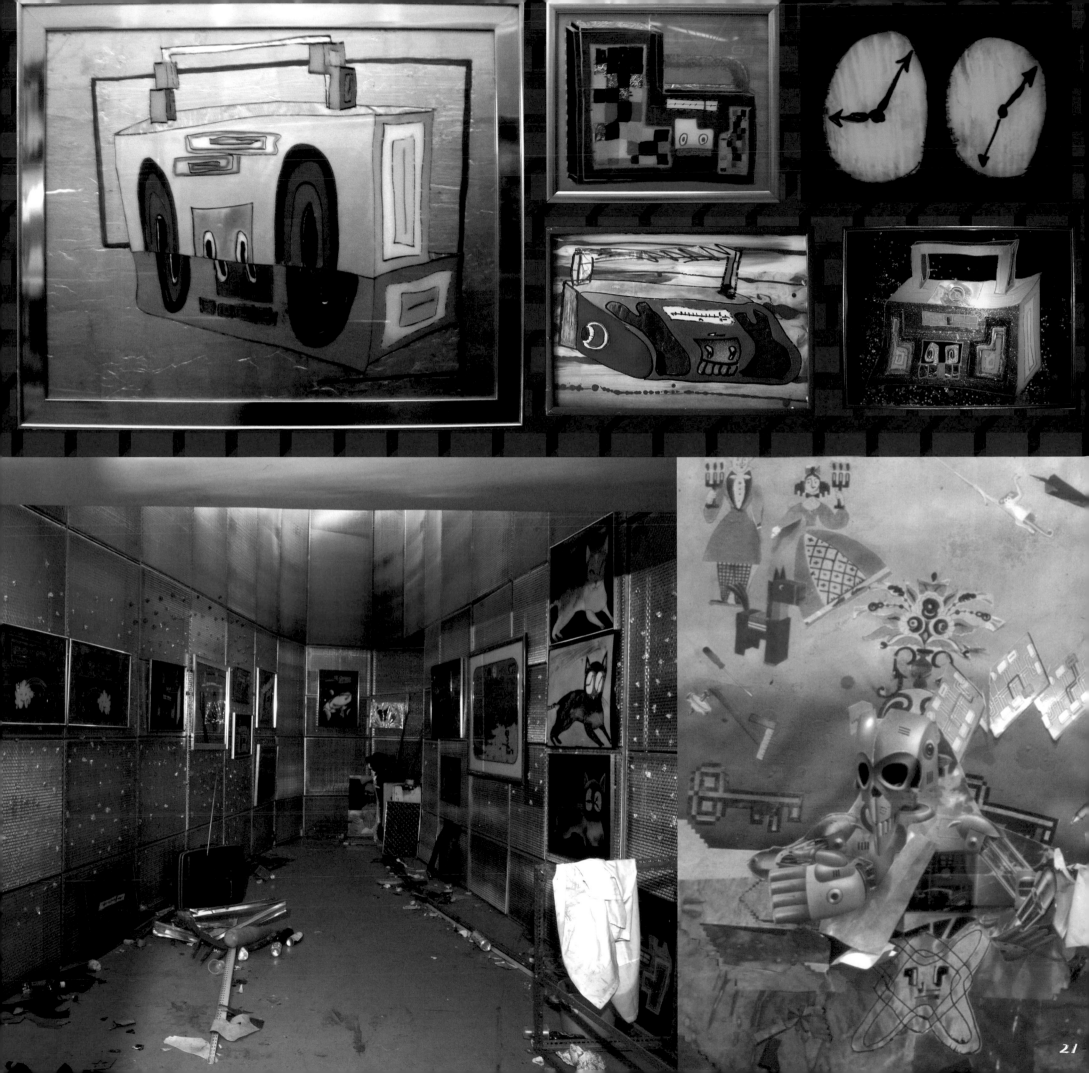

BEIG

Cory is a computer nerd first and an artist second, which is to say his aesthetic and conceptual allegiances are to his dork peers and not to the history of art, though both inform his work. He's too fully integrated into both the aesthetic universe and the language of programming to permit any flippant use of the digital medium: Cory doesn't make art about "digital concerns"; being digitally concerned, he makes art. Think of him as a sculptor, rearranging 8-bit chunks of unalterable Nintendo Entertainment System image data into phenomenal bricolage video-cathedrals. Or, as Alex Galloway of Radical Software Group suggests, think of him as a math artist, since at the ground level Cory's art really is .dw spritedata_start20 or set $2006 $3F. Often in his work he will have to first develop a language and structure with which he can only then begin to think about programming the result: for example he created the interface through which Paper Rad's Jacob Ciocci could compose the score for Super Mario Movie. Notable for its innovative use of medium and technical mastery, Cory's gallery work brings up many interesting new ways of conceptualizing digital art-making. It's most groundbreaking, however, for coupling conceptual elegance with rare emotional depth. His luminous Mario cloud chapel at the Whitney, his first major foray into the art world, making anyone who thought digital was a "cold" medium think again about its emotive potential. He has organized art shows, video screenings, performances (Another Bad Creation at Deitch), and music tours (Summer of HTML Tour with Paperrad.org), always chasing the excitement of collaboration and finding ways to get old video games do awesome things.

beige

Ludacris ‹
Reel2Reel
Sugar Hill
50 Cent
Lil John
M + M
Aliya
IF
Le Car
Heezer

nI-pod still
2K4

Cory is a founding member of Beige, a.k.a. the Beige Programming Ensemble/ Beige Records, a loose-knit crew of like-minded computer programmers and enthusiasts, making music and weird computer stuff. Having graduated from the Oberlin Conservartory of Music, Cory dreams of making a replica of EddieVan Halen's 1978 "Frankenstrat" guitar and listens to acid house. He would like everyone to know that he loves surfing the INTERNET. He has been included in Seeing Double at the Guggenheim, the 2004 Liverpool Biennial, and the 2004 Whitney Biennial of American Art, at which he debuted the spectaculat 8-bit faux- ipod (at left) and did a night of jangly green screen videos, shot live with a bunch of really psyched teenagers. Cory also organized The Infinite Fill show at Foxy Productions with his sister Jamie, an open call black-and-white only art show based on the old MAC Paint. He presented the reprogrammed Nintendo cartridge, Super Mario Movie, at Deitch Projects in collaboration with Paper Rad, about which he says, "picture title screens, messed up fantasy worlds, castles floating on rainbow colored 8-bit clouds, waterfalls, underwater dungeon nightmare ravescapes, dance parties, floating mushroom level scenes, Mario alone on a cloud crying, fireball flicker patterns, and video synth knitted 60 frames per second seizure vidz. Each scene will also have music & all being generated by this one 32k 1984 cartridge!!!!!!!!!!!" Judgging by the exclamation points, Cory is more excited about the prospect of mailing this mystery hacked Nintendo cartridge to his friends and influences than any-thing else, as he writes "imagine getting this in the mail one day out of the blue!!!!!!!!!!!!!!!!...>>!!!!!

All images courtesy the artist and Team Gallery. Page 22: still from I Shot Andy Warhol cartridge, 2003. This page clockwise: still from nI-POD video, 2004; Totally Fucked , hacked Super Mario cartridge, 2003; Unix manual page for Pizza Party Program, 2004. Page 24: Paper Rad and Cory Arcangel, Super Mario Movie, handmade hacked Super Mario Brothers cartridge, installation view, Deitch Projects, January 15- March 2, 2005; Paper Rad and Cory Arcangel, Super Mario Movie, installation view, photo Hikari Yokoyama; Paper Rad and Cory at opening, photo Hikari Yokoyama. Page 25: Paper Rad and Cory Arcangel, Super Mario Movie, installation view; Space Invader, hacked Atari cartridge, 2004; Cat Rave, 2004, video, collaboration with Frankie Martin; Japanese Driving Game, hacked Famicom cartridge, 2004; Sans Simon, video, 2004.

```
|pizza_party(1)            BEIGE            pizza_party(1)

NAME
      pizza_party - text-based client for ordering pizza.

SYNOPSIS
      pizza_party [-o|--onions] [-g|--green-peppers] [-m|--mush-
      rooms]  [-v|--olives]   [-t|--tomatoes]   [-h|--pineapple]
      [-x|--extra-cheese] [-d|--cheddar-cheese] [-p|--pepperoni]
      [-s|--sausage] [-w|--ham] [-b|--bacon]  [-e|--ground-beef]
      [-c|--grilled-chicken] [-z|--anchovies] [-u|--extra-sauce]
      [-U|--user=  username]     [-P|--password=  pasword]
      [-I|--input-file= input-file] [-V|--verbose] [-Q|--quiet]
      [-F|--force] [QUANTITY] [SIZE] [CRUST]

DESCRIPTION
      The pizza_party program provides a text only command  line
      interface  for  ordering  DOMINOS pizza from the terminal.
      This program is intended to aid in the throwing  of  PIZZA
      PARTIES which are also sometimes known as ZA PARTIES

USAGE

      pizza_party -pmx 2 medium regular

      Orders 2 medium regular crust pizzas with pepperoni, mush-
      rooms, and extra-cheese.

DIRECTIONS
      You will first need to go to www.dominos.quikorder.com and
      sign up for an account.  Then use your user name and pass-
      word  in  the .pizza_partyrc file, or in your command line
      request.

OPTIONS
      -o|--onions
            Order your pizza with onions.

      -m|--mushrooms
            Order your pizza with mushrooms.

      -v|--olives
:0
```

UNIX pizza party program 2K4

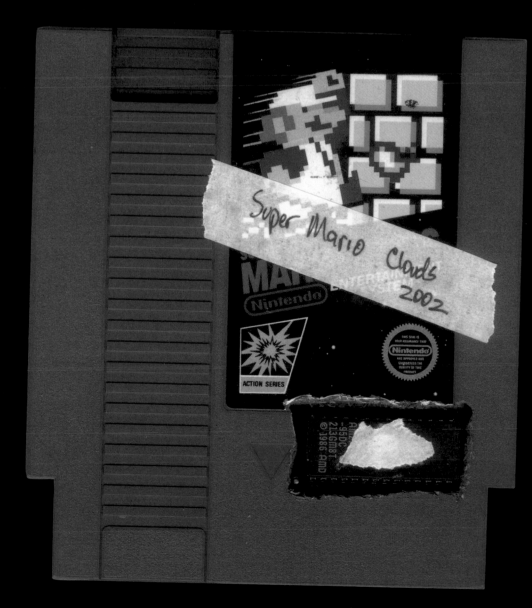

Super Mario Clouds 2002

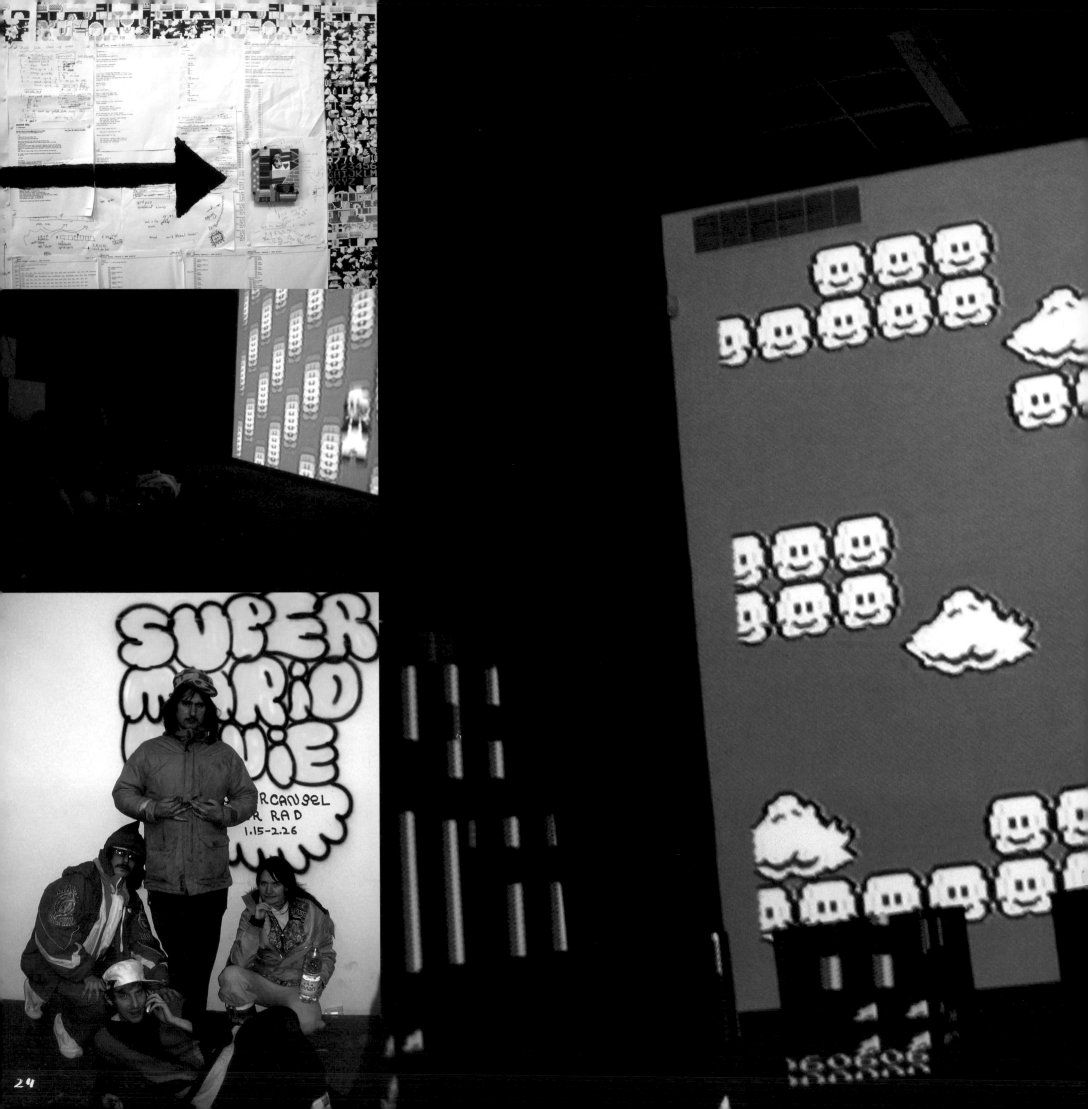

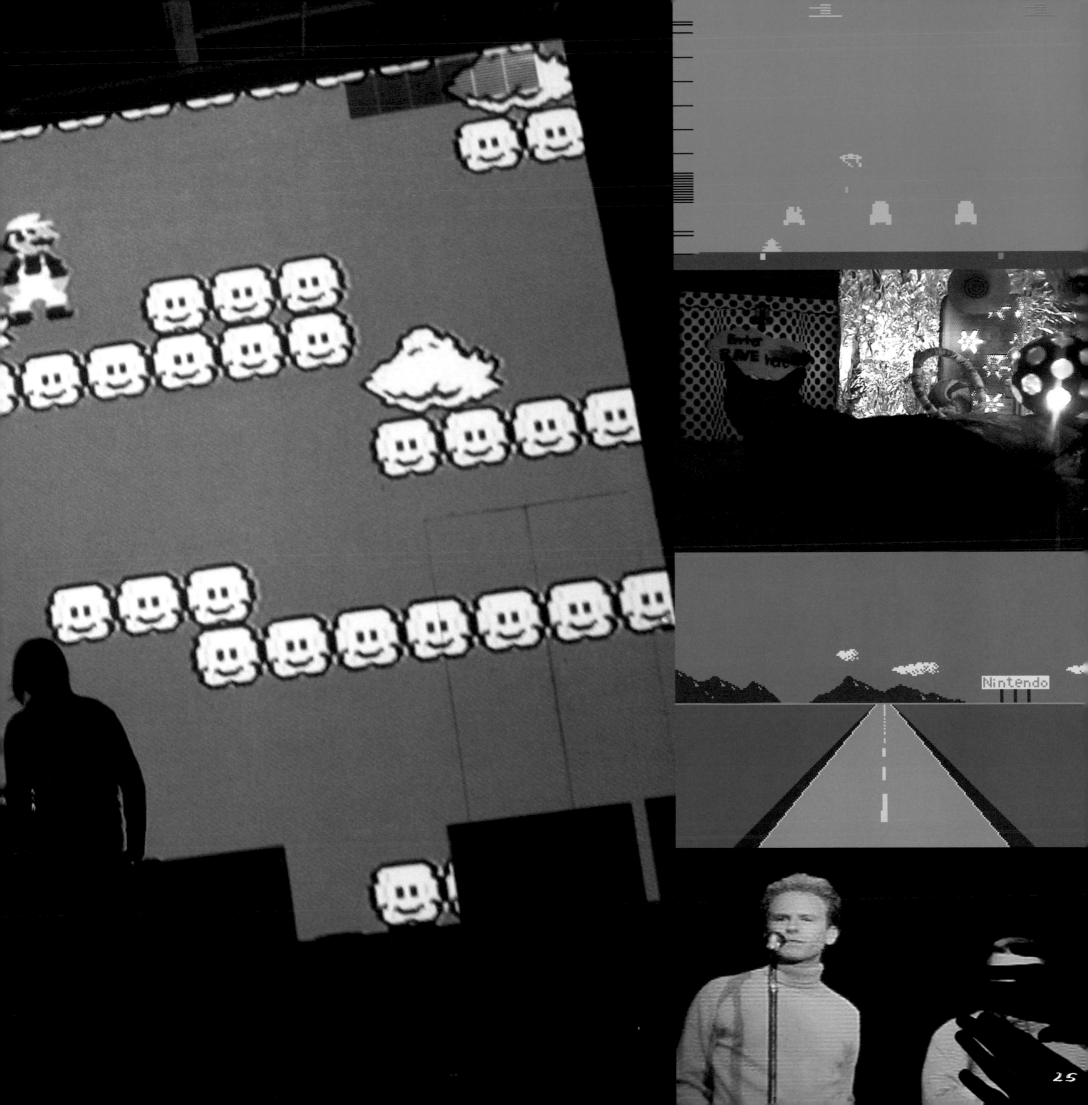

Le Tigre

FEMINISTS WE'RE CALLING YOU

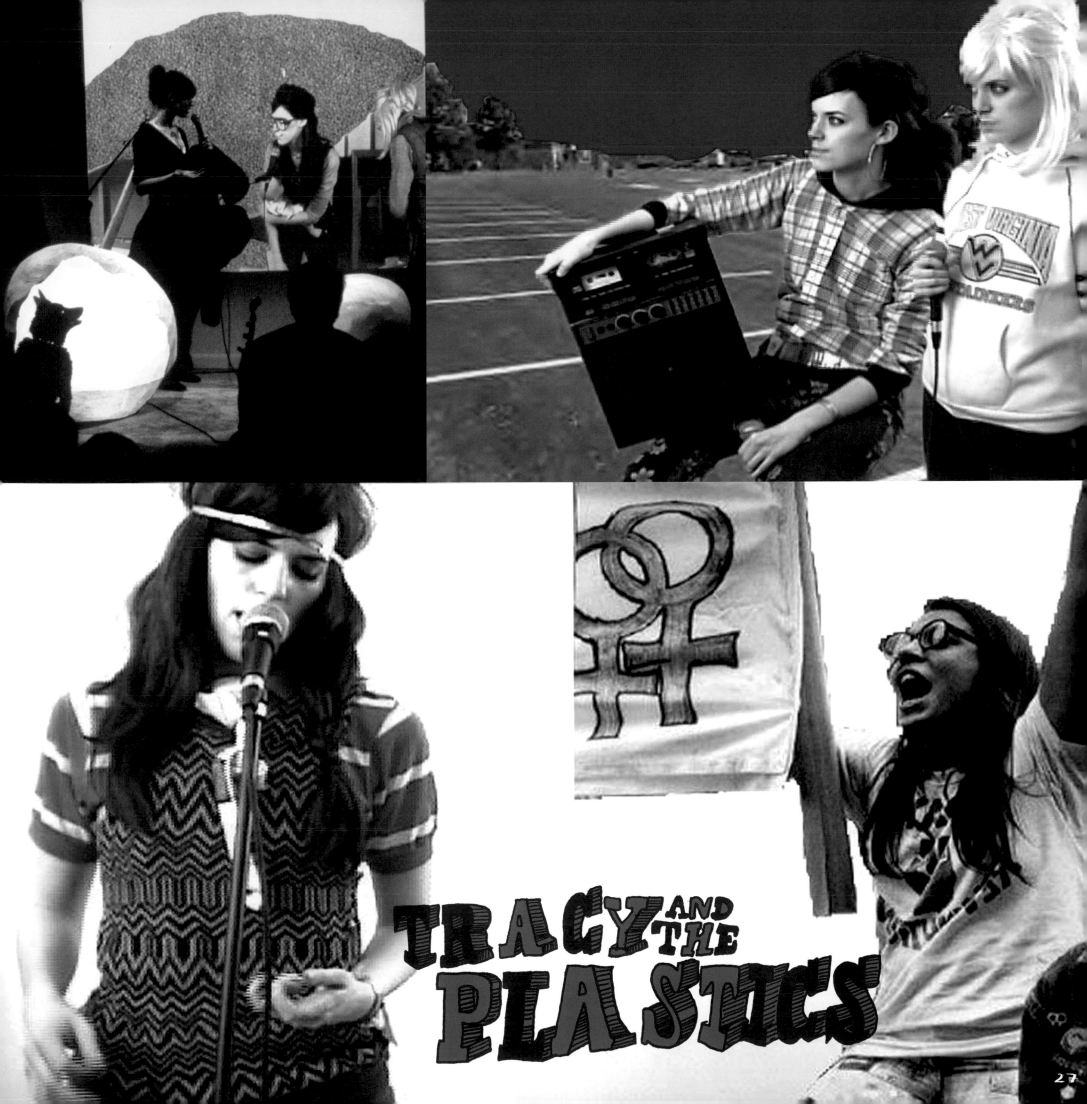

TRACY AND THE PLASTICS

BARR

AND ITS POLLITICAL, AND POLLITICS ISN'T NECESARRIL
JUST GUERILLA FIGHTERS, PRIME MINISTERS AND
WHO CHEATED IN THE PRIMARIES, IT'S ALSO WHO AM I
IN RELATION TO YOU, WHO ARE WE, AND THE WAY WE CAN
SEE OURSELVES IN RELATION TO THE OTHER KIDS, THE ONES
IN THE MAGAZINES AND THE ONES WHO MISS OUT
ON SHIT—THAT DOESN'T EVEN MATTER ANYWAYS—
CAUSE THEY LIVE ~~FAR~~ FAR AWAY FROM THE CITIES AND
YET THEY'RE STILL REBELLING FROM THE SYSTEMS
AND THE NORMS THAT'S SAYING "BE BUMMED +
BE BORED" AND THEY'RE TAKING MATTERS INTO THEIR
OWN HANDS, AND THAT'S WHAT MATTERS, HOW
EVERYONE'S OWN PLAN WORKS OUT. AND WE CAN GIVE ALL
CREDIT IN THE END, OR THE MIDDLE. RATHER THAN
FRONTING ON SCENE POLLITICALS, AND IF WE'RE HERE,
WE'RE PROBABLY ALL SPECIAL ART REBELS OR SOMETHING,
SO LET'S ALL BE SPECIAL ART REBELS TOGETHER, SAME LEVEL, ANYWAYS,
AND IF NOT THE SAME, THEN SO CLOSE, SO HERE'S A
TOAST TO US, GO US. AND IT GOES B IS FOR INSPIRATIONAL
HEALING, A IS FOR LECTURE, R IS FOR MUSIC, AND R
IS FOR RIGHT NOW. IT GOES B IS FOR INSPIRATIONAL
HEALING, A IS FOR LECTURE, R IS FOR MUSIC, AND R IS
FOR RIGHT NOW.

BARR (Brendan Fowler) is a ridiculously insane performer/guru/musician fellow, and if the most frequent description of his music is "um, minimal handmade drumbeats that he kinda talks over", it's because whatever he's onto is something unnameably, radically new. It's part self-help for fucked-up, jaded, hipster-intellectual activist punks, part rallying cry to all kids everywhere in the name of political equality. BARR performances are uncomfortable because you have no idea what this supertall, superloud maniac might do, as he is 100% no filter, no fear, talking serious, heavy shit to you over some beats. Tracy and the Plastics (Wynne Greenwood) means a new-media band that consists of Wynne on stage making music and interacting with her pre-recorded band mates (also Wynne), all spliced up with graphics and video compositions. It can go from pretty high-theoretical to sweetly slapstick, but carries an immediacy and razor-sharp wit that gets audiences involved and in synch with it. For example, once at this LTTR performance thing at Art in General her video skipped something and she started over, and was met with the encouraging theory-taunts of "compulsive re-enactment!!! Compulsive re-enactment!!!" I mean ??? Awesome. Le Tigre, of course, is this pioneering new-media, new-feminism punk band consisting of Kathleen Hanna, Johanna Fateman, and JD Samson. They met at a DUMBO loft party after extended zine exchange and, in their own words, "wanted to make a new kind of feminist pop music, something our community can dance to. In our scene, the notion of community had been so problematized by postmodernist theory and identity politics gone haywire, that is was easier to retreat into irony or purely oppositional self-definitions. We wanted to be sincere and take risks."

What these performers all have in common, besides the fact that Brendan, Wynne, and JD have all collaborated in various ways in the past and the future, is an ability to develop new ways of performing music that brings radical values to the fore without boring the shit out of everyone. Barr hails from LA via Baltimore and New York City, and has played basements, art openings, packed LA loft parties, and cool music venues across the US. He has a new album coming out on Kill Rock Stars, but to get the amazing old one just go to barrbarr.com. Tracy + the Plastics has been featured in the 2004 Whitney Biennial of American Art and numerous rad art shows and screenings, and they perform often at the Kitchen and other places that tracyandtheplastics.com can lead you to. Le Tigre has played sold-out shows around the world and have a ton of interesting info and links on letigreworld.com.

All images courtesy the artists. Page 26: Le Tigre photos, courtesy Le Tigre. Page 27: ROOM, Tracy and the Plastics at The Kitchen, February 2005, collaboration with Fawn Krieger, photo Paula Court; Tracy and the Plastics performance video, 2003; Tracy and the Plastics performance video, 2004. Page 28: BARR performance, photo Todd Cole; BARR install view from Session the Bowl, Deitch Projects, Winter 2003; BARR performance, David Kordansky Gallery, 2004. This page: JD Samson; BARR performance in Majority Whip, White Box, May 2004; Le Tigre video; JD and Wynne, photo Brendan Fowler; BARR performance, Tokyo, 2004, photo Todd Cole.

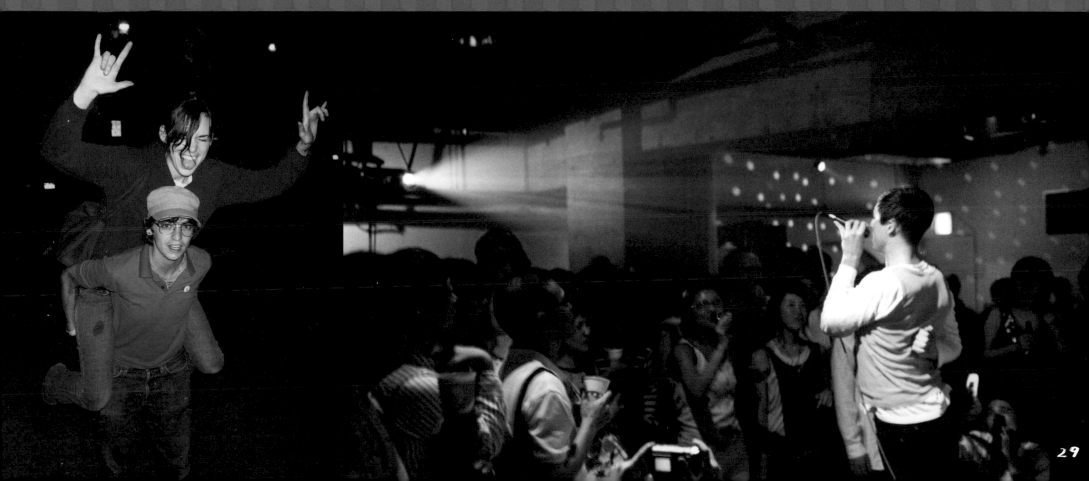

Ry Fyan's paintings are frequently mistaken for collages, as their insanely precise photorealistic renderings of various post-consumer debris are even more realistic-looking then their media references. Often containing incisive critiques of the cultural, the small moments in Ry's carry very big ideas. There is something redemptive in his urge to fish poetic and timeless sentiment out of the morass of contemporary ugliness; the two teens sticking their hands in each others pants in Hypnogogic Vacua, at left, helps take the curse off the advertisement's scripted idea of romance right above it; the lack of natural beauty interacting in a woman's face in detail of Untitled, (2005), below, wage compositional war with the eddying cultural garbage blowing through it. His belabored surfaces often circulate images from ancient cultures and de contemporary ones in a way that seems almost mournful of how the trappings of our current civilization might be viewed in coming millennia. If the beauty of his images is hard to capture in reproduction, that is part of the point: to make beautiful objects that aren't iterable, but rather that remain solid things standing apart from capitalist production, independent because there is just one and you really have got go visit it.

Two paintings included in a Rivington Arms group show, "Don't Be Scared", in the summer of 2002 introduced everyone to his innovate aesthetic. Since then multiple paintings and drawings in successful group shows have kept everyone fascinated as he prepares for his debut solo show of new paintings in 2005. Ry also records uncomfortable nature ambience and related noises under the monikers Fedatris Troom and Driving Miss Jay-Z. He is preparing to release an awesomely intricate hand-painted comic called Detritus Harp.

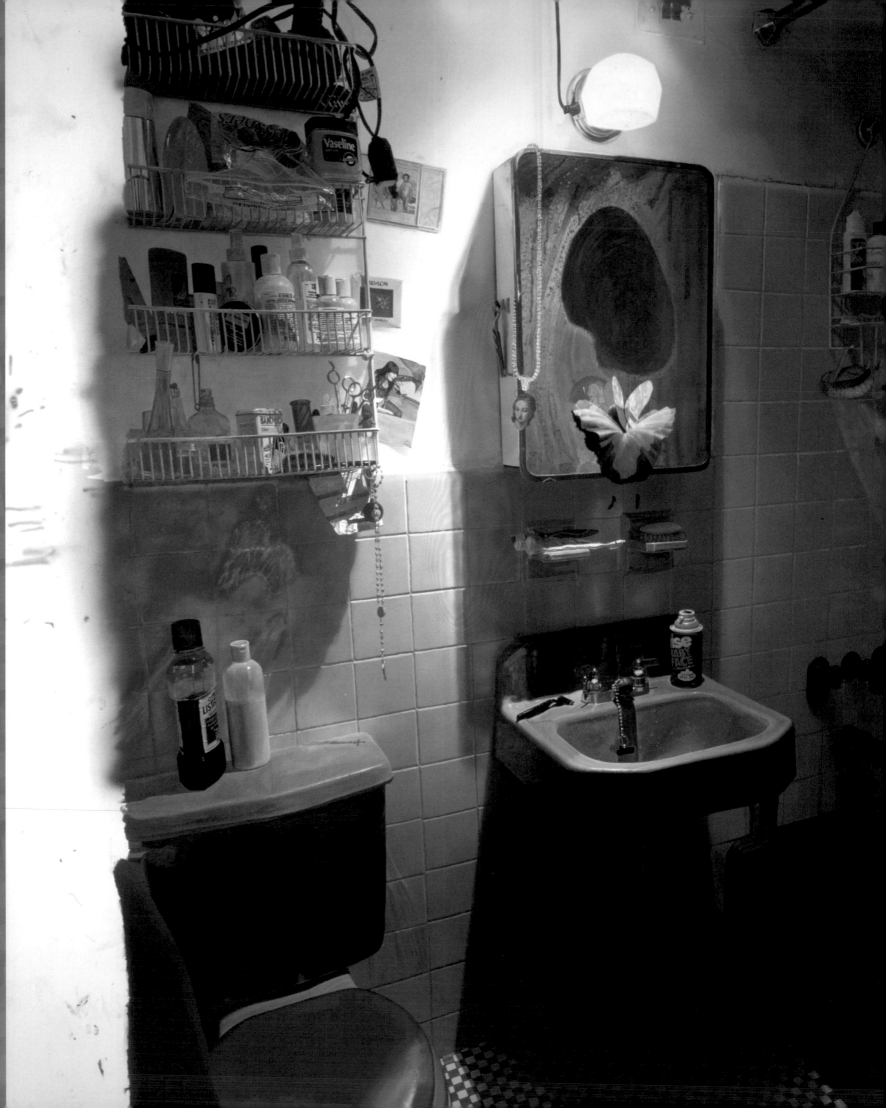

Dan Colen

Dan takes familiar subject matter— his bathroom, his bedroom, his chest, his friend Dash Snow's old living room— and breaches the commonplace with serious, and often religious, reveries, intruding like a rapturous hallucination. Executing these visions in a photorealistic manner, Dan fantastically uses light and shadow to generate mood, making the representational nonetheless environmental and particular. His standout solo show, *Seven Days Always Seemed Like A Bit Of An Exaggeration*, in the fall of 2003 at Rivington Arms, wowed a young art crowd who might have forgotten what exceptional paint handling looked like. More technically adept than many much older artists, Dan's paintings tackle content that deals with a poetic adolescence and coming-of-age struggles, including religious ones. But, for all the beauty packed into every inch of canvas, the viewer might be forgiven for finding more God in the details than in the religious symbols planted in the scene. While the compositions are theatrical, the real drama is the beautiful way a crease of plaid shifts color tone in space, or the strange overlapping shadows on a tile hit by light reflected from a bottle of Listerine.

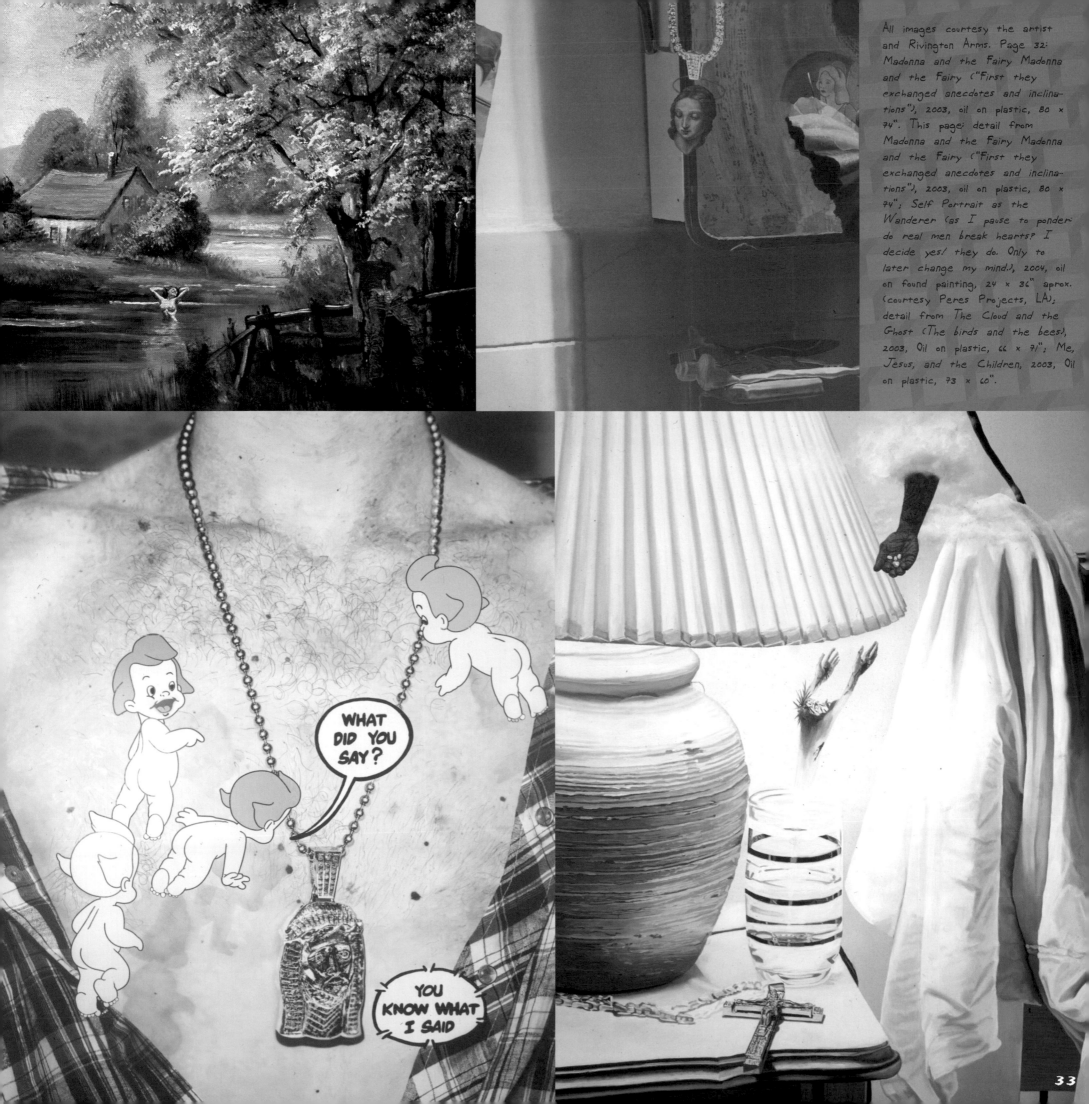

All images courtesy the artist and Rivington Arms. Page 32: Madonna and the Fairy Madonna and the Fairy ("First they exchanged anecdotes and inclinations"), 2003, oil on plastic, 80 x 74". This page: detail from Madonna and the Fairy Madonna and the Fairy ("First they exchanged anecdotes and inclinations"), 2003, oil on plastic, 80 x 74"; Self Portrait as the Wanderer (as I pause to ponder: do real men break hearts? I decide yes! they do. Only to later change my mind.), 2004, oil on found painting, 24 x 36" aprox. (courtesy Peres Projects, LA); detail from The Cloud and the Ghost (The birds and the bees), 2003, Oil on plastic, 66 x 71"; Me, Jesus, and the Children, 2003, Oil on plastic, 73 x 60".

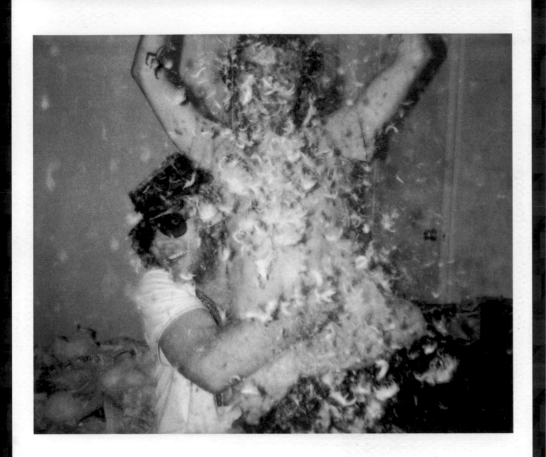

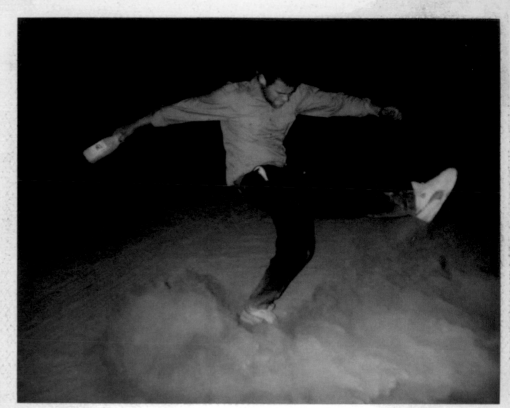

DASHSnow

34

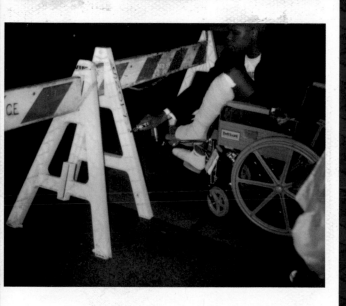

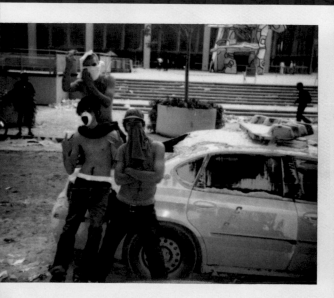

Dash has been documenting his rather exceptional life with assuredly exceptional Polaroids for over five years. With a starkly discernable stylistic touch (even under what are inferably extreme circumstances), Dash captures the harsh lows and exuberant highs that lurk behind a mediated version of drugs, sex, affluence, poverty, or whatever you wanna call the "downtown scene". Adept at capturing amazing un-stageable, un-fakeable photos of a diversity of people with a non-patronizing documentary eye, Dash's work provides an invaluable look at life in New York right now. A wheel-chair-ridden friend catches a tag on a police barricade, some suggestive back alley violence is perpetrated by a dude whose jacket reads "Fear the Darkness", a lady asleep on the subway with a "Jesus Loves Me" t-shirt gets her purse lifted by some kerchiefed punk— I mean, it's hard sometimes to believe that shit like this actually happened. Half-soft orgies, porn, heroin and hamster nests, robbery, refuse, jump-kicking and sucker-punching, blow, blowjobs; this art is authentic in ways most contemporary photographers (and audiences) have forgotten. Dash may or may not decide to show art in a gallery setting, as his work— you might be able to tell— isn't made with that intent, but it would be a valuable contribution to the abatement of bullshit art if he did.

All images courtesy the artist.

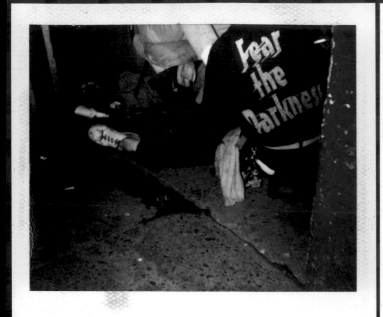

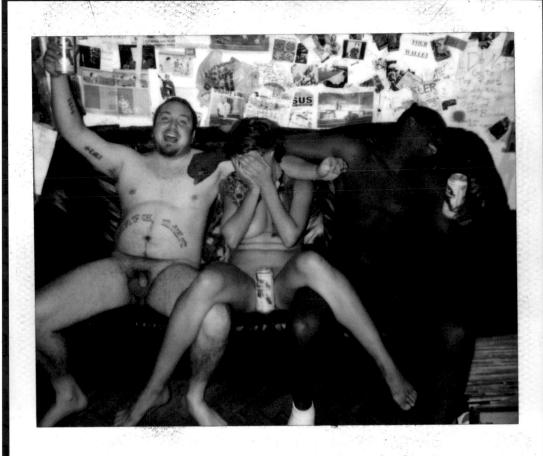
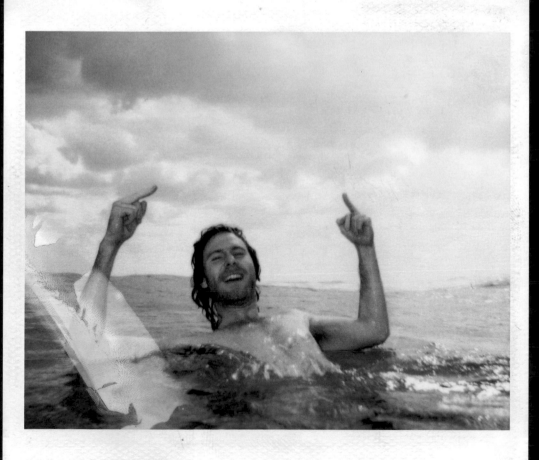
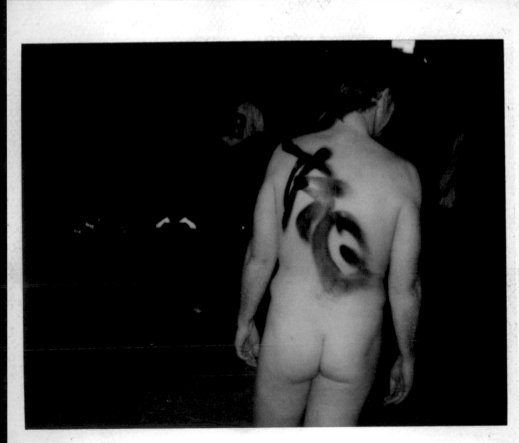

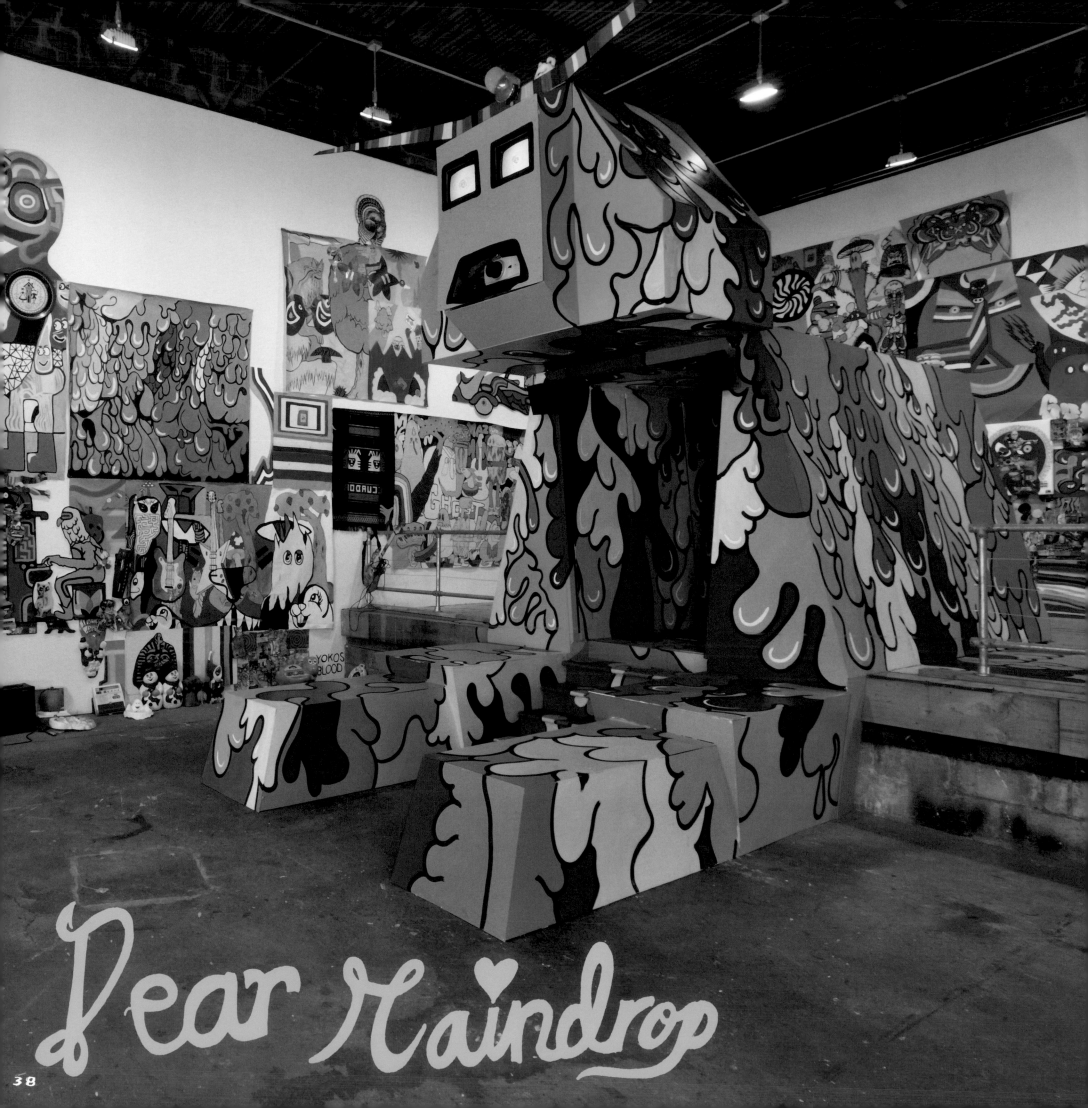

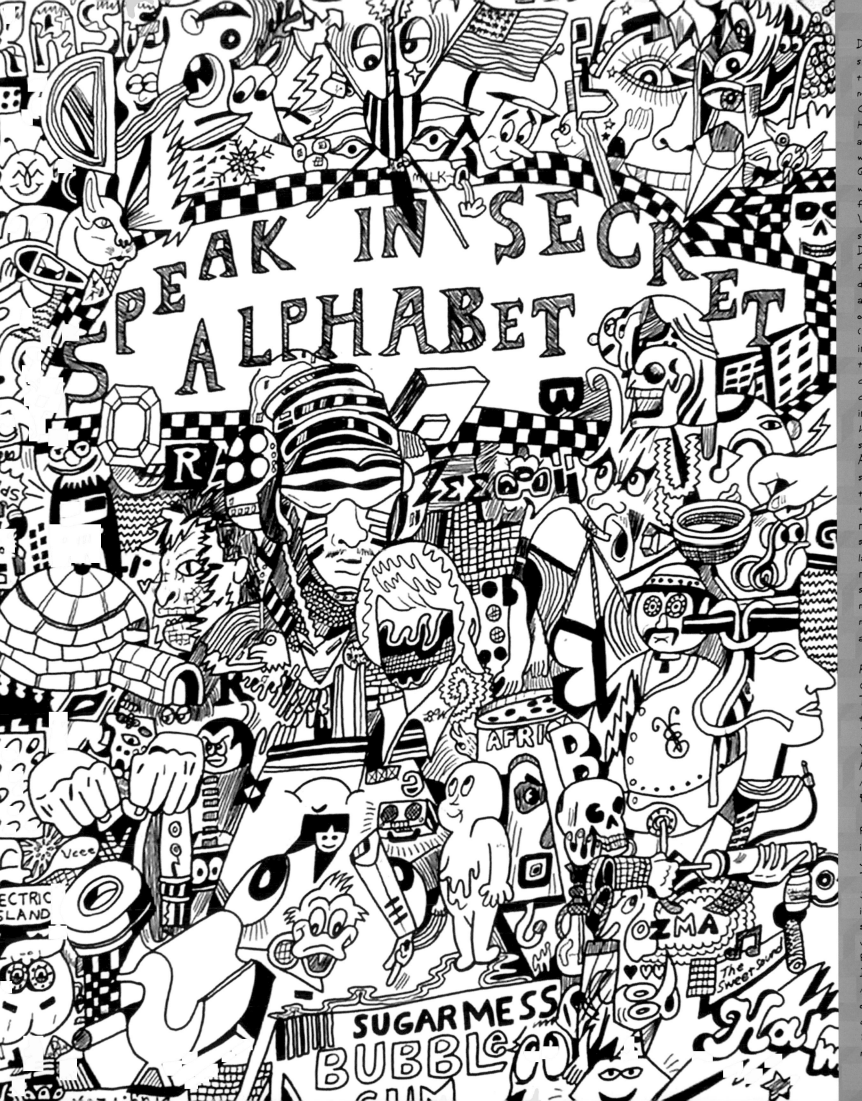

SPEAK IN SECRET ALPHABET

Dearraindrop are prophets of the sinister swirl of media imagery that irrationally commingles and mutates in our nether-consciousness. Collaborating with the late George Harrison, the future Kenny Scharf, and various awesomeness along their way, the group consists of Laura Grant, Billy Grant, and Joe Grillo, who go all the way back to the future but currently work in Virginia Beach, Los Angeles, and sometimes New York. Visiting a Dearraindrop show is like being flushed down reality into a black-lit, day-glo aquarium of decanted cultural precipitate and psychotic acid ooze. Take Riddle of the Sphinx (Summer 2004), at Deitch Projects in which myths, symbols, and cartoons took on a life of their own, conveying the horror of basic concepts in meltdown. Winking, jabbering, and hieroglyphic, their hall of horror vacui was an uneasy dream squeezed full of monsters and American archetypes: a fucked-up summer wonderland. Beamed from the mouth of a giant, melting, multicolor sphinx/instrument, their newest video, Dracula Mountain, splattered living kaleidoscopic collages to tracks by epic Providence noise-band Lightning Bolt. Their speech matches their clothes matches their art, from the microcosm of a six-inch collage to a 2000sq. ft. installation.

Recent shows at Deitch, John Connelly Presents, and Hanna in Tokyo have been lauded widely in the press, including The New York Times' "Art and Artists of the Year", plus the descriptively titled Adrian Dannatt interview for The Art Newspaper, "One, Two, Three, Four, Doodelator."

Page 38: Riddle of the Sphinx, installation view, Deitch Projects, June 25- August 7, 2004, photo Tom Powel Imaging. This page: Speak In Secret Alphabet, 2004, ink on paper, 11 x 14". Page 40: sequence from Dracula Mountain, video by Billy Grant, 15min, 2004. Page 41: installation at Coney Island as part of The Dreamland Artist's Club, opened Summer 2003, organized by Creative Time, image courtesy Creative Time; Vanilla Fudge, 2004, acrylic and mixed media on canvas, 5 x 8'.

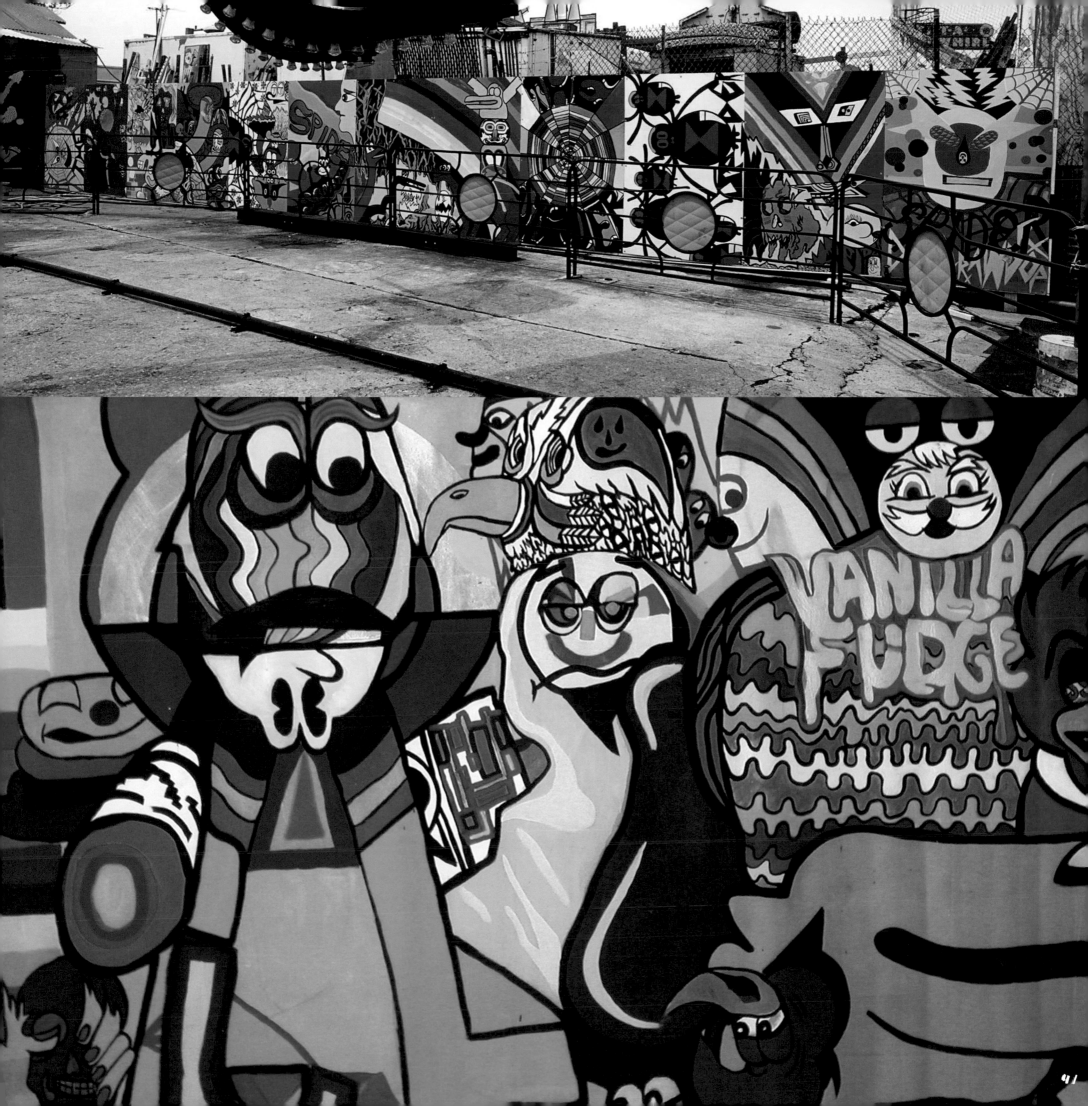

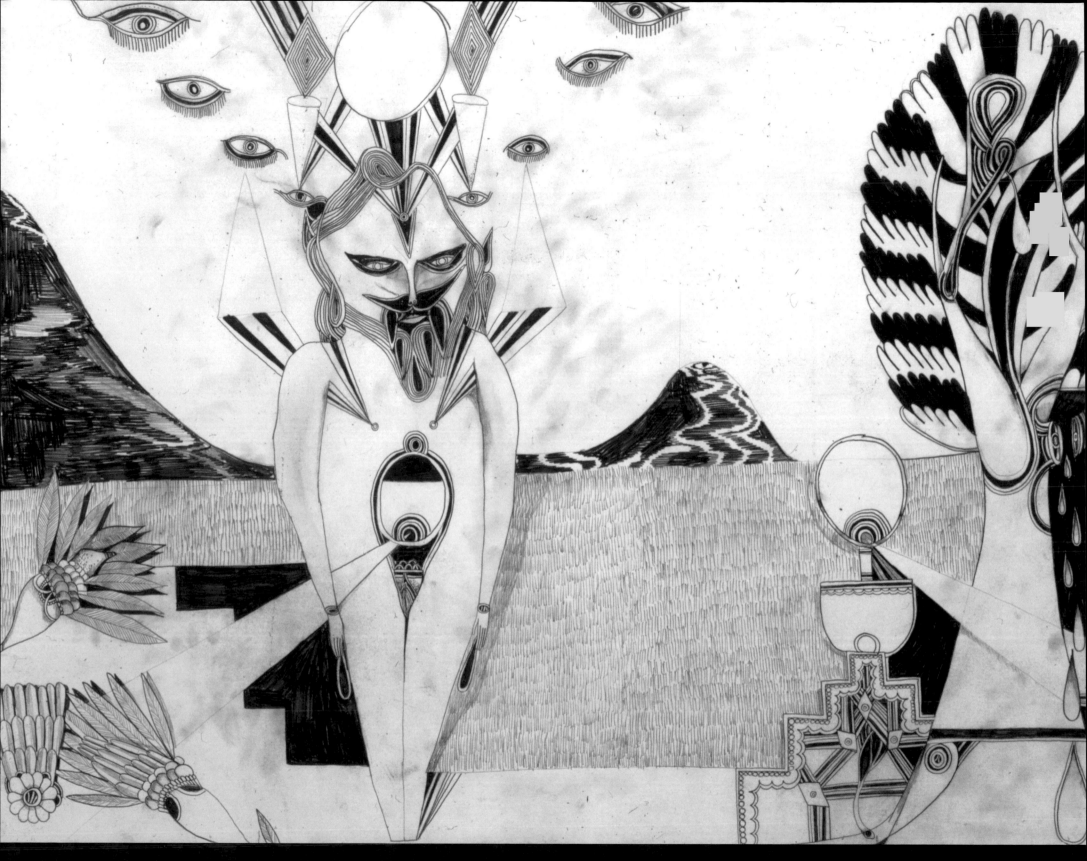

Bay Area artist Keegan McHargue creates patterned explorations of myth and ceremony, circulating hybrid beings, warriors, and wizards in strange tableaux of hidden portent. In his meticulous and well-crafted works on panel and paper, he builds his highly idiosyncratic environments using a precise line and a subdued palette. Often taking inspiration from literary, religious, or occult sources, Keegan conjures a wildly-imaginative variety of creatures to populate and describe a world uniquely his: finely-haired oxmen, hooka smoking beardos in lavender camisoles, hermaphroditic bird rulers, veiled meth-lab aliens, and other beings too weird for concise description. Circuits and conduits, veins and aqueducts unite the figures with each other and their environment in an almost biological thicket of interconnection. Negating our educated dependence on received forms and structures, Keegan provides the viewer with a sense of joy in the dis-

ruption of conventional modes of expression; buildings collapse and fold up into the picture plane, while faces unfold to show all their sides. His almost cubist deconstruction of figural volumes with patterning gives the viewer the sensation that he or she is seeing a face or body again for the first time, accurately-- a body in collapsed time and full simultanaeity.

Keegan's debut shows at Rivington Arms and Brooklyn Fire Proof in the summer of 2003 introduced New York to his very fresh type of graphically inclined painting. A huge six-foot drawing at The Wrong Gallery, inclusion in the great group shows We Are Electric curated by Chris Perez at Deitch, Incantations at Metro Pictures, and Matthew Marks' Fear No Evil, and a solo show at Jack Hanley (Spring 2004), demonstrated his rapid evolution into an artist of rare poetry and depth.

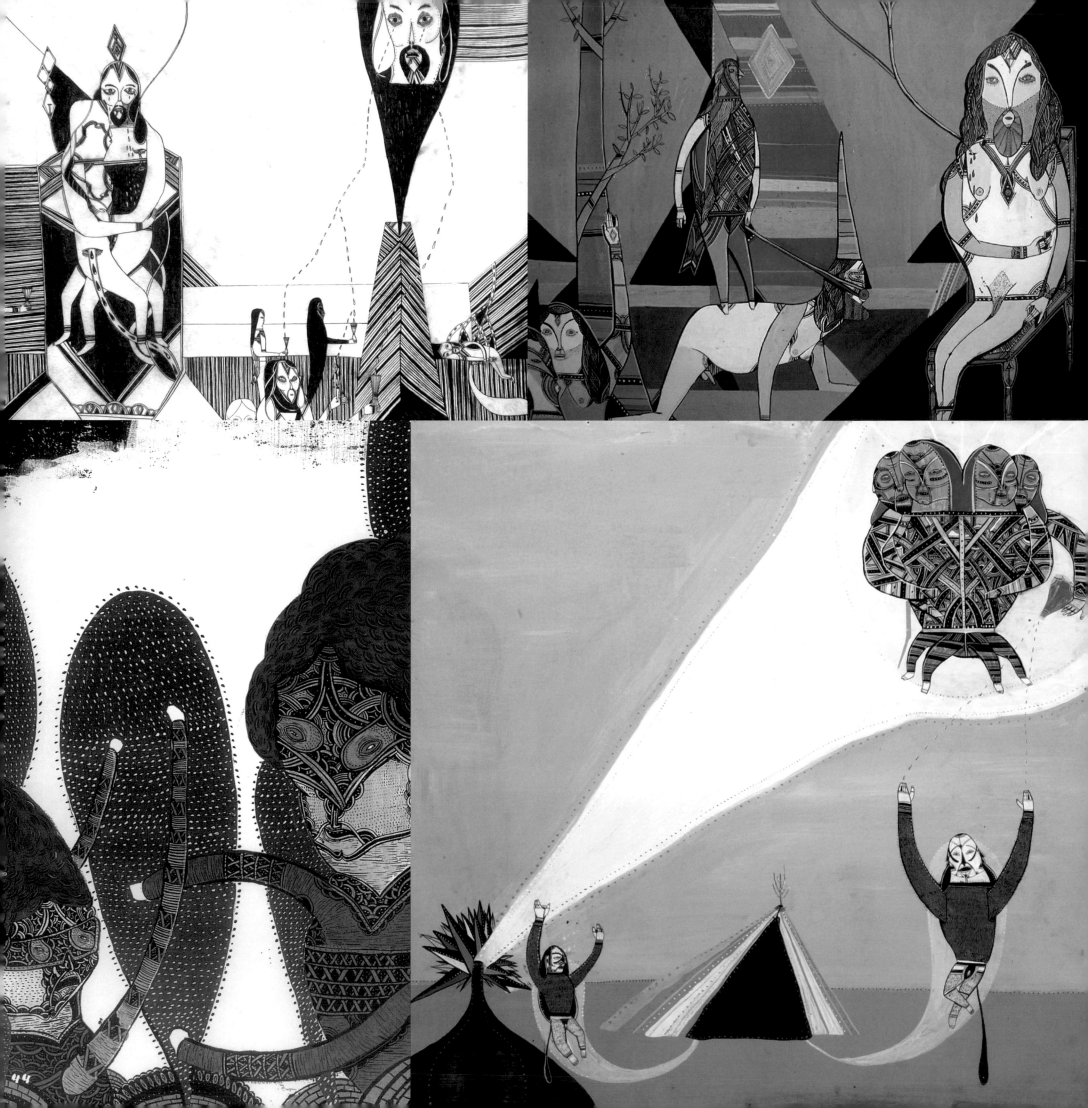

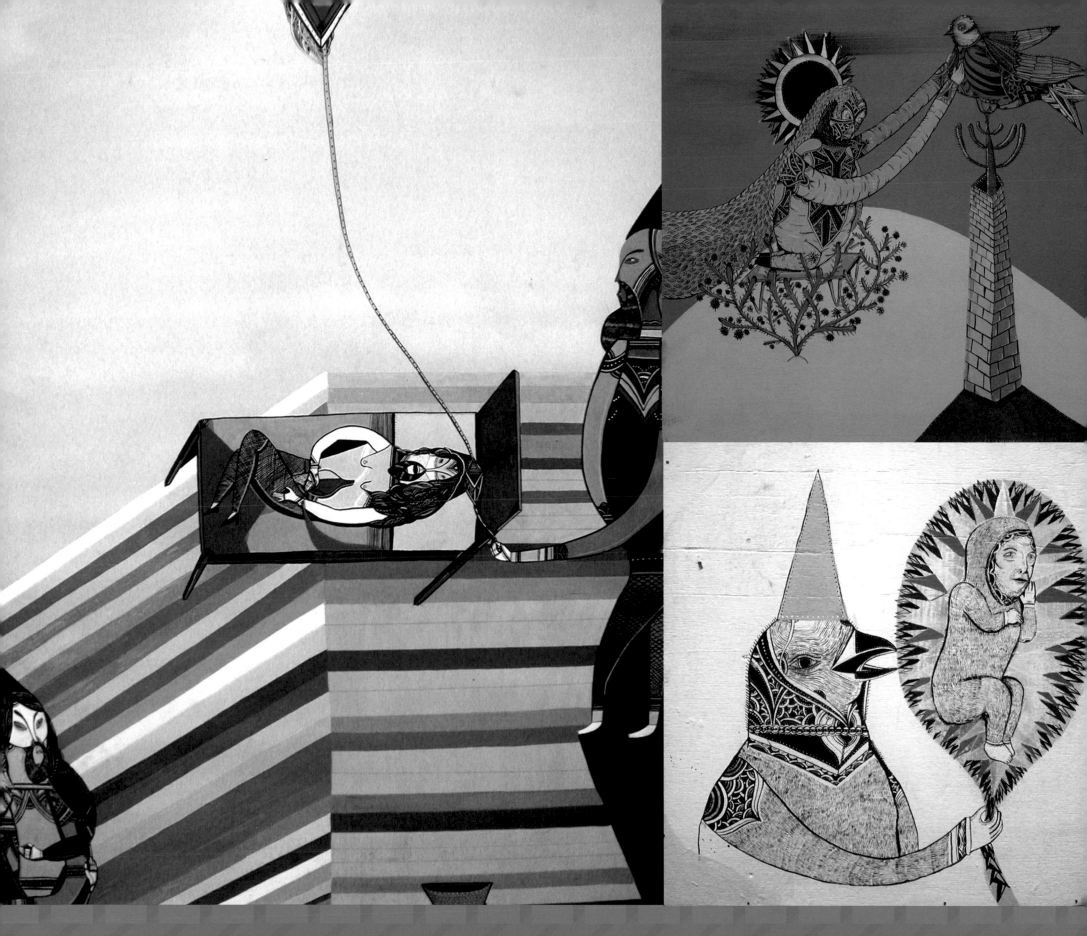

JULES DE BALINCOURT

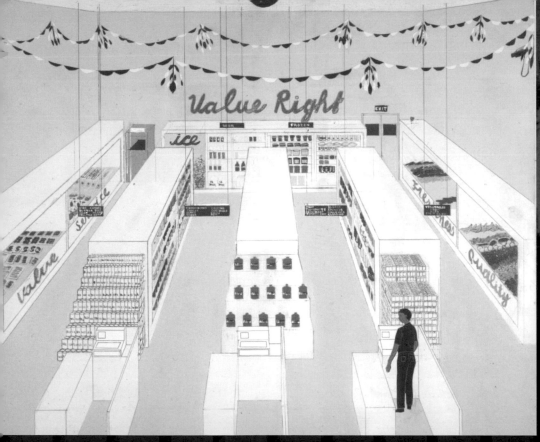

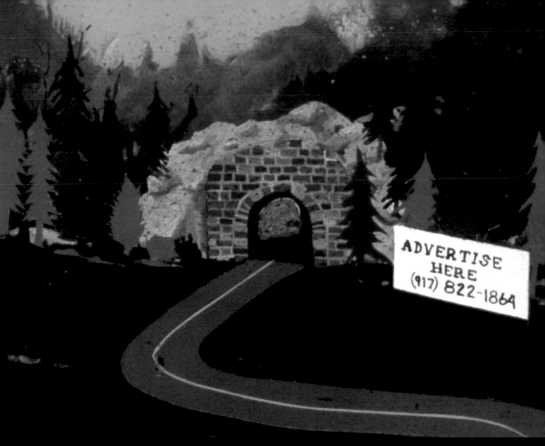

Whether in his lushly hued paintings or his diverse sculptural installations, Jules de Balincourt builds worlds of strange occurrence and serious commentary. From an aurora borealis in a shopping mall's food court, to a rainbow global media outpost amidst arctic tundra, to skiers blissfully traversing a snowy mountain of post-consumer waste, Jules' wit and elegance are never far from a pointed and sincere critique of the cultural. LA backyard-scapes of lavish laziness are rendered in the same lush pinks and oranges as a hippie gathering in the winter forest; people fleeing into the mountains may or may not be going on a healthful jog, and Jules' "Men's Safety Center" looks conspicuously like the Animal Testing Lab in an adjacent painting. A stand-out solo show at LFL featured not only an array of paintings on panel, but also a huge collaborative (and functional) tree-house and various dioramas showing his world in three-dimensions. Text pieces take familiar phrases like "if you see something say something" or "you build it we burn it" and in the staging of them, Jules brings out their uncanny associations or hidden subtexts. Rendered in a folk idiom familiar to recent San Francisco tendencies but fleshed out with a formally attentive precision, Jules' art remains very of the earth while seeking the transcendental.

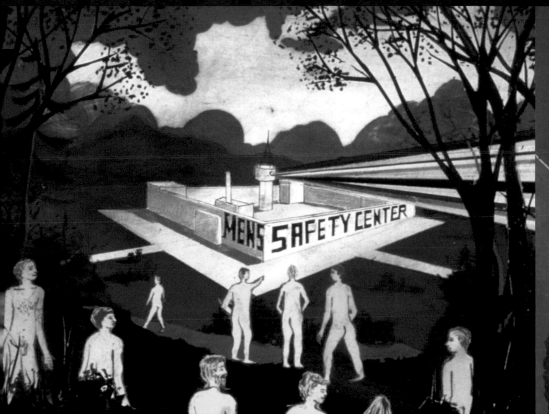

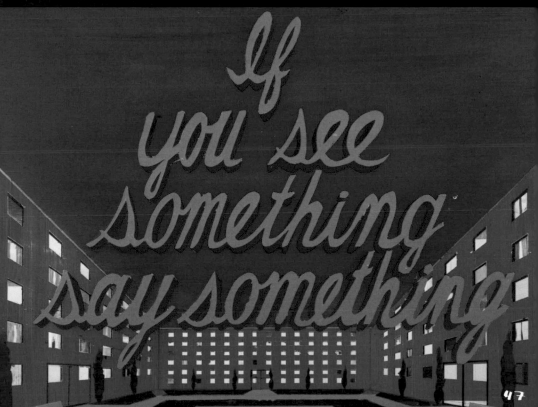

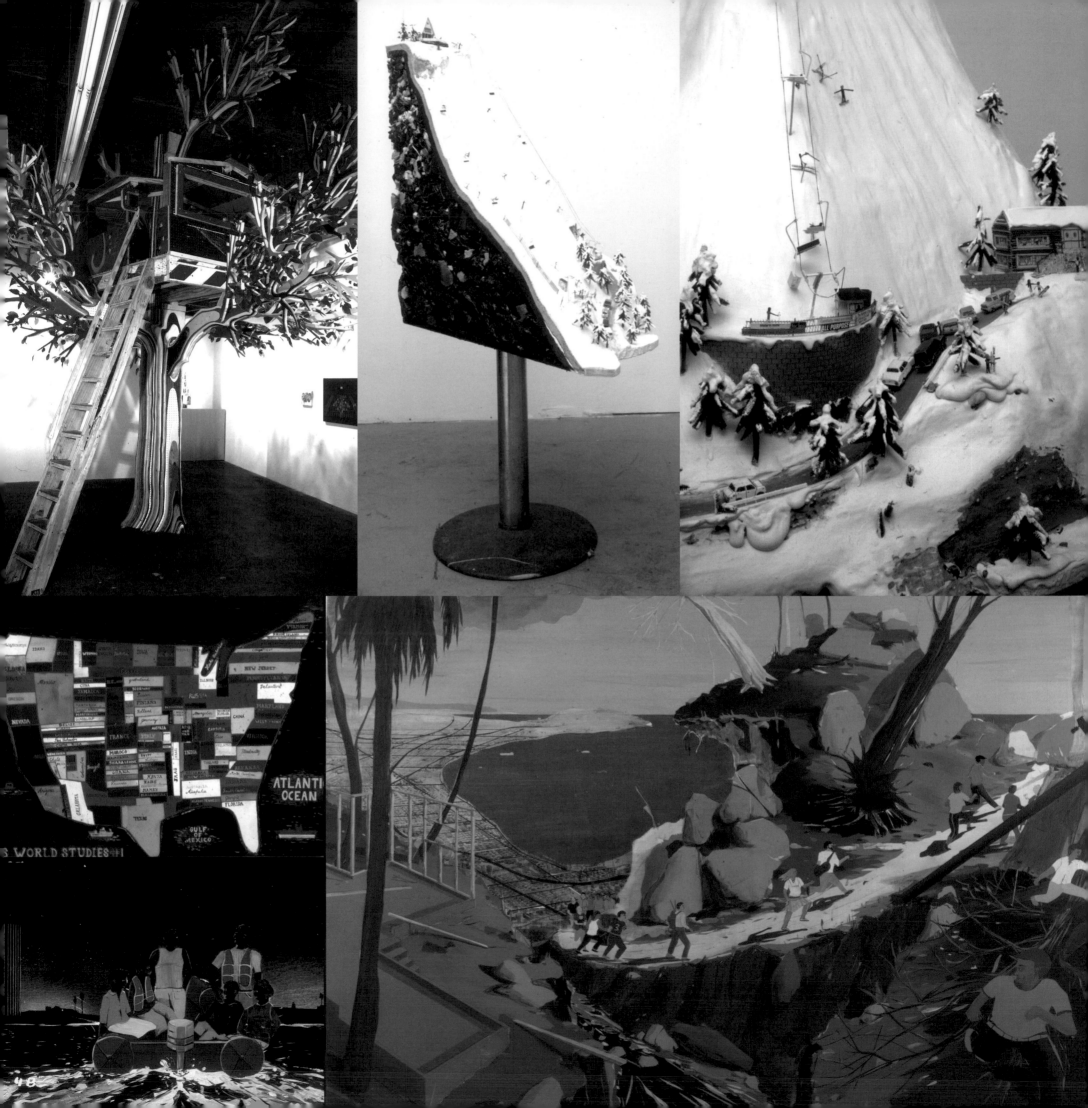

ESSAYS

CORY ARCANGEL
PHILIP GUICHARD
LAWRENCE RINDER
JEFFREY DEITCH
KATHY GRAYSON
ASSUME VIVID ASTRO FOCUS
JIM DRAIN

Forwarded message
Date: Wed, 1 Sep 2004 16:42:44 -0400 (EDT)
From: cory arcangel < arcangel@cs.oberlin.edu>
To: Katherine Grayson < kathy@deitch.com>
Subject: Re: +++

On Wed, 1 Sep 2004, Katherine Grayson wrote:

> hey cory been meaning to ask you:
>
> was there one moment, event, etc where you
> were aware that something new was going on with
> things and were excited and wanted to get
> involved- whether it's the art community, or music,
> or in general? can you think of something that was
> really inspiring and indicative of a new sorta goings-on?
>
> ok

oh ok,...good question.

I could prolly think of a few the most OBVIOUS time
was...when i first heard the record "maxi german rave
blast hits 3" by Bodenstandig 2000:

http://www.pitchforkmedia.com/record-reviews/b/
bodenstandig-2000/
maxi-german-rave-blast-hits-3.shtml

It was 1999, and my roommate at the time Paul B.
Davis and a few friends (this group would later be
called BEIGE cause that was the name of our record
label) were working on our record called "the 8bit
Construction Set" which was a DJ battle record where
one side we made with a commodore 64 and the other
we made with the Atari800,....anyway so basically we had
been collecting and studying these old 8bit computers for
a few years, learning how to make music on them, and
whatever (later I would get obsessed with making videos
on them).......we did this just by ourselves in our room
which was piled high with any kinda computer junk you
can imagine (also remember ebay had just started to
get popular)..it was kinda like we were archaeologists who
just discovered some weird land that we kinda remember

At right: The 8-Bit Contruction Set and Bodenstandig 2000, 2001; The
Making of Super Mario Clouds DVD.

from when we were like 6 years old, (but not really cause by the time we got down with computers they had mice, and trash cans)....so kinda by ourselves we had gotten pretty deep into the 8bit world. So then through a contact at a UK record label who knew we were doing this stuff we got a email about this new record on Rephlex Records by this group of two German Guys called Bodenstandig 2000: http://bodenstandig.de/

Bodenstandig were 2 German guys who described themselves as "Hard Rocking Scientists", and their record was the best thing I had ever heard. Think pure real deal 8bit chip tunes ("chip tune" means music made on the original sound chips of old video games and home computers) with harmonic German folk singing over the top. Like a video game folk music, but more importantly not silly, or ironic,.... also, the music wasnt samples, but actually made on a music program that one of the members of the band wrote for the atari Falcon home computer (If you have ever programmed computers you know it is ULTRA hardcore to program your own music tracker and sequencer, especially for a 16 bit machine). So the record was basically the REAL DEAL. These weren't guys doing it cause it was retro cool, but doing it cause they loved it, and had always made music that way. It was just awesome. Their lyrics were even about being computer nerds (this song talk about how back in the day you had to actually make your own computer cables.....):

Back then we were nothing but cablefreax, lonesome cablefreax
Soldering was our joy
Soldering, not killing, cyberspace, not spam
Soldering was our destiny
Some even called us cyberpunx

Though they don't exist at all
Our insulating tape was striped in black and yellow
We sieved silicon.

So, after that record I knew something was up. Paul and I's first reaction was we had already been one upped, and we hadn't even released our record yet!! ha ha ha (the 8bit Construction Set wouldn't be finished for a few more months). But more importantly here was a record made by computer nerds on totally junk $5 computers. I had never seen anything like it before....totally 100% punk nerdzone. It was the first genuine expression of a generation that grew glued to computers and video games I had ever seen....... I instantly knew this record was where it was at. Needless to say I was totally blow away..........

We eventually met Bodenstandig over email, and a few years later in 2001 "the 8bit Construction set" (we had somehow become a band at that point) was flown to Munich to particiapte in an exhibition called Make World, and as part of the show, there was a performance night called RoXor (computer nerd for "to rock") organized

At left: Super Mario Clouds installation view at Team Gallery, 2003, photo Paul Laster; The Infinite Fill Show at Foxy Production, July, 2004; 8-Bit Construction Set, first performance NYC,

by an European group called micromusic (a web community that sprung up around the obsession of low fi chip music) . Our record was well recieved by the hip-hop comminuty in the US (are only US show at that point was with Cannibal OX, + Kaiju at a Soundlab show in NYC) and we still hadn't found any like Nerds in this country. But at this show in Germany I realized there was a whole scene of geeks making this kinda music (please note, nerd and geek are no long negative words) Anyway performing music at the opening night in Germany was Bodenstandig 2000. The best picture I remember is of the two German guys rapping over 8bit Ragga beats about tele-text porn. It was insane ...so was Rolemodel, a young Swedish kid who grilled me before the show about my 8bit programming chops (it was obvious very quick he could program me under the table) named Johan who had just released his Gameboy music program called lit-tlesounddj....this is a program that lets you make songs on your Gameboy . It was and is responsible for most of the "Gameboy" musicians that perform today....for his performance he just sat there making his Gameboy tweak out in various dance type tracks....I remember thinking the sounds the Gameboy were making were soooooo weird they had to be the work of the person who actually pro-grammed the sequencer....like a mad scientist torturing his creation...., and last was the YM Rockers.... they were English kids who make Atari ST dance music, and regularly, to this day, release Atari ST music compilations on floppy disks//////// how rad is that????. But any-way at that point I realized in each country there were kids who decided either cause they were nerds, or were lazy, or never knew any better, never stopped playing on their crap computers, and decided to go about their business as if 32 bit machines were never invented. i am 100% a product of this universe.........

:)
Cory

+

SIGNATURE ->

MY HOMEPAGE:

www.beigerecords.com/cory/

BEIGE PROGRAMMING ENSEMBLE HOMEPAGE:

www.post-data.org/beige/

BEIGE RECORDS HOMEPAGE:

www.beigerecords.com/
+

At right: The 8-Bit Construction Set installation view, Deadtech Gallery, Chicago, 2001, photo Roland McIntosh.

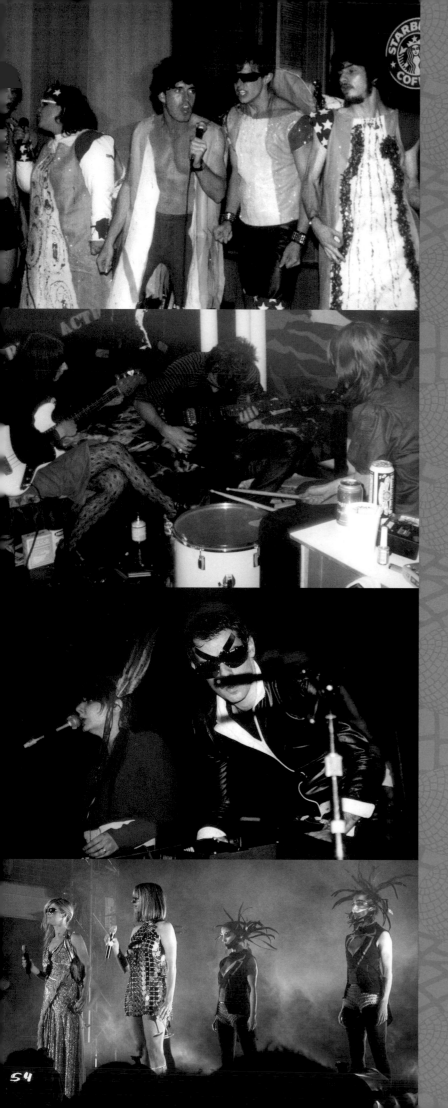

SOUR LIGHTNING
BY PHIILLIP GUICHARD

Astor Place Starbucks, 1998. An all-new variety show wants to enter-
tain you. First up is Andrew W.K., a dirty Detroit rock teen playing pre-
programmed partytime arena metal and vaulting over his keyboard,
still five years away from meeting his Kit Kat destiny. Next is Sweet
Thunder, the prog-mess collective that only sings songs about Niagara
Falls. Members incude Kelly Kuvo (ex-Scissor Girls), Jody Mechanic
(alter-ego: Monotrona), Gavin Russom (five years away from signing to
DFA with Delia Gonzalez), Lizzy Yoder, and Casey Spooner, whose side-
project, Sasquatch, is also debuting that night. Sasquatch lip-synch to
super-flat electro pre-programmed by Warren Fischer, wearing zany
outfits pilfered from the photo shoots Casey styles. Afterwards,
Kathleen Hanna and Johanna Fateman-- soon to roar into life as Le
Tigre-- run up to sing their praises while Gabe Andruzzi-- not yet the
Rapture's utility player-- slinks away with his posse. Nobody accepts
Gavin's invitation to conga line through the coffeemart.

On the other side of the tracks, another group of messy art kids is
birthing a series of incestual noise bands, performing one-off gigs at
galleries like Kenny Schachter and Greene Naftali or at art-party
events at Hotel 17 or P.S.I. Their names are Actress, Bedroom
Productions, Russia, and Neon France, but five years later you will
know them as Gang Gang Dance, Angelblood, Captain Comatose, Tara
DeLong, and A.R.E. Weapons. For now they play to crowds of twenty
friends, but it doesn't matter: their blood is coursing with the narcot-
ic of the now.

One year later. Sasquatch, now known as Fischerspooner, is playing
Windows On The World at the top of the World Trade Center. Andrew
W.K., currently an F.I.T. student, plays the role later to be filled by
Jeremiah Clancy: Casey's on-stage dresser. A year later, he'll smash his

At left: first Fischerspooner performance, photo Kelly Kuvo; Actress rehearsal,
photo Kelly Kuvo; Actress performance, photo Kelly Kuvo; Fischerspooner at Irving
Plaza, photo Conrad Ventur.

face with a brick to achieve bloody realness in his iconic shoot with Roe Ethridge. But now, across town, Actress are smashing their heads against canvases until they're bloody. It all still seems realer than fake.

Fall 2000. I return to NYC after spending the summer in Seattle recording my first album. At Ryan McGinley's first opening I meet Steve Lafreniere, who invites me to his weekly party at Passerby. The following Monday, as I walk into the bar for the first time, my song "(Inside The) Sleep Pavilion" is playing. There on the disco-light floor I meet Momus, who's just finished "Fakeways," his aural documentary about this emerging, formless scene. He's connecting the dots and planning a CD compilation, "Superheroes." It's 1978 again, he's Brian Eno, and this is going to be his "No New York." It's Fischerspooner, The Centuries, Actress, me, Sweet Thunder, A.R.E. Weapons.

Until Fischerspooner's lawyer says no, and the project fritters away like yesterday's brain cells. Momus tells me all this on our way to Alleged Gallery, where we're going to see Markus Popp (Oval)'s Skotodesk sound installation. He's rumored to be performing that evening with Will Oldham, Harmony Korine, Brian DeGraw, and Bjork. But Markus decides he doesn't want to and this dream jam is forced to remain theoretical.

Halloween 2000. We walk and roll to A.F.A. Gallery where we drink 4oz cans of Budweiser while Spencer Sweeney screams

and stomps on a squeak toy. Patterson Beckwith takes polaroids of a crowd that seems dying to slice the knife of night. My boyfriend starts to crash so we leave before A.R.E. Weapons plays, but on the way out catch Larry Tee emerging from a cab.

Everything is still chaos and reference points have yet to be drawn. Is this neo-no-wave or new-new-wave or new-neo-electro? Maybe-wave?

Steve Lafreniere throws a party for his Nelson Sullivan video series, and Larry Tee DJ's. A year ago he was spinning house at G. Lounge, but here he plays Fischerspooner, Bedroom Productions and Peaches, with old gems like "Supermodel" slipped in somewhere.

January 2001. A line is crossed. Actress make their final statement at one of Suzanne Ackermann and Jeff Ryan (Excepter)'s roving Satyrday Knights loft parties. While I'm pissing away $2 beer, Actress wail through their sole song of the evening, a raggedy cover of "Salt Of The Earth," until their chanteuse Lizzy Bougatsous douses her breasts with vodka and lights them up. Chaos comes fast, the party dwindles, and the fire department arrives to douse the embers of the scene.

With the burning of tits comes the close of a chapter in New York City history. Gone are the death-defying virtuosities, the fate-tempting, the beautiful invincibility. Chris Burden becomes Kris Kross, acts clean up or perish, and

At right: Sasquatch, photo Conrad Ventur; A.R.E. Weapons, photo Conrad Ventur; Bedroom Productions at Badd, photo Conrad Ventur; Mono Trona, photo Conrad Ventur.

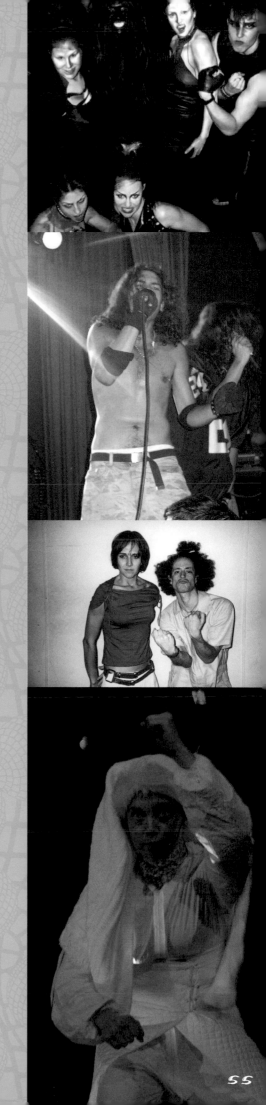

the broom of popularity sweeps away most of the mess that made everything valuable.

The scene has to self-censor. How long can you be tickled by fear until it fizzles? Giuliani-era NYC could never engender a scene like Norway's Black Metal scene; this urban forest is merely a shared illusion. For a band to kill themselves onstage would be no more than making good on G.G. Allin's unfulfilled promise, and nobody wants shit flung on their new As Four. Any reality can be embraced as long as it leaves no stain, any scene's ok so long as it remains but a dream: easier to shake than a hangover, nothing lingering. Mortality's the most garish party crasher, worse than Mom with pink curlers: nobody wants to be grounded in front of their friends. And death is the ultimate grounding.

Then crash, bang, 9/11 slams the book shut. Terrorism is now more than just a fashion trope, fear is a reality and not just a game. The date can be used as a line of demarcation, like Brian Eno getting hit by that car in 1973. But who's to say that "Another Green World" is any less valid than "Taking Tiger Mountain (By Strategy)"? It depends on your system. Music, art and drugs: all just vogues, and fashion is the ultimate unreliable witness. Everything trickles down and congeals in puddles equal in volume but unequal in shape.

From the ashes of this spiraling scene comes Larry Tee to compile and package

it as Electroclash. His CD compilation takes the dancier end of this messy spectrum and repackages it into a familiar club context, making it easier to take than a pill: just pop it. Art terrorism gives way to a fashion porn that's all money shots. Insanity gets molded, reference points are laid down, the insurrection becomes a revival. The scary future becomes the half-remembered 80s.

The Electroclash Festival is a hipster funhouse, the sound of $10,000 worth of champagne spraying onto titties. This is the new Defining Moment, epochal even, fraught with historical import. The secret is spilled, the media's maw is gaping and yapping, and the mogul's fingers are snapping a happy beat as Apples churn out arpeggiated basslines, hair becomes asymmetrical and clothes slash themselves up. Everything comes together for the first time and there is nothing to do but diverge.

Months later. After an evening spent packaging K48 zines and narrowly avoiding arrest for turnstile-jumping, we make it to the sterile nightclub Spa to catch a show by The Centuries. They are ketamine androids performing nightmare cabaret in hell, circuits misfiring wildly, so off they're beyond on. The club is semi-packed, Bjork and Moby have tables and drinks, and anything can happen. It's hard to say exactly what does transpire, but in my rotten and foggedover memory they do a 45-minute version of "NY Fairytales"-- their track on

At left: Warren Fischer, photo Scott Hug; Casey Spooner, photo Conrad Ventur; The Centuries, photo Scott Hug; Melissa and Christine from W.I.T., photo Scott Hug.

the "Electroclash" compilation, that was cathartic, traumatized, avant-avant. The packed audience wheedles and thins as James screeches in an androgynous bodysuit. Chill winds drift through the club, thinning the crowd further until DJ Spencer Product is told by management to cut them off, and on comes Hungry Wives' "It's Over." James shatters a light on stage and gets dragged out by security. It truly is over.

The elite cultural virus has spread to the Midwest minority masses, Vice washes their hands and escapes the taint of backlash, and the fash-mags move on. There's no loyalty there. Sorry. Electroclash dies like that point in the night when you're trying to snort the gleaming whites of the "i-D" cover model's eye because you mistook it for that last granule of coke. Time to get some sleep.

Newly sprouted groups like the Scissor Sisters go from "Electrobix" to Elton John and escape the stigmata. From wigs to toupees, the fire tumbles downhill towards a dimming light and survives only in the form of MTV promo soundbites. The anthem is now a jingle.

Or Not.

Has time moved forward as irretrievably as fashion makes it seem? Is an idea co-opted by Madonna completely drained of what initially made it flame? Doesn't have to be: the Bodenstandig 2000 song that The Girl And Soccer Star were jocking in 2000 rematerialized in 2004 at an Index party being spun by Bjork from her I-Book and, months later

slithered into the murky veins of "Medulla," for consumption by the millions.

Others took Luxx fare to new places. DFA began taking elements from the vocal vocabulary and sonic library electroclash had been raiding, and fused them with post-punk and no-wave, soldering the past to the present to erect an aural bridge spanning the widening gap electroclash left as it repli-cunted itself into a semen-stained corner. Records like "Losing My Edge" and "House of Jealous Lovers" filled the void so perfectly that they were universally accepted; like candles in a cave, everyone wanted one.

And even now, whilst these words are being written, the irrefutable pulse of the dance beat has been pared down into a tribal thrum that chases eternal pulsations. Black Dice have refined their overblown noise assaults into sun-streaked traffic jam symphonies, skeletally sketching barely tolerable tropes while neon seagulls soar overhead. Animal Collective continue to pursue the purity of childlike glee, delving deep into psychic interiors and shedding scraps of crumbly zen. Excepter conjure unpinnable moments that you can coexist with but never begin to define. And Gang Gang Dance, featuring first-wave survivors Lizzy Bougatsous and Brian DeGraw, focus their chaotic fury into stone-solid slabs of overhead otherness.

How long can you dwell in vacuums? As long as they continue renewing themselves. The present will keep us smiling until we decide to scowl again. The new version is still writing itself.

At right: Prance, photo Scott Hug; Fischerspooner, photo Conrad Ventur; The Centuries, photo Scott Hug; Larry T, photo Conrad Ventur.

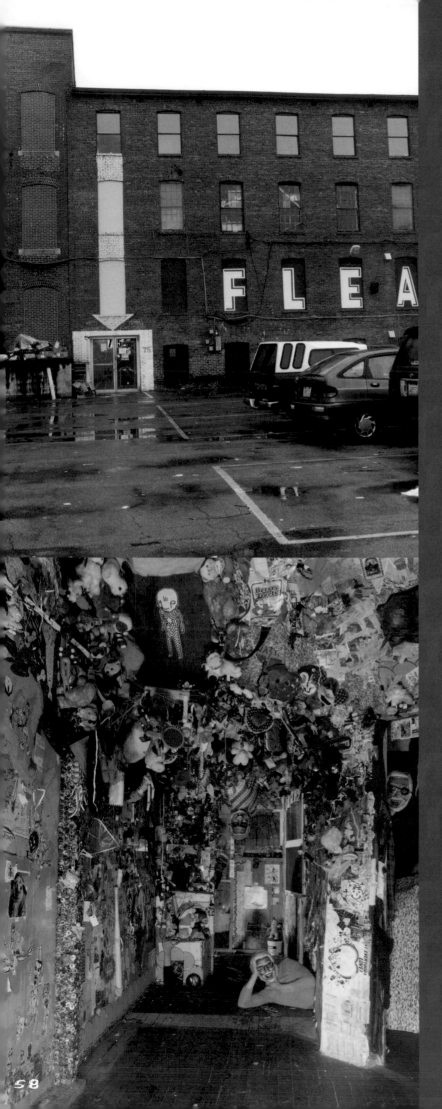

FORT THUNDER, FORCEFIELD, AND THE NEW YORK ART WORLD

BY LAWRENCE RINDER

PHOTOGRAPHS BY

HISHAM BHAROOCHA

I only glimpsed it for a moment, but as soon as I did, I knew that Fort Thunder was the motherload. I was traveling around the country looking for art for the 2002 Biennial, keeping a journal as I went. Here's what I wrote the day after visiting the Fort: "I walked around in a stupefied, ecstatic trance. The place is a dream: generous, creative, crazy in all the best ways. They are living an ideal without articulating it as a dogma, without marketing it, without theorizing it, just living it and dwelling in the amazing results." Even so, I had only a vague idea of what I was looking at. I was unaware of the huge impact that the residents of Fort Thunder had already had, especially in the fields of comics and music. I was clueless as to the incredibly rich national culture for which Olneyville the derelict district on the west side of Providence in which Fort Thunder was located not Chelsea, was the center of the art world. I felt like I had stepped through a mirror into a parallel universe in which art was more likely to be given away than sold, in which the astonishing talents of numerous individuals was married to a remarkable absence of self-promotion and ego.

A mythology has grown around Fort Thunder, and understandably so; it's hard not to use hyperbole to describe what happened there. Ten thousand square feet of unfettered creativity, a communal living situation governed by a single rule: you are free to make noise at any hour of the day or night. My first impression was of an undifferentiated storm of artistry encompassing the interior architecture and decor of the Fort itself— an insane assemblage of trash covering every available surface, cacophonous sounds emanating from the mixing room, twisted and obscure posters that covered the walls of the screen-print shop, tangled mounds of souped-up bicycles, odd knit costumes and bedrooms each of which was an installation artwork in its own right.[1]

Only now am I slowly beginning to recognize and appreciate the individual genius of the Fort's various residents and associates. Brian Chippendale, known to music fans for his role as the drummer in the Fort Thunder-based bands Mindflayer (with Mat Brinkman) and Lightning Bolt (with Brian Gibson), deserves to be equally celebrated for his moody, rough-hewn, and densely-composed comics. Chippendale's narrative drawings covered the walls of Fort Thunder in literally thousands of tiny panels and were recently made available in a book titled Maggots. His comics, writes Tom Spurgeon, "burn with the energy of a 5-year-old running around the yard with his pants off."[2] Mat Brinkman, another of Fort Thunder's guiding spirits, creates amazing sound effects by "torturing analog devices until they die."[3] His affection for noise- loud noise- underlies the sound of the Fort Thunder-based band Forcefield. Brinkman, like many Fort Thunderites, is both a musician and a visual artist. His comics typically feature the trials and tribulations of various monster-like creatures and have been collected recently under the title Teratoid Heights, which was blurbed by his publisher Tom Devlin of Highwater books as, "J.R.R. Tolkein-style adventure, videogame inspired syncopation and an endless barrage of cable-television nature films all filtered through the reddened eyes of a marijuana-addled teenager."[4] Jim Drain is a master of knitting, creating fantastical shrouds which have helped to transform the members of Forcefield from their earthly selves to their space alien identities: Meerck Puffy, Patootie Lobe, Gorgon Radeo, and LeGeef. He, too, creates distinctive comics that have been published alongside Chippendale's, Brinkman's and others' in Fort Thunder's tabloid format newspaper, Paper Rodeo. Ara Peterson, a member of Forcefield though he never lived at the Fort, works in a variety of media including sculpture, drawing, and prints. His stunning, abstract videos

borrow equally from cheesy sci-fi effects and the history of avant-garde film. In addition to their individual work, Peterson and Drain are pursuing ongoing collaborations on large-scale sculptures and installations. Leif Goldberg is characteristically multi-talented, performing with Forcefield as well as working as a printmaker, puppeteer, animator, and editor (with Mat Brinkman) of Paper Rodeo. He is especially known for his ecologically themed comics and dizzyingly complex, exceptionally colorful screen-prints. There are many other artists such as Paul Lyons, Brian Ralph, Rob Coggeshal, Kate Malone, Liz Luisada, Michael Townsend, Peter Edwards, Peter Fuller, Andy Estep, Freddy Jones, Eric Talley, Erin Rosenthal, Joel Kyak, Shawn Greenlee, Maki Hanada, and Raphael Lyon who lived there or passed through whose individual work I would love to know better. Because of the ephemeral nature of much of what was made, only those who were lucky enough to be there can really appreciate the full scope of Fort Thunder's art revolution.

Among those who have heard of Fort Thunder, most know of it through the comics or the music that were produced there. The now legendary Providence sound was nurtured at the Fort in countless shows including- besides Mindflayer, Lightning Bolt, and Forcefield- dozens of other extraordinary bands such as Black Dice, Arab on Radar, Olneyville Sound System, Pleasurehorse, and 25 Suaves, to name a few. Most of the Fort Thunder residents who played in bands also drew comics, although these communities did not generally overlap outside of the Fort. Although each artist developed a unique visual style, there is a distinctive Fort Thunder comic aesthetic that typically involves marks and images of unusual density, a suggestion of narrative with monster-like protagonists, innovative manipulation of the sequential panel form, and a willingness to devote

[illegible footnote text]

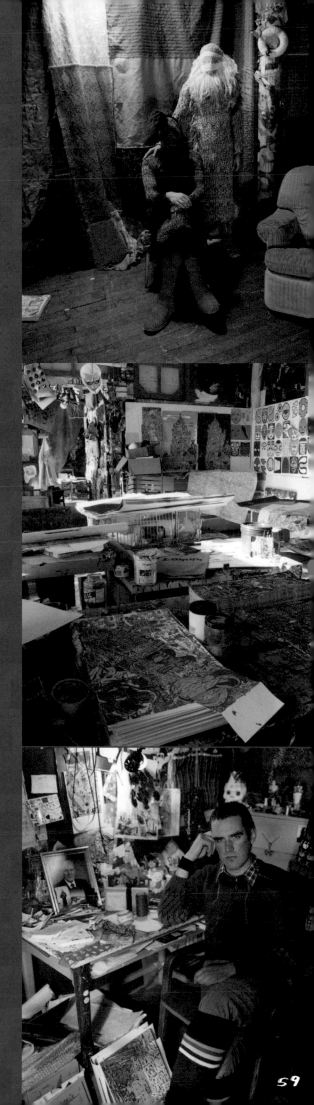

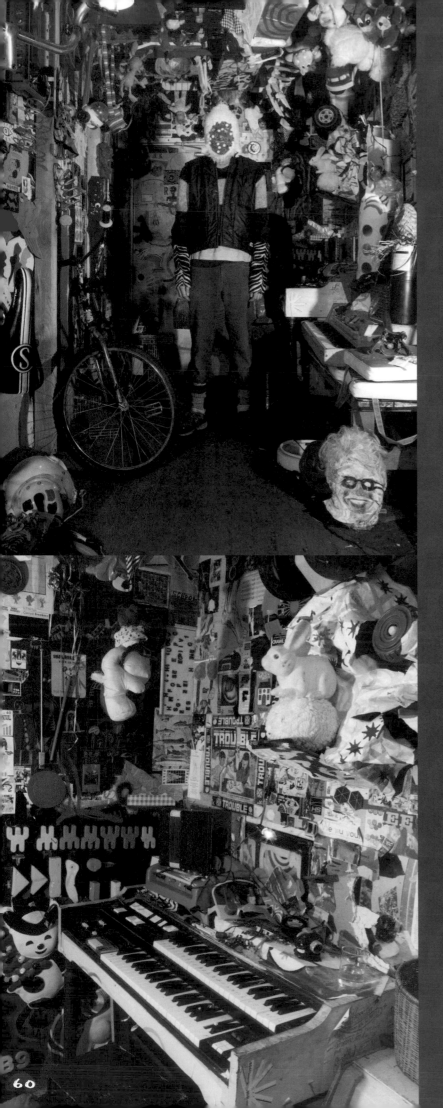

long hours to labor-intensive process-es such as multi-color silkscreening. Numerous critics have alluded to the distinctively innocent yet knowing style of drawing common to the Fort artists. "Picasso said he wanted to draw like a kid," observed Chris Lanier in a review of Mat Brinkman's *Teratoid Heights*, "the Thunder folks want to draw like a Special Ed kid who's fielding transmissions from plan-et Gxxylplzz on his braces." [5]

Besides the band recordings and pub-lished comics, one of the more palpa-ble residues of the Fort is the aston-ishing body of prints that were made at one time or another by just about every resident. The prints were usu-ally made to advertise rock shows both at the Fort and elsewhere in Providence, although at times they were put to other uses, as when Brian Chippendale created a psychedelic screen-printed pattern to cover the walls of his bedroom. The posters often reflected the style of the artists' comic work, though some, like Mat Brinkman, used the posters as an opportunity to explore alternative rep-resentational modes. As a group, the Fort Thunder posters constitute one of the most remarkable visual expressions in American art of the 1990s. Like rock posters of the 1960s, these prints possess an identifiable aesthetic that situates them in a particular time and place. Innovative as it is, the poster work has only rarely been shown and may well vanish without ever being comprehensively collected, documented, or catalogued. The posters were sim-ply intended to be stapled up in cafes, record stores, and out of doors. Among these artists there never was and is not now a desire for permanence or notoriety outside the small circle of local fans.

While the atmosphere of the Fort has been described by some residents as 'competitive,' there was neverthe-less a productive spirit of collabora-tion. This is obvious from the effort that went into producing Paper Rodeo, into the dozen or more bands that included Fort Thunder residents and into the multi-media events that often culminated in crazed, costumed wrestling matches. The sense of openness in these projects extended to the way Fort Thunder existed in the fabric of the city itself. Although filled with artwork, electron-ic equipment, printing presses, musical instruments, and all the residents' personal possessions, once the lock broke, it was never fixed. Rather than risking theft, the Fort was con-versely prone to a surfeit of dona-tions. Once they saw what the Thunderers could do with junk, people would bring just about anything by. The piles of re-jiggered bicycles, in particular, which could be taken and ridden away at will, were the result of unsolicited donations from all over the city upon which Pete Fuller worked his mechanical magic. Fort Thunder was like a magical cornucopia, spewing forth creative work of all kinds at every hour of the day and night. There has not been a collec-tion of such remarkably gifted artists

working in tandem since the legendary Black Mountain College brought together under one roof the likes of Robert Rauschenberg, John Cage, Merce Cunningham, Jasper Johns, Cy Twombly, and Ray Johnson.

Fort Thunder began in 1995 when Brian Chippendale and Mat Brinkman selected a floor of a recently-vacated mill building as a site for booking shows.[6] To save money, they decided to live there as well. The community that came to occupy and frequent the space, however, had begun to coalesce even before the space was found. Providence in the mid-1990s had a lively scene of skaters, comic artists, and musicians, many of whom were students at or dropouts from the Rhode Island School of Design (RISD). Collective artistic activity and spontaneous performance were common. One group, for example, consisted of RISD students who occasionally pushed shopping carts filled with accumulated trash to one of Providence's main shopping streets and then played music amid the piles of junk. Several bands producing the now distinctive Providence sound existed before Fort Thunder opened. Among the most important of these were Dropdead, Six Finger Satellite and Thee Hydrogen Terrors, which, as Jim Drain recalls, began when, "local Rhode Island college kids started hanging with RISD and Brown University kids-when that happened the feeling of here/'home' happened."[7] A key event in the emergence of the Fort Thunder community occurred on May Day, 1993. On that day, Brian Chippendale and Mat Brinkman, among others, organized a large party in the abandoned railroad tunnels that run beneath the east side of Providence. Less a celebration of working class struggle than a rite mark-

ing the pagan proto-Halloween festival known as Beltain, the party involved dozens of fiery torches spread throughout the darkened tunnel, copious drumming, and outrageous costumes. Unfortunately, the event, which was attended by several hundred people, was raided by the police who used tear gas and pepper spray to subdue and disperse the crowd. CNN reported on the event, calling it evidence of a Satanic cult.

Hardly Satanic, the Fort Thunder scene was imbued with an almost childlike innocence. The darkness and edginess of much of the work, whether in comics, music, video, or in the occasionally violent wrestling shows, expressed feelings that were hardly occult but rather emerged from the familiar fears of any conscious person trying to make their way in our time of environmental destruction, social upheaval and nascent fascism. Their work was rarely directly political, but rather used archetypal themes to express allegorically the underlying tensions of our times. They borrowed heavily from fantasy literature, science fiction TV and film, and role-playing games like Dungeons and Dragons. In contrast to many other artists working at the same time for whom the challenge was to create a digital, virtual reality, much of the work made at Fort Thunder was an attempt to make a real reality of stories, images, and objects that had only existed virtually before.

Fort Thunder was a powerful community, but also a fragile one. As a curator from a major New York museum, I represented one of the forces that had the capacity to bring their dream to an end. Perhaps it was nothing more than their normal laconicism, but Mat, Jim, and Leif seemed strangely quiet when they first met me on neutral ground,

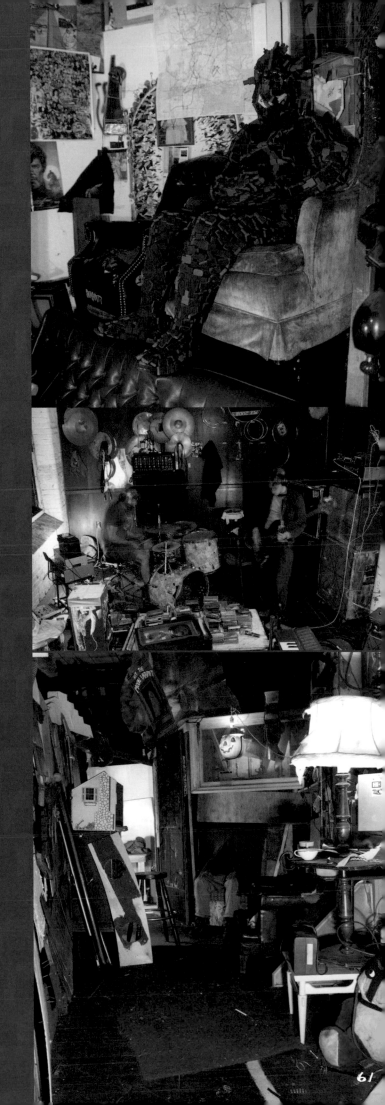

Photographs: Raphaela Lyons, beginning 1999 in studio, reference photos, originally published in Motel, Summer 2002. Photography: Scott H.

61

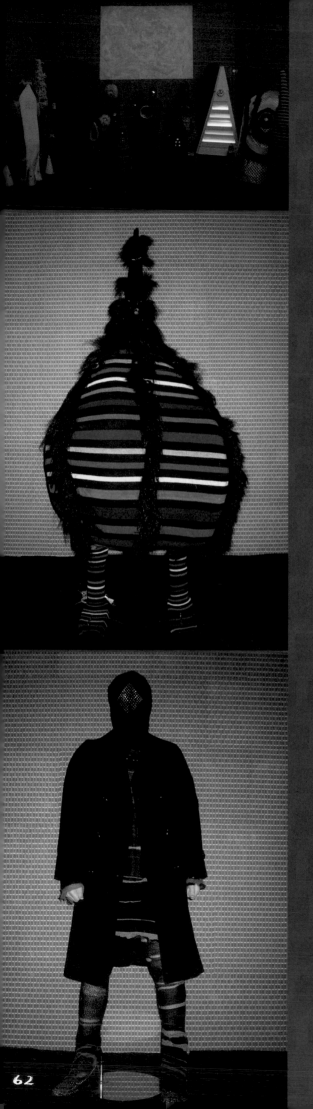

at a nearby coffeeshop. I came bearing the promise of fame and fortune, but also an intimation of doom. How could the delicate ecology of Fort Thunder, based as it was on qualities utterly antithetical to the New York art world, survive transplantation? It was not without mixed feelings that I ultimately offered these three Fort Thunder residents along with Ara Peterson- who together comprised the band Forcefield- a place in the 2002 Biennial. But it was my job to present the best art being made in the US and, in that sense, including their work was one of the easiest selections I had to make. It was up to them, I felt, to decline if they preferred.

Happily for me and many others they accepted and went on to create one of the most memorable and well-received projects in the exhibition. Already widely known to an audience outside of the museum's usual crowd, Forcefield was suddenly known to the mainstream. To many, their Biennial installation, entitled *Third Annual Roggabogga*, may have seemed like something of an anomaly in the exhibition. Most people had never seen anything like this before. What were these strange creatures adorned with day-glo fur, sequins, and flashing lights? The film looked a bit like other experimental films, but what was it doing projected onto a wall covered in psychedelic orange wallpaper? And that loud noise, what's that about? Yet, to the extent that this work, and much of the other work by the Fort Thunder artists, grew out of an interest in comics, science fiction, computer games, rock shows, and, to an extent, skater culture, *Third Annual Roogabooga* resonated with numerous other works in the Biennial. Chris Johanson's comic-inspired stairwell installation, Trenton Doyle Hancock's cartoony paintings of a self-invented universe, the late Margaret Kilgallen's enveloping hobo-skater-tagger environment (generously recreated by her husband

Barry McGee), Christian Marclay's surrealistic band instruments, Destroy All Monsters Collective's billboards celebrating Detroit music and kiddie TV show history, Ari Marcopolous' offhand photographs and videos of international snowboarders, and Chris Ware's visually arresting comic drawings were not influenced by Forcefield or Fort Thunder, but certainly emerged from related milieux. All of these artists found their primary influences less in the history of art than in a range of vernacular cultures, drawing on aspects of musical and visual practices from rock shows, graffiti, and video games to comicbook superheroes and children's art that are not much embraced by the mainstream art world.

Unfortunately, the Biennial marked the end of Forcefield. The stresses of engaging with an institution on the scale of the Whitney, along with disagreements on the next steps to take, led to the disbanding of the group. Brinkman and Goldberg had serious reservations about engaging with the New York art world and had no interest in producing work for gallery shows or participating in a conventional art market. Drain and Peterson enjoyed the larger audiences and felt that there would be opportunities for growth if they accepted the challenges of fitting their distinctive work practices into the more conventional framework of commercial gallery exhibitions. Another factor contributing to the demise of Forcefield was the end of Fort Thunder itself. The old brick mill was sold to a developer who evicted the residents in early 2002 (during the run of the Biennial) in order to begin demolition. In place of the sprawling old industrial complex, the developer built for Providence a one-story retail mall called Eagle Square.

Providence has since spawned a number of other vital

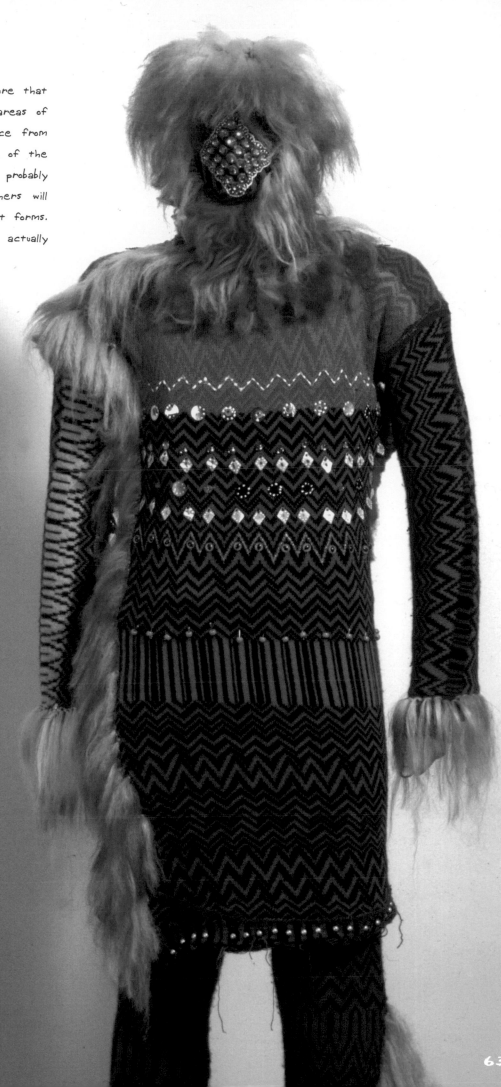

art collectives, including the Dirt Palace and Hive Archive, yet the dynamic culture that once sustained Fort Thunder, based as it was on exceptionally cheap rent, vast areas of essentially unregulated space, as well as, I'm afraid, having a comfortable distance from the New York art world, is probably gone forever. One wonders what will become of the dozens of profoundly gifted artists who were nurtured by that scene. Some will probably stay in Providence, developing their work in a somewhat less communal form. Others will migrate to even more remote towns and cities, generating new communities and art forms. Some will become art stars, showing and selling their work in New York, if not actually living there. And that, should it come to pass, will be just another strange page in the remarkable story of Fort Thunder.

NOTES

1. Evocative photos of Fort Thunder by Black Dice drummer Hisham Baroocha, along with an article by Lois Maffeo, can be found in *Nest* No. 13, Summer 2001.

2. Tom Spurgeon, *The Comics Journal* #256, October 2003, pp. 68–69.

3. Mindflayer website, http://mindflayer.com/ info.html.

4. Tom Devlin, "Books: Teratoid Heights," in *Highwater Books*, www.highwaterbooks.com/ teratoid_book.html

5. Chris Lanier, "Thunderation! Some notes on *Teratoid Heights* and the 'Fort,'" in *The High Hat*, www.thehighhat.com/ Marginalia/003/teratoid.html.

6. An excellent in-depth history of Fort Thunder by Tom Spurgeon, as well as interviews with several of the key members can be found in *The Comics Journal* #256, October 2003.

7. Email to the author, July 21, 2004.

Forcefield, *Gorgon Radeo (Autumn Shroud)*, 2001, knitted yarn and plastic mannequin with stand, 72 × 24", Whitney Museum of American Art, New York; Purchase, with Director's Discretionary Funds, 2002, photo credit Jerry L. Thompson.

Live the Art by Jeffrey Deitch

Did it all start in the Starbucks at Astor Place? In a story that I always assumed to be more fiction than fact, Casey Spooner traces the birth of Fischerspooner and the art and music community that developed around it to an improvised performance at the Astor Place Starbucks in February 1999. In his essay in this book on the new music that is emerging from the art community, Phiiliip describes the same event, though with a different interpretation, confirming its occurrence. He even produced a copy of the deliberately cheesy poster that advertised it.

Twenty-five years ago, a performance that helped to launch a new artistic community would have taken place in a dive on the Bowery or in a run-down storefront on the Lower East Side, not in a Starbucks. That was before the packaging of downtown culture became a global industry and a platform for real estate development. Perhaps a reverse takeover of a Starbucks was the right scenario for the launch of an art performance band when the standard venues for vanguard art and performance were becoming increasingly corporate and professional. Reverend Billy had a similar insight when he began taking over Starbucks branches to preach the anti-corporate gospel of his Church of Stop Shopping.

The emergence of a new artistic community can often be tied to a specific location or an actual event, but the origins of the community of artists, musicians, and performers described in this book, many of whom are all of the above, is much more complicated. Although New York is the place where most of the people in this community met and where most of them now live, many of them would say that their artistic inspiration developed outside of New York. For art world veterans who have taken for granted that underground art communities are incubated someplace below Fourteenth Street, it might come as a surprise to hear this generation of artists cite Providence, Philadelphia, Portland, and San Francisco as the places where their current artistic attitude developed. The last time such a vibrant artistic community emerged from the underground was in the late '70s and early '80s with the fortuitous connection between the graffiti writers and hip hop musicians from the Bronx and the punk bands and post-conceptual artists from the Lower East Side. This time, twenty-five years later, the combination is equally unexpected and hopefully just as fertile, with the neo-counter culture of Providence's Fort Thunder mixing with the skateboard street art subculture of San Francisco, meeting in the clubs and communal loft spaces of New York.

Fischerspooner, performance at Deitch Projects,
May, 2002. Photo credit Tom Powel Imaging.

New artistic communities emerge around remarkable people, not just around inspiring places. In 1998, I was fortunate to meet Barry McGee, a legendary underground artist known for his work on the streets of San Francisco, who introduced me to a new community of artists and to the new audience that was developing for their work. I had first learned about Barry when I overheard Ann Philbin, the former Director of the Drawing Center— now Director of the UCLA Hammer Museum— talking about the Drawing Center's Barry McGee opening in 1997. She had been expecting a normal art world crowd, but when she opened the gallery door at 6:00 PM, she was astonished to see the street outside filled with several hundred kids waiting for the show to open, many of them carrying skateboards. I was fascinated by this story and was determined to meet Barry and learn more about his art and his community. I was told to forget about it; he would never answer the telephone or respond to letters from an art dealer. I finally arranged to accompany a mutual friend to St. Louis, where Barry and his wife Margaret Kilgallen were installing exhibitions and participating in a graffiti jamboree. Barry turned out to be one of the most engaging and generous artists I have ever met and he continues to connect me to new networks of artists and musicians.

When asked about the people who have inspired them, a number of the artists featured in this book mention Barry, Margaret Kilgallen, and Chris Johanson, the leaders of what has been called the San Francisco Mission School. Better known by his street name, Twist, Barry became an underground folk hero through his beautifully subversive work on the streets of San Francisco. His poignant portraits of men left behind by the tech economy contrasted with the upscale advertising images flooding the city's gentrifying neighborhoods. Margaret celebrated the nearly forgotten vernacular imagery of faded shop signs, old letterpress type, and the mysterious chalk tags on boxcars drawn by the hobos who rode the freights. Chris was a skateboarder and a kind of street philosopher who began hanging his distinctive visual parables at Adobe Books in the Mission District. Without really intending to be an artist, his work began to be followed by the art community as well as by the skateboarder subculture. Although the three artists initially received very little attention from the mainstream art world, the underground network of surfers, skateboarders, and graffiti artists spread the word about their work.

It was through Barry McGee that I first heard about Forcefield. Although Fort Thunder and the remarkable scene that was developing in Providence was still below the radar of the mainstream New York art world, the word was out through

Margaret Kilgallen, To Friend and Foe, installation at Deitch Projects, September 9– October 9, 1999. Photo credit Tom Powel Imaging.

the same kind of underground network of zines, no-profit storefront galleries, and illegal performance spaces that carried the news from San Francisco. Most of the artists in these circles were either in bands or connected with bands and would travel for performances, sometimes across the country. Each performance widened the circle, creating a community of like-minded artists and musicians.

The San Francisco and Providence artists had a lot in common. First, there was the pride they took in using discarded materials, and their interest in dying crafts and hand-made objects. There was little differentiation between visual art, music, and other creative expression. It was all part of the art, and part of their approach to life. There was also a lack of interest in the conventional art system of commercial galleries, critics, curators, and museums. The underground San Francisco and Providence art communities had their own extensive communications network. They did not need the mainstream art world in order to find a large, enthusiastic audience. Slowly, some of these artists have come "above ground," but on their own terms. Others have remained resolutely underground.

Meanwhile, around 2000, the art community in New York was changing. Art was increasingly being viewed as a platform for creativity rather than as a narrow discipline focused on art about art. Art was becoming an arena where musicians, designers, and performers could collaborate across media and break new ground. Fashion shows by some of the radical designers became performance art and their clothes could be exhibited as sculpture. A new audience began to enter the art community through forward fashion and new music. For the first time in years, great new bands like Fischerspooner, Le Tigre, Black Dice, and Animal Collective began emerging from the art world. A group of fresh cultural entrepreneurs appeared on the scene, connecting creative people. Larry Tee crystallized the new music underground by gathering some of the best new musical talent under the umbrella of Electroclash. DJs and music producers like James Murphy of DFA and nightlife impresarios like Tommy Saleh were forming a new scene that fused the energy of the new art, music, and fashion crowds. The drag king Murray Hill, "the hardest working middle-aged man in show business," became master of ceremonies for the transformation of some of the most radical performance art into neo-burlesque. Scott Hug helped to tie it all together through his magazine K-48.

New York was also seeing a revival of street art and graffiti, and connections were forming between the masters of New York Wild Style graffiti like Futura

Barry McGee, installation view, The Buddy System, Mach 20 – April 24, 1999, Deitch Projects, NYC. Photo credit Tom Powel Imaging.

and Lee and the new generation of writers and poster artists coming from San Francisco, Los Angeles, and other cities like Philadelphia. Following the lead of Futura, a community of graf and street artists began making art "products" and several new galleries/stores like Recon and alife opened to promote this new direction. When Barry McGee came to New York to install a project at our gallery in April 1999, every night was an open house with old school and new generation graffiti writers, photographers, and allied artists coming to meet and exchange ideas. ESPO took Barry on an all night tagging tour of subway tunnels. Aaron Rose, whose Alleged Gallery was one of the first to make the California/New York street and skateboard art connection, would come by to discuss his new projects.

The connections made through Barry's Buddy System project led to the most exuberant exhibition we had ever presented at Deitch Projects, Street Market, with Barry McGee, Steve "ESPO" Powers, and Todd "REAS" James. We constructed an entire urban street in the gallery, complete with overturned trailer trucks and bodegas stocked with mock ESPO merchandise. More than 1,000 people packed the opening in November 2000. Some of the toughest thugs in the city joined with old school and new generation graffiti writers, downtown fashionistas, and even Robert de Niro to listen to Thirstin Howl and the Lo Lifes rap from the top of one of the overturned trucks. I had not seen this kind of mix since Fun Gallery openings in 1982.

One of the first new artist "collectives" to make art as fashion, performance, and conceptual branding was the Bernadette Corporation. Their work deliberately dissolved the hierarchy between art, fashion, and marketing. In the spring of 1997, my neighbor, the late Colin de Land, asked if I would collaborate with him to present the Bernadette Corporation's fashion show in the former Canal Lumber warehouse on Wooster Street, which I had bought the year before. The space was still a lumberyard, just without the lumber. But Bernadette worked with Julian LaVerdiere and his production design company Big Room to transform the building into a retro-futuristic fantasy. The set-up was totally illegal, with flares bursting with flames as the models walked down a makeshift staircase made from stacks of Jeff Koons sculpture crates. The downtown art/fashion community that now numbers in the thousands was just starting to develop at that time and it was only later that I began to understand what the Bernadette Corporation had helped to create. Cindy Greene, former lead singer of Fischerspooner and now the co-designer of the art fashion label Libertine, told me last year that it had all started for her with the Bernadette Corporation's show.

Barry McGee, Todd James, and Stephen Powers, Street Market, October 5 – December 2, 2000, Deitch Projects. Photo credit Tom Powel Imaging.

It was another art/fashion/performance event at my gallery that convinced me a new sensibility had taken hold and that a new creative community had formed that embraced an expanded approach that fused art, fashion and music and was linking the new groups of artists emerging from San Francisco, Providence, and the Lower East Side. As the climax of Paper Magazine's art and fashion Paper Project on September 9, 2001, As Four covered the roof of my Grand Street building with black stretch fabric and presented an astonishing combination of sculpture, fashion, and dance to the accompaniment of an otherworldly Theremin player. An enormous crowd of people who I recognized from fashion, music, skateboarding, and street art communities blocked traffic on Grand Street. The effect was ecstatic. Then, two days later, came the attack on the World Trade Center.

Pundits declared the end of irony and many assumed that art would soon become stridently political. But in the uncanny way that artists can predict the course of events before they actually happen, an artistic response to the new political climate had already begun, even before 9/11. Sincerity, rather than irony, characterized the new artistic attitude that emphasized a collective approach and an embrace of the positive. As Four, for instance, is made up of a German, an Israeli, a Palestinian, and a Russian, who live and work as a family. The artist Assume Vivid Astro Focus redefines individual artistic initiative to encompass creative collaboration. The shared attitude is a collective embrace of art as a life-affirming experience.

My own immersion in this new artistic community took place during the three months of rehearsal and three nights of performance that I presented with Fisherspooner in the spring of 2002. Their performances were Wagnerian "total works of art," updated for the new millennium. Music, dance, theater, fashion, sculpture, video, and graphic design were fused into a confounding and entertaining immersive experience. One of the most interesting aspects of Fischerspooner from an artistic point of view is the way they function as a platform for creative collaboration. Many of the most innovative designers, artists, photographers, illustrators, and choreographers on the scene were drawn into the production of the work. My collaboration with Fischerspooner connected me with more than one hundred new artists and cultural creators and continues to lead me to new projects.

In November 2002, I received an email announcement from a San Francisco gallery that I had never heard of with an astonishing image that stopped in my tracks. It was Peres Projects's evite for its Assume Vivid Astro Focus exhibition. The image

Claire Rojas, Table Turner, installation view, November 12–December 18, 2004, Deitch Projects. Photo credit Tom Powel Imaging.

was a still from the Walking on Thin Ice video collage, made in collaboration with Honeygun Labs. I instantly emailed the gallery to ask for more information and about two hours later, Javier Peres, who happened to be in New York that day, was in front of me with his laptop. Assume Vivid Astro Focus was what I had been waiting for, an artist who put together elements of the San Francisco underground, New York club culture, and the Fort Thunder pan-aesthetic into a single body of work. He was the link between the most interesting new artistic directions, and, as I began to understand, a social link as well through his collaborative approach.

Eight months after Javier's email, Assume Vivid Astro Focus mounted one of the most ambitious and most exciting exhibitions I ever presented in my gallery. Every surface of the gallery- the facade, the floors, the ceiling, as well as the walls- was covered with his vibrant work. There were about eight collaborators, including the great tattoo artist JK5, who set up his tattoo parlor in the storefront and was busy with clients- including police officers from the First Precinct- every day for two months. One day in July, Dearraindrop showed up uninvited to give an impromptu performance that ended with them throwing their instruments on the floor, and resulted in an ambitious gallery project the following summer.

These fortuitous encounters led me to try to better understand this nationwide web of underground connections and influences. They also prompted me to make an outline of the characteristics of this new approach to art and the art life:

TRAVEL GUIDE TO LIVED ART

Art is about lived experience- not art about art.

Art is part of a creative, artistic life orientation

Sincerity
Faith in ability to communicate through art
Belief in the expressive potential of art making
Not ironic

Not depraved
Not abject
Not angry like skateboard art
Embracing

K-48 Klubhouse, installation view, November 21- December 20, 2003, Deitch Projects Brooklyn. Photo credit Tom Powel Imaging.

Handmade, hands-on method of making art

Feeling for craft

Handmade materials

Vernacular painting and drawing techniques, knitting

Feeling of immediacy

Personal involvement

Anti-fabrication

Found objects

Scavenger orientation

Reluctance to pay for art materials

Use of post-consumer materials as inspiration

Materials tied to personal past, childhood, toys and games, old computers, video games

Use of recycled materials

Community orientation

Places and events that generate energy

Magazines, zines, books, clubs that foster collaborative projects

Nature of artists' work is collaborative

Art/music/fashion fusion

Artists work in range of media

Artists live the art

Centered in New York, but not New York centered.

Nationwide community of artists

Vibrant communities in San Francisco, Los Angeles, Providence, Portland, Philadelphia

Communication through band tours and zines

Below mainstream media

Artists travel like and with bands.

Many artists are in bands or collaborating with bands.

Fusion of fantasy and reality

Enlargement of private world

Fantasy as platform for engagement, not escapism

All-sexual

Not strident about sexual politics

Naturalism

Revival of late '60s styles

Sampling of earlier styles that encompassed music, fashion, lifestyle, not just visual art

Heritage of Pop art, but the Pop of hand-painted signs and vernacular culture, not the high-gloss upscale Pop

Influence of underground comics

Less materialistic orientation

Art as a natural part of pop culture

Art is colorful, not black-and-white

Art not as art historical reference, but as cultural history

Dearraindrop, Riddle of the Sphinx, installation view, June 25–August 7, 2004, Deitch Projects. Photo credit Tom Powel Imaging.

LIVE THROUGH THIS
NEW YORK NOW

BY KATHY GRAYSON

So the first second I arrive in New York, I'm in Matthew Marks staring at this drawing, packed tight in the summer opening's elegantly accessorized crowd whose vibes were comparably oppressive to the temperature. It has this dude in a black suit and tie, on his hands and knees, with sort of floppy ears and a mushed little pug face. Above him, in a strange, sloped scrawl of capitals: HOW DID I BECOME A FUCKED UP DOG PERSON?

There I am, having just completed some thesis called, roughly, "The Techno-Sublime and Cyberfeminism in the Video Work of Mariko Mori," and this drawing is kicking my rigorously entheorized ass. As much as I would like to believe otherwise, I can't avoid the feeling that I am on the wrong side of this drawing's implied dichotomy. Insular theory had been keeping me warm enough at snowed-in Dartmouth, but suddenly this drawing by Chris Johanson plants itself in my imagination and will not be appeased. Hot under the critical collar, I con the school into giving me a bunch of money to go down to New York for the 2002 Whitney Biennial, almost on a whim. Lucky, stupid me, not even expecting anything more than the prefab soft-conceptualism that was clogging *Artforum* and my lectures in contemporary art history class at that time, I stumble into two of the most important installations shaping new art making in 2005: Chris Johanson's stairwell and Forcefield's lair.

Walking up the dismally middle school stairs of the Whitney, you see first one little dude walking on a lot of brown that reads "THIS IS WHAT IT IS", then some radiant, snaking wood path coming 3D out of his head, up, out of the brown, and shooting up the stairs. Bounding enthusiastically up the other flights, you then see two fellows hidden in the thicket of rainbow wood, broken down on the side of the life road, one going "I DON'T KNOW WHAT'S UP," and the other "I DO AND SOMETIMES I THINK IT'S REALLY FUCKED UP." Above them some more dudes, cars, and shops team up into a cityscape of hectic intersection all in the shadow of an exploding rainbow swastika. There are thought bubbles everywhere, some angry motorists, yoga, homelessness— and at the summit on the next floor is this universe, with all kinds of bizarre and extraneous planets labeled "grey area," "plants and animals ONLY," "PERFECT (really fake)."

Forcefield's room is insane. It's hard to recreate now in my mind the disjuncture upon entering a dark creature-filled party to which you may or may not have been invited. Entering the lair you stumble into a radiant fur obelisk with big light up eyes winking at you and you swear you hear it growl— a rustle behind you and you look to see that the fellow in the electric zigzag knit shroud moved his arm you're just sure of it. With the silk-screened

THIS IS WHAT IT IS

71

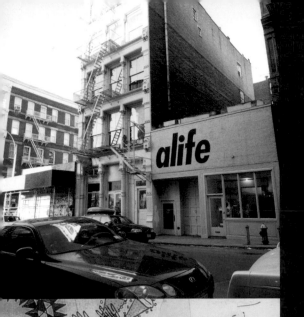

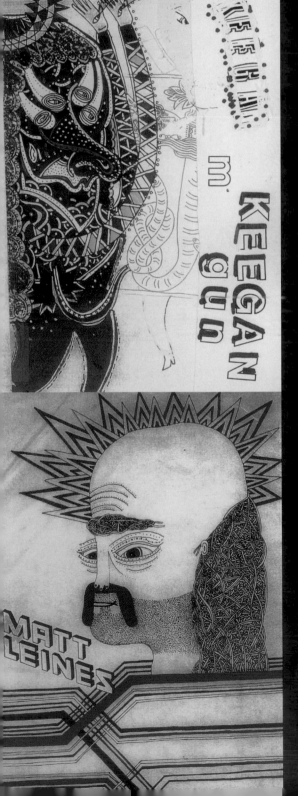

interference-patterning walls spinning your eyeballs and some really intergalactic beeping shit blowing your ear-mind, the room is a suffused volume of conductive dissonance: blue + orange, Modernist sculpture + thrift store + outer space— holyshit! It's the first and only time that a total autonomous zone is annexed in the Whitney and is owned entirely. You are someplace, but not here— someplace much, much better than here.

What both these Whitney installations did for many people, for the artists in this book, and for me in my head there at that moment, was explode what we expected from an art experience and what artists limitingly thought we were expected to make. A general audience (and sometimes also people who write about the "Technosublime") can always tell when things are sincere and real, and you knew in a heartbeat that these two contributions were. In the simplest of terms, you could tell these artists MEANT IT, and meant for you as a viewer to experience it as closely as possible to how they did. There was nothing else going on at that time that was so free with materials, making figurative sculpture rad again, putting out a whole complete ethos; an integrated multimedia aesthetic that was smart, funny, critical and transformative. Both transformations were such simple things— radically brilliant as those things tend to be, but simple— I mean, one of Forcefield's most resonnant innovations was essentially to make a knit jumpsuit but to cover up the whole head and face. What a seemingly innocent move-- what a wonderful moment, though, for everyone.

I gave a lecture on the Biennial as part of the grant requirement, and for the first time enjoyed actually not finding the critical terms to process and package the experience; the hubbub of critical jargon grows quiet, ideal if you mean to do any serious thinking or feeling. In the aftermath of exploded convention I had found the silence of an unoccupied and truly new critical space. There are precious few conversion-level art experiences we all get to have, and I would tally this preceding bit up as three.

The day before graduation, I remember sitting in the topmost aerie of our historic library tower, talking on my cell phone to the then-director of the Whitney Museum, a Dartmouth alumnus offering some free advice. He was telling me not to work at a commercial gallery because I'd never have a serious career in a museum setting afterwards or something, and there's me thinking if I worked at Deitch I just might get to meet Chris Johanson. Feeling there was a lot more that art could be than the art I was learning about, stifled by four years in the stuffy old boys' club of frat bankers, surveying this predicament from the historical apex of the campus, no less and then hearing an alum spell out what seemingly additional bland academicism I was to embark upon, I mean that pretty much did it for me. These Biennial installations were shot through with the suggestion of a whole different lifestyle and political economy and I needed to investigate. It was about finding one set of operating assumptions and worldview completely bankrupt and needing to start things over almost from first principles. It was about wanting not to read a processed version of art but to live the art.

SPECIAL ART REBELS

And then! Brendan Fowler and Chris Johanson come into New York to help install Chris' show at Deitch. I have the FUCKED UP DOG PERSON as my screensaver and they've just walked in the door, Brendan this tall, superloud dude yelling to Chris, "Omigod, Chris, check it out that girl has you as her screensaver!" Not exactly the type of introduction I'd hoped for. I follow Chris around, showing up early to work to watch him turn the preceding Richard Woods show's floor and wall panels into a huge half-globe traversed by a colonial ship and a big bag of money. He's there, spontaneously creating what to me are like koans of contemporary thought-- this one drawing has these fellows in rainbow cat suits sorta loping around, one going, THIS WORKSHOP IS EXCELLENT! And confirmed below: THIS WORKSHOP IS HIGHLY REGARDED AS AN EXCELLENT WORKSHOP. He was simultaneously unmasking the idiocy of these affluent exec types while sympathizing with the extreme measures their dulled psyches must go through just to begin to connect again. I hadn't

met someone who was so articulate in his way, so firm in a conviction to live cheaply and sustainably apart from a very dark mainstream, uninvolved in consumer culture, academic pretension, corporate media and questionable sponsorship. Armies of kids across the country are quite familiar with this, but I had come up in a way where this was like Breaking News. All over the place, there are people living inspirational ways and making art about it, and a huge extended community of them opened up through Chris— it was like tugging on a mushroom and getting the two-acre mycelium. The first of these was Brendan Fowler.

Brendan built this geodesic dome for Chris that ended up looking more like an impaired igloo but was still pretty rad. Sticking around to play some shows, Brendan helped the alife guys organize inventory for their really fresh art multiples and zines mini-store at Deitch that December. He handed me one zine like it was this sacred object and was like "Kathy, this is the raddest shit ever please have this— these two guys Keegan McHargue and Matt Leines made this." Flipping through what was essentially four pages of color Xerox with a staple in the middle one easily could have gotten the impression it was made by like inter-dimensional warrior priests or I don't even know that the fuck— it was fully something unlike anything I had ever seen. It took me probably three seconds to beg them to come to New York, partly to put them in this show I was plotting but mostly I just wanted to meet them, see if they really were human organisms, I think.

Keegan was amped. He was on his way here anyway for a show at Rivington Arms at the same time since his friend Dash had turned Mirabelle and Melissa

onto his work also. I remember thinking that no one at Dartmouth had a name anywhere resembling words like "Keegan" or "Dash", and this, I thought, boded very well. Keegan made the art for both shows on a train coming to New York for the first time. We installed this show Dirt Wizards at what The New York Times would call a "ramshackle" gallery in Brooklyn because the people that ran it, Burr and Pearl, were awesome and kind and bullshit-free and made us feel really psyched. The artists and I built this fourteen-foot wall because the place needed another wall and spent days baking to death in July while Keegan painted this geode-mural, his friend Dylan painted a million little hairs on this other wall, and Justin Samson faux-wood paneled his. I remember biking totally an hour late to the opening because I wanted so badly to finish stapling the zine we made for the show— a zine, afterall, was its inspiration.

Six months later, interviewing Keegan for this Wrong Gallery show that Ali Subotnik and Maurizio Cattelan let me organize (that included two Dirt Wizards, Keegan and Matt Leines), Keegan reflected on how his recent art experiences in New York and how it came to pass that he suddenly had a big art world audience. Telling me that he never had an interest in participating in the art world, only that he had just taken the time to do things himself and live apart from what he thought to be a really fucked-up status quo. He described a way of living of which his art was a natural and logical extension, not a career decision. We walked around for a few days, the recorder thing always in our faces, me usually too hung-over for coherence, but it was fine since I could never get a word in edgewise: Keegan talking volumes, like the free associative exploded interconnec-

Installation artwork by Justin Samson and Keegan McHargue for Dirt Wizards, Brooklyn Fire Proof, July ... zine cover, Matt Leines, Brian Belott and Melissa Brown's gallery, Greenpoint, 2003; Opp ... Chris Johanson, This Workshop is Excellent, 2002, acrylic on paper, 22 x 30

73

tion you see in his paintings. One second I'm hearing about Portland's current incarnation of DIY kids piling five-hundred bikes outside a rock show, the next about how he went to college for "lore" and has worn the same pair of pants for three weeks— wryly thinking that's the sort of tidbit readers might gravitate towards.

But from working with Keegan on such a normal human level, I got a first-hand, no-bullshit look at the real ways that lifestyle and new art making can interact, and are interacting in new ways. It wasn't just reading a press release, hearing that Keegan used to write graffiti or was from Portland, and making the facile interpretation that "street art" and Northwest American Indian iconography might "inform his process." Because they don't. It's not helpful to dissect the internationally synthetic feel of his work into its component parts. The only insight to be gained there is from its undifferentiated generality— a generality that comes from privileging other ways of knowing and other traditions largely outside of the Western Canon, freely sampling from those instead of some art historical grab-bag. Another blunder would be to suggest his use of found materials is not some sort of nod to Bay Area trends instead of a sincere effort to make the best things the best way you can within your current means; a well-known Bay Area artist first taught Keegan how to paint and make panels out of found wood when he was crashing on the guy's couch. With Keegan it was bananas to see how having a distinctive style of mark-making, a style one rigorously develops apart from accepted hierarchies of secondary education, could win you the fucked and inaccurate label of "outsider artist"— and don't get me started on what an intensely dumb term that is just from the get-go. Fusing an idea to its image-conveyance without the meddling meta-awareness of an academically impaired self-conscious doesn't making you intuitively gifted but just an "outsider", or worse, "faux-naïve"???

Meeting Dearraindrop that summer made a similar impression: their speech matches their clothes matches their art; polyglot, radiant, hilarious, exuberant, aggressive, smart, spastic and open— celebratory of new experiences, new creatures, new objects of wonder, and new juxtapositions. They struck me as free artists of themselves, to borrow a phrase. I was finding that a more sophisticated understanding of what Keegan, or Dearraindrop, or any of these artists were up to really required a disavowal of

knee-jerk academic responses and a more generous move to understand the various ways that art, sincere to the core and intimately informed by a lifestyle or cultural position or whatever you want to call it, necessitates a different approach.

While Keegan was still in town, we met Brian Belott at his crazed group show opening at Canada when he gave my friends some mushrooms without even knowing, like some jolly drug elf whose collages and handmade things were awesome. Devendra Banhart, one of Keegan's old friends, had drawings up in the Canada show as well, drawings that had all the delicacy and kick of his songs and were weird, intricate, and vintage-feeling in the same way. Immediately following this melee, we go to hear Devendra play Joe's Pub and he fully calls my friend out on the drugs in the middle of his set, a packed room of thirty-somethings turning their heads in contempt.

That night, seeing where Brian lived was a whole other thing. He and the members of this band, Sleep Tantn live in this full-on mead hall of a building in Greenpoint. Knee deep in an exploded collage/instrument, I worry about my cigarette igniting a brush fire. There are lots of self-constructed boats around which seem to be oft-used for some daring East River expeditions, and lots of interesting stuff to trip out on or pass out on top of. I walk in and discover Brian running around with his beard on fire. Trying to blow it out for him, I find that this clearly was not the desired response. Joe from Dearraindrop is peering though a huge bunch of cilantro that he's holding up to his face, just screaming "I don't give a fuck who the president is!" and painter Melissa Brown is grabbing the mic out of Michael Williams' hands and commanding the attention of the place, so much as it is able to be command-ed. I'm there with Juan, director of vehemently political non-profit gallery White Box, whose eyebrows were raised more than once, especially at Joe's comment. But his presence actually threw into stark relief the amazing ways that this whole shit was political. And how there was still awesome, shitty, independent artforts even in New York, scratching it out even here in one of the most intense, expensive cities. Walking home at dawn I think I expand-ed my personal definition of PSYCHED.

LOOK AN ESSAY

This book project is not at all after in any way anything

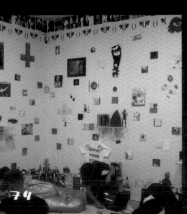

like sticking a new term on a new movement; I mean, for goodness' sake this is really obvious, right? Totally let's [be] broadminded and embrace multiplicity and, most impor[tantly], not market ourselves. It does not suffice to sa[y that] these artists share working methods, subject matter, [or] formal concerns only— that's affinity at the curatoria[l] level and largely uninteresting. It's more nuanced, [in] affinities at the level of ideology, and could bett[er] be described as a complex community and collab-orati[on-based] network of very different practices that are [ho]stile to generalizing terms but share a unique ev[olving] ethos, and sincerity. The term "interdisciplinary" [is a w]ay of making safe and understandable what could be[tter be] described as "antidisciplinary", which is more accurat[e], but please understand I am not terribly eager to develop some critical language to tie bows around these tendencie[s], not until critical language itself becomes a whole lot less suspect. Thus, this specific unity underly-ing th[e pl]urality can best be elaborated by the artists thems[elves] in all the complexities of their output and can best [be], well, FELT. Similarities range from obvious (dir[ect li]nks of collaboration) to more subtle (something that [?] approaches an ethic) but to extract a few glar-ing commonalities I would say this:

What distinguishes the best of what's going on right now from the rest is that unmistakable, un-fakeable sincerity that runs underneath all of it. A fundamental difference exists between that which is held at a conceptual arms-length and a creation fused to the complexly intersect-ing [s]pheres of intellect, intuition, and experience that make up a *lifestyle*, not an *art* style. You'd be challenged to find anything ironic in the work that is put there by the artists themselves: says Keegan, "I have very little irony in my day to day life and even less in my art." This art is not about art. This art is not critical of the nature of painting; it lacks meta-anything or self-reference, it does not explore the nature of artistic production nor does it respond to, attack, or reintegrate an[y] [?] preceding mini-movement— it is not about art, it is about SOMETHING ELSE and, like, about fucking time, [you] know? There's so much to explore both as an artist [and] a critic, even in seemingly simple areas like how artists use materials in new ways to take on mean-ing, how one invests an artwork with radical values, how meaning is made or marred in the surrounding discourse of the object- lots of spaces opening up into larger spaces that have been overlooked in favor of propping up artworks with jargon-heavy scaffolding.

Sincerity— scary word! For me personally, this term was allowed to reenter discourse almost solely because of Chris Johanson. With this illusory naivete invading the meaning church around the back with a sort of cynical reason, Chris manages a plain-spokenness whose new-age lexicon suggests irony, but behind the viewer's defenses grabs onto something real. Who knows how exactly he reinvents such generalized, devalued language with a profound ref-erent, but you feel it. And this is bigger than what's going on in the freshest fine art: Animal Collective, Joanna Newsom, and Devendra Banhart's new albums led the New York Times' Alec Hanley Bemis to wonder at their childlike sincerity and utter lack of ironic anything. And in fiction you find McSweeney's cult writers, trying desperately to wring one drop of meaning from poststruc-tural disenfranchisement, seem suddenly less of-the-moment than someone like JT Leroy's drenching meaning-from-a-fire-hose. If these artists are any indication, rejoicing in a thicket of meaninglessness seems to have finally given way to vision and conviction.

ANTI-PROFESSIONAL

One seemingly innocent, but very relevant, commonality in this book is the anti-professional nature of much of this artwork. Most of these artists are not pedigreed MFA stars, and the breadth of their background breathes life into what can become a tedious parade of academic assembly line art. There are a finite number of very specific rotations of thought that are presented to you in an academic setting as being generative to good art making— trust me, I have endured this firsthand and was given a refresher course last week at some Ivy League's open studios. Often you're encouraged to find a tidbit from critical theory that has a contrived person-al significance. Then it gets coupled with a firmly staked-out stylistic position to make your brand stand out nicely from the other brands. Lastly, materials or medi-um that are *least* suited to your expressive ends are used in an attempt to create a frisson of excitement for your soulless, limpid pile.

Now, for me, the capacity to feel something as an art viewer— more than a small, congratulatory pat on the back from deciphering the pat conceptual content of work of

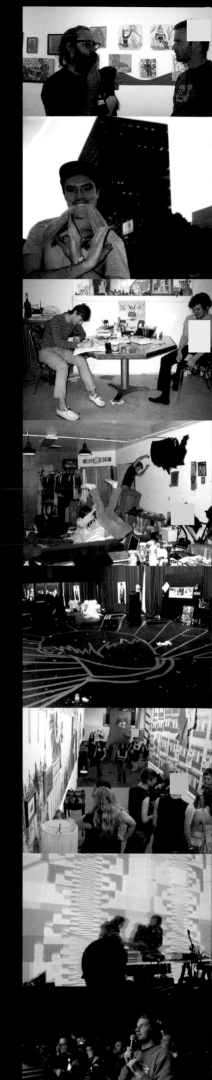

Chris Johanson at New Image Art, LA, FARR, photo Dash Snow; Keegan and Ry, photo Peter Sutherland; Kathy, Keegan, and Ry, photo Katie Davies; Phillip's *Guided By Lightning* show at Deitch Brooklyn, December 2004; Scott, Michael, and Avenue D in Majority Whip instal-lation, White Box, May 2004; *Treehouse* at Deitch as part of Low Level All Stars, February 24, 2005; Katy in Low Level All Stars.

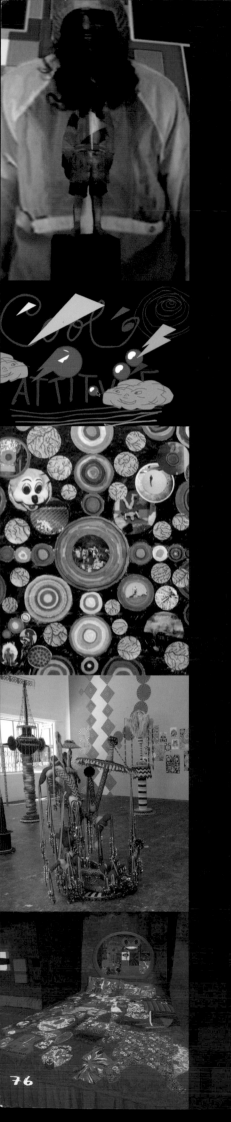

this sort— is an important thing to pursue and preserve. So my bristling at this type of soft-entheorized behavior comes from the belief that every time someone takes something lived and real and makes it an "art" they diminish everyone's ability to think and feel through an artwork, everyone's ability to broaden their capacity for empathy. In Chris Johanson terms, this ability depends at least somewhat on a trust circle; a delicate arrangement in which faking, biting, and posturing can really piss in the baby pool. Which is why a return to sincerity in this new art is so precarious, and why I feel so hostile to the word "faux naïve" being applied to this art, or pretty much ever being typed on any word processor ever again.

The technique— humble materials, sometimes hasty rendering, unironic use of text or symbol— is not an adopted mantle; artists are using, rather, a technique that most appropriately suits their expressive needs. Pillaging troves of junk for materials and mining the psychic detritus of whatever you wanna call a stratified generational unconscious, artists are finding something in the refuse that is redeemable. Ry's razor-sharp paintings of post-consumer waste swirl ominously like a filthy breeze through his paintings, Jules paves over a pile of trash to make a ski slope, Misaki sews a beautiful biplane out of a stained parka, Cory turns a quasi-obsolete computer cartridge from the 80s into a hiccupping vortex of clouds and energy— and on and on. Were you so inclined, you could see this broad and multiple tendency as having come from both aforementioned Biennial installations: Chris Johanson and the West Coast insistence on legible rendering and found materials, but also in a different way from Providence's bananas pack rat craziness, their genius at imbuing humdrum found materials with a sense of the uncanny. Or, as Jim Drain puts it, "trading tapes made out of goo and finding junk that Fine Americans would throw away that you could use a billion more times until it dissolved into doves."

This is one of the overarching motifs in new art making— getting unexpected results from innovative misuse that are exciting. Forcefield's preference for dissonance is a profound influence; the optical disruptions of complementary colors, and the contextual dissonance of a thrift store blanket and outer space provide a sort of painful excitement, the feeling of being on the outer fringes of experience, where innovation is bred. Many of the artists and musicians in this book are taking technology or machines and using them in the wrong

way. I remember Mat Brinkman played this "new noise" event thing downstairs at Northsix, with nerdy guys fully clutching notebooks and not even moving a muscle during the show, but, in between sets, crowding up to examine the hardware, scribbling away furiously, angling to see how Mat had rigged up his old, fucked-up machines. And of course, taking a tool and using it in the "wrong" way is a great tradition in art making. In this incarnation, it's partly the punk tradition of anti-mastery and urgent experimentation, but without the insistence on discord and error. These artists are using this energy to revive bankrupt styles or methods without the sloppy nostalgia, invigorating them through inventive new use.

NOT NEW YORK

Remembered with equal fondness as the destruction of property and possession with intent, though, are times when everyone in this scene sits around making stuff, sharing books, music, zines, posters, when you really get the feeling that everyone is putting their own shit out and there is just so, so much to look at and listen to. With artists on tour with musicians coming through New York, showing films, doing all kinds of shit for which the term "antidisciplinary" was introduced, there are really just not enough hours in the daytime or nighttime to be a young person. All this frenetic activity is kaleidoscopically beautiful; the breadth of possibility of medium, the encouraging audiences and venues and the pervasive ethos of doing things yourself, for yourself, without sanction— financial or otherwise— from any establishment. Paperrad and BEIGE, plus Brian Belott et al. and Dearraindrop— all these traveling kooks were doing shows at not just galleries, but like where-the-fuck-am-I little hole in the wall places— packed ones, packed kitchens and basements, packed word-of-mouth sort of things, not exclusionary but personal— people cramming into a sweaty living room motivated not by hype but by abundant enthusiasms, people that go to shows and DANCE.

Awesome: I remember this one show in Greenpoint at which this dude and his dudefriend were opening for Brendan and one is just some mustachioed, rapper-type white fellow wearing a pink tutu. Just to make everyone feel more comfortable if there are people in the crowd for whom that might make them more comfortable. Really! These were guys coming from a trans/ gay-friendly whatever artfort in Chicago and they were not making a statement with the get-up— with all these variously costumed bands I dare you to find

omeone wearing a costume to transgress, to be ironic, to be post-ironic, whatever. It's pretty safe to say that a lot of this costuming is a move to break down barriers of expectation and also a pretty straightforward effort to not be publicized, not to be marketed, not to grace hipster magazine covers. This is Assume Vivid Astro Focus's method of keeping his collaborations about the collaboration and not just becoming about him as some art star: always appearing behind masks. Lo and behold, that nice respite from a sea of competing faces and the liberation of anonymity is also somewhere in the Forcefield move to cover up the faces of their shrouds.

But all of this is definitely not a subculture— you are loath to think in those generalizing terms because it's the quickest way to find yourself the target of a focus group. This whatnot, then, this thing that I would identify with but defy labeling, has no qualities, it seems. Rather, it is defined by a unifying set of developmental experiences and contemporary challenges— similar commitments and patterns of thinking; maybe similar tools in the belt, but very different belts. And very different haircuts. So how do we all find each other in a crowd? It can no longer be anything external or you risk having it pop up near-instantaneously in a Diesel add or something; it has to be a covert operation in which you wink with what you create and not with how you adorn yourself.

There are a million ways to wink at eachother, across countries, everywhere, and it's through these channels of independent media that we can all stay in touch with those who inspire us, wherever they go. It's no longer that everyone has to come to New York and do the same shit that we do— most of the energy is coming to us via other cities. I think it's important to recognize that New York is partly the point but mostly the gateway through which all the energy gets beamed to a wider audience, and maybe the biggest hub of this network of inter-communication but not the network itself. As Hanna from Little Cakes says of her circle, some of the energy is even anti-New York, or anti- a certain kind of New Yorkness. Keegan told me when he was living here for a few months that "New York is a good example of the modern world at its weak; I think it's a lot of mind control." But it's money too— Matt's studio is his parent's basement in New Jersey— cheap! Jim still lives in Providence, haunting an

old fabric factory and riding the bus. Ry's back home in Portland on a painting sabbatical, recording animal music as "Driving Miss Jay-Z," Keegan feels more at home in the Bay area, Paperrad's homebase is western Mass, and Dearraindrop likes the thrift stores better in Virginia Beach. Whatever: everyone wanders around constantly, jet setters sans jets. You hear reports from the field about what people are hip to in different places, if you're lucky you go have shows of your own there or go there on tour, or just find something in the mail you didn't expect. In that spirit, these things that pass around through everyone's hands like drugs (sometimes drugs), like Forcefield videos people got who knows where, Paperrodeos sorta stained but readable, little artist books, comics, photos, posters, flyers, wobbly-camera rock show videos, and all the esoterica you can pile up— these things serve to begin the connections of a community. People are so eager to share the independently-made things that inspire them that some zine printed in Portland or wherever can pass though hundreds of people's hands all the way to the other side of the country.

No books, magazines, or mainstream whatever were hyping this— that's not how these influences traveled. This vibe actually did travel apart from conventional media channels; if you were brave enough you might even say "underground."

MYCELIUM

The "underground," as Roberta Smith writes in the New York Times' "A Bread Crumb Trail to the Spirit of the Times," is everywhere— if you consider "underground" as describing less the surrounding economic discourse external to a work and instead as suggestive of something intrinsic to the work itself. If by "underground" you mean art that somehow (and multiply, complexly, diversely) expresses an independent spirit committed to autonomy and authenticity, not an anti-everything but a pro- something new... not incapable of affiliation but rather affiliating along lines that conform to a personal ethic of anti-corporate, anti-media, anti-sponsorship, pro-human, pro-animal orientation. If that's how you define it, then I'll give it a maybe. Calling something underground is a pretty embarrassing thing to say, or so we've been trained to think by watching the word's referent publicly mangled. I sort of learned from Brendan that it's hard to shape your worldview in terms you can use to communicate with others without a bit of that embarrassment, a bit of that nomen-

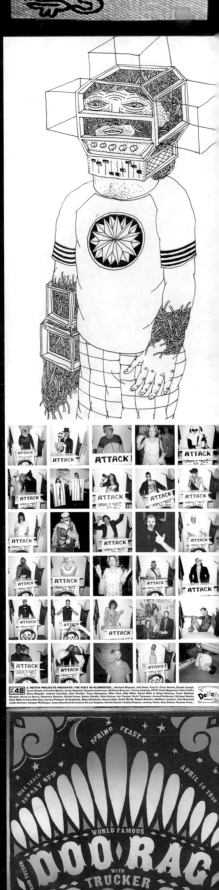

At right: unknown flyers, Matt Leines drawing, Kult Klubhouse poster by Scott Hug, Doo Rag poster, Mat Brinkman, courtesy Brian Belott.

77

clature, though. I remember watching him play some show at the now-defunct Right Bank— this small awesomeness on Kent with the Manhattan skyline behind the stage— and he said, fully meaning it, and absolutely making everyone else mean it, and not feeling embarrassed thinking it: "and its political— and politics isn't necessarily just guerilla fighters prime ministers and who cheated in the primaries, its also who am I in relation to you, who are we, and the way we can see ourselves in relation to the other kids, the ones in the magazines and the ones who miss out on shit— and if we're here, we're probably all special art rebels or something anyways, so lets all be special art rebels together, same level."

It was a call to get everyone off their high hipster horse to come together in political ways to affect change. Together! Dorky, but together, and that togetherness is a huge part of why this art looks like it does: the most interesting part of the organization of this group of people is the insane degree of complexity with which everyone is interconnected. Brian Belott and the Huron Street people, who came from various Providence beginnings, put the Dearraindrop people up when they're in town, who in turn used to affiliate with the Paper Rad people, who have gone on tour with Cory, who also curated a show featuring a bunch of the artists in this book including Justin, who collaborated with A.V.A.F. in Miami and lives with me and Ry, who in turn showed with Dash and Dan at Rivington Arms a while ago, Dash having used Brendan, Dan, Ryan, Ry, Keegan— I mean the majority of these people— as his subjects, Dash's awesome-looking living room wall being the subject of Dan's next painting, who seems to be in all of Ryan's early photographs— Ryan who is close friends with Brendan and Phiiliip and Terrence, who are all in the next K48 issue Eli's friend Scott is doing, which also includes Jules, Matt Leines, Devendra— and on and on, ad infinitum.

But this is not just a fun connect-the-dots game of who hangs out with who and who parties together, because they don't, always, and that would be confusing causality. There are reasons that these particular people are those who affiliate and there is much in their nature of affiliation to yield a better understanding of this very interesting anting. Of course, there are moments in which everyone comes out of the woodwork for something in which you can see the community come together, like Scott's Now Playing thing at D'amelio Terras, Ryan's Whitney afterparty at ACE, the Majority Whip show at Whitebox (to which almost all the included artists in this book donated artwork and time to raise money for voter registration), Dearraindrop's Deitch opening, and a million other events. It's very logical and natural the way that like-minded people at some point will cross paths, but this grouping is unique in that the very nature of the work is about proliferating paths, paths being an integral part of the output. Eli, Scott and Brendan, to name just three, are like walking coordinators of game; they do in their sleep. They aren't happy unless they're bringing up and bringing with, wherever they are going. It's a catchy optimism, that all you need is a good plot and good friends.

I remember really staring at Ryan McGinley's photo of himself having sex with this guy on his bed where they're both sort of laughing and looking a little embarrassed. What was more striking than the subject matter or the disarmingly lovely way in wich it was portrayed was the fact that his bedroom wall was totally covered with Polaroids. I mean, this guy sleeps surrounded by hundreds of photos of his friends wallpapered everywhere?? It was sorta amazing, Ryan's obsessive urge to give image to a community, needing to visualize connection on his own terms. This spirit of documentary photography is very much a part of this scene— and that part that gets brought up fast and is most wildly misunderstood. But its basis is in the feeling that no matter how much whatever magazine wants the rights to

your face, you can still take matters into your own hands. Trying not to take this analysis too personally to heart, it seemed like this photo of him fucking some dude was really a photo about community building. Scott has always been committed to this as well— putting in every K48 issue photos of the community members his long arms draw in, not to show how cool everyone is, but more so we all can recognize each other around town and get into contact. I remember after some party I threw in my loft that someone had torn out and pocketed just the four pages of contributors from issue #3, and not being that puzzled as to why.

If this is giving more of an idea of what it's like in the interstices of this art making, in a network of connection to it, I would hasten to add that on the single unit of the artist working with his or her materials, there is a great deal of serious activity. You can't look at one of Jules' or Ry's or Dan's paintings with some knowledge of a "scene" and think you have a chance of getting at it. Art is ultimately a lonely business, as the thousands of lines of code Cory has written might bespeak. Many artworks in this book are invested with a careful and studied content, precision draughtmanship, and sophisticated formal intuition. A thorough understanding of the pieces can only come from the viewer's personal reflection on these points as well; knowing the context or lifestyle it comes out of is only a beginning. As Alika of Dearraindrop very wryly tells me, his "scene" coalesced in the library.

But the community-building urge is enormous— you have to try hard NOT to get involved in things— please don't let the snobbishness of Chelsea gallery staff or glossy magazines make you think otherwise for a second. Get into Phiiliip, Grant, and Avenue D's Panty Party at Opaline you just had to doff your pants; to get involved in K48, just email Scott; send a zine or a CD to some friends you don't think use regular mail anymore... I mean, I don't think I can type the word "inclusive" enough times here. And this is the spirit of the art itself, too, that you can feel reaching out to you through the art object. For example, I go to this Whitney performance

thing as part of the 2004 Biennial with Dash, Ry, Katie Davis, Scott Hug and Phiiliip. There, Cory Arcangel is on the stage in the cafe area with a whole bunch of contraptions, debuting his IPOD piece. And he's just this stand-up comedian-level hilarious nice person, standing in front of some screen that says "Dollarz + data Noise, hacking the hell out of the Nintendo Entertainment System, upload that HIZZY to the DIZIEEE!!! RAM???" like totally, totally psyched on what he's doing, while everyone is just, like, what the flying fuck is this? And then by the end of this talk/performance— no joke, how cliche— this very elderly woman next to me with whom I had been chatting, grabs my knee and goes, "I understand it now, I do!" I mean, bananas. He's taking stuff that is, if not always highly complex, then exceedingly intimidating, and he's making it accessible and interesting to what you'd think would be the most skeptical of audiences. And this is not just a nice afterthought for Cory, it's part of the art— its prime moving force to communicate and demystify. Intrinsic to the hacker sort of approach, or whatever you want to call it, is the mandate to share— any cool hacks, codes, viruses, etc., are posted shareware, free use, "copyleft" to use the vernacular. For his Foxy Production Infinite Fill show, Cory and his sister Jamie posted an open call online for submissions. He even has elaborately photoed instructions on his site so you can make any of his artworks yourself (or try to!)

B IS FOR POLITICAL

So all these aforementioned characteristics that define this energy— sincerity, collaboration, antiprofessionalism, antidisciplinarity, etc.— mean something really specific and exciting in terms of the political economy with which the scene is unavoidably bound up. That is to say, the sincerity running through art like this resituates the artistic subject in a way that is not apolitical. Heaven forbid we get to talk about an artist as a person, one with ideas they try to get across in paint, to a viewer (also a person) that will react based on those visual criteria. Remember how fun that was? It allows us once again to talk in a straightforward manner about matters of experience and lived reality— here, where idiosyncrasy mines personal experience to celebrate its

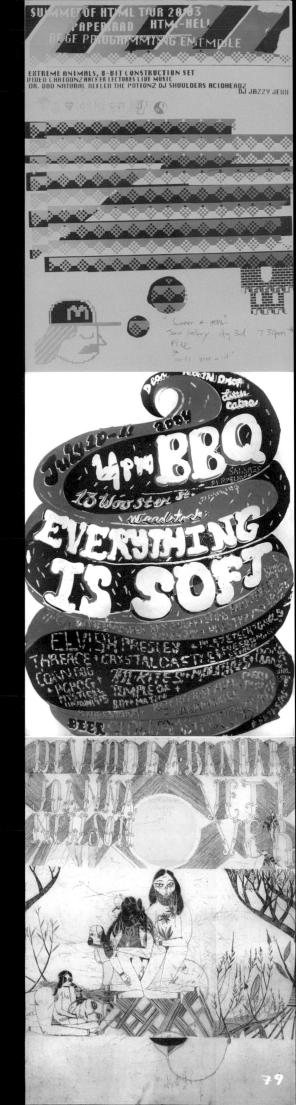

At right: Summer of HTML Tour tour poster, Summer 2003, Beige and Paper Rad; Devendra Banhart tour poster, 2004, artwork Keegan McHargue; Everything is Soft event poster, July 10th, 2004 in Dearraindrop installation at Deitch Projects, 18 Wooster Street, organized by Little Cakes.

interconnective potential, rather that seeking to create hermetic little worlds of one. Lines are connecting lines, celebrating the interrelationship between objects and actions, bodies and their environment. This art is not nostalgic for lost origins, it is not invested with a longing for the referent, it's originary instead of post-anything; as Carlo McCormick said, it is pre-something we haven't discovered yet. It's art characterized by a belief in the expressive potential of materials and their ability to convey subject matter.

What's fun about the art world is that so much can go on under this protective umbrella of funding, where there is an audience and a budget and a whole elaborate critical infrastructure for your random installation, your labored collage, or your curatorial proposal. And it can all operate (mostly) outside of a commercialized discourse. You don't have to sell your style to a shoe company or a design firm. You don't have to sell your off-duty life to Vice and your face to an ad campaign. It is crucial that the networks of media that popularize and commodify this aesthetic for their own commercial ends are not misunderstood by artists and art professionals as collaborating distributors of this artwork. This blending of genres is not the innocent commingling of creative peoples across draconian art lines in order to reinvigorate each other and produce some odd hybrid vigor. Any artists who think they are "democratizing" the art object, making it accessible in a diversified fall line limited edition whatnot in Tokion stores or whatever, are wholly mistaken. Using a culture notorious for its destruction of corporate property and a total distrust of advertising and the media, Nike et al. has been all over the jock of "skate/graffiti artists," rapidly purchasing and restyling many of the artists from the traveling Beautiful Losers show. Watching the lickety-split deacquisition of war-won ideals is completely infuriating: if you want some firsthand accounts of who said rad and who said go fuck yourself (um, Chris Johanson quelle surprise) then read Ryan McGinnis's book Sponsorship.

One of the most encouraging and striking things that the artists in this book have in common is that they go so far out of their way to stand apart from these economies of exploitation. Part of the anti-professionalism, part of the urge to do things yourself, independently, responsibly, and ethically means that these included artists by and large tell meddling magazines, corporations, and even galleries to fuck off. Which is not to say that companies haven't found some way to latch onto them: often the artist's style is just straight lifted to make them a poster

kid for something they think sucks. Take Vice magazine, speaking of sucking:

One of the many kind fellow outsiders and genius nice people I met through Keegan was Dash— whom I had "met" before on the cover of Vice, sitting at Dartmouth wishing I were in New York. Dash, for all his more public talents, is secretly one of the best photographers around. Like Keegan, he has charisma coming out his ears I mean this guy is one of those people who has one perpetually-arched eyebrow like he is too no good, or is infinitely about to be. Which turns out to be a pretty fair assessment. I'm sitting on his black leather couch— which after seeing some of his photos you might think twice about sitting on— looking through boxes and boxes, I mean, years of polaroids. And if you saw this staggering archive you, too, would be immediately struck by how, even with so simple and restrictive a format, you can pick one of his photos out of a stack of a hundred other people's polaroids in a second. His stylistic touch is just that good— who the hell knows how— I'm sure he took some of these photos pretty fucked-up but he could still compose it, in some cases under intense pressure (cops, impending death, etc.). It's pretty dope— some photos, it's just like no WAY that person posed for that, some person on the street just really openly showing something illegal or just weird to the camera. It's a skill that only the best photographers have, to be granted insider status into diverse groups of people and to depict them without condescension, which is, I suppose, where the charisma part comes in. The content of the photos can be pretty raw: it's real drugs, real poverty, wealth, shit, and crime. It's also real trust-funded hipsters sometimes, but 100% no filter. You know the difference between real sex and not real sex? It's that. And what these photos serve to do is really obliterate the soft-core media version of sex and drugs— his work is too innocent, actually, to be dour, too exuberant to be anything but celebratory. Quite frankly think his photos are real in a sense that is almost such a distant memory that the sense of it is lost— lost to every hipster taking drunk photos of their friends and thinking it's comparable, and with every advertisement copying his style.

And so it's baffling the amount of weird hype surrounding this work that is in its whole being so authentic. How can you bite this? It is so palpably this guy's life you're looking at. But then, of course, this work is a gold mine to a rag like Vice needing something like Dash's authenticity to lend credibility their patina of "genuine downtown fucked-up glamour" which inadequately hides their Nike-hawking dark neo-conservatism. Not

At left: Andrew Jeffrey Wright zine; Paper Rad zine; LTTR issue #2; Ashley Macomber and Shay Nowick collaborative zine; Dylan Walker and Keegan McHargue collaborative zine; KnitKnit issue #3.

that anyone in New York gives a shit about the magazine, but by virtue of it being free and how its used as a hipness barometer by tons of kids in other parts of America, Vice is super super fucked to be pitching our community in such distorted form and— peace, ok, whatever, I'm sorry I brought this up now I'm totally pissed off again. The way our position as truculent young people is so rapidly taken over and distortedly projected back to us in the media is just so infuriating, of course, and it makes some feel like we have to be continually on the move, searching for new (and often very vintage) terrain on which to set up temporary camps. It's painful to see people relinquish strongholds as quickly as they are taken, but longing for a territory to defend would just be the flipside of the same misleading metaphor. If subversion is defined for us by ad execs as just some kind of incoherent rejection of whatever the status quo happens to be, endless quests for fringes of experience, shock avant guardism as an inexhaustible source of fodder for lifestyle glossies, then no one should want anything to do with being subversive. If every revolution is a Dodge revolution— well, you get the idea. But at least in our semi-protected area of fine art practice, we should be encouraged by what is an undeniable return to authenticity because once you re-grant the idea of authorship and are interested, at least somewhat, in who made something and why (an interest which no one could really shake anyway), then artists have an opportunity to do so much more than just make an art.

For these artists whose output is indissoluble from their life and personal politics, there is the opportunity for their behavior and lifestyle to shape things. This is where we as artists get to redefine subversion, the only place where it can reside now— in the lived politics and lifestyle and personal choices of artists with cultural capital. And there really is a platform and an audience and a means to distribute it that is not fucked. As Wynne Greenwood (Tracy and the Plastics) puts it, we can still scavenge pop pleasure from the ideological wasteland of the mainstream and infuse it with radical values. This is crucial: this is what a return to sincerity and authenticity can allow in the realm of the political. This is the promise I felt behind Chris Johanson's and Forcefield's Biennial projects.

And this is the most oft-overlooked component critically. Writing an article on Tibetan Art or some literally foreign terrain, critics brag how they go out of their way to read criticism local to the art's culture, but, boy, are they bad at following this advice when it comes to young artists here in New York. If you want at this stuff, you might try understanding it in its own language of experience and dare to participate, dare to have an openness and generosity of critical spirit to match that of the art making. It's not something I am capable of communicating in print (hence the 500-plus images in this book!) To the extent that what I'm getting at is of a more anthropological than empirical art historical nature, I'm trying to hold as true as possible to the subjectively-held meanings, values, and beliefs of the artists themselves. Maybe the description of a relatively unknown goings-on is best written by those with some lived understanding of it. Or maybe not. But you won't find any manifesto makers here. This is one of the characteristics of this new sincerity (if you want to call it that): there is no room for exclusionary language, for heady, definitive tracts. Manifesto making comes from a lineage of progress and conserved quantities, as does most criticism, and it is hostile to the fundamental organization of this exuberant and lived art making, hostile to its core values. Of course the art world proper, apart from the more protected enclaves mentioned in this book, does not tend to operate on principles of community, sincerity, or collaboration, either, to say the least. It will be interesting to see, then, in the extended play how the admixture of these worlds plays itself out, as the force of a strong conviction can cleave a whole lot to its will.

I carried the new Kramer's Ergot 5 home from Spoonbill with more than usual haste, even for the December temperature. It's one of those comic anthologies that has stayed rad despite its increased popularity, and since you can count those things on one hand, I wasn't about to let it out of mine. On page like eighty-something there is this drawing by Chris Forgues that has in the top left "FUCK THE PRESIDENT" folllowed by "FUCK ALL YOU CAREERISTS", suggesting equal enmity for like the devil's right hand and something for which I had yet to find a sufficient term. Once again, I started thinking about what side of this distinction I was on, having a career of sorts, working really hard to excel and grow, having ambitions and dreams that I chase, busting my ass to help artists pursue their fledgling careers. And, while I think we are all "careerists" in a way, this nomenclature brought home to me what is the central point of what I've been feeling the past few years and what this book, in a way, hopes to address. Which is that selective affiliation is not as baffling as people might think, and that every time someone sacrifices money or their "career" or their pretensions to protect and care for a belief that is larger than all those things, it's a small miracle. It's heroic, and a million small heroisms make more than just art movements.

At right: Andrew Jeffrey Wright zine; Chris Lindig zine; Misaki Kawai zine; Kus issue #5, 2004, courtesy Scott Hug; Matt Leines zine; Taylor McKimens zine from Clementine Gallery, 2003.

A.V.A.F.'s to do list VIII:

1. Start collecting Heavy Metal magazines thru ebay. Improve picture disc collection;

2. Research: Victor Vasarely, Aubrey Bearsdley, Hajime Sorayama, Guido Crepax, Islamic/Arabic designs, Menphis design (Ettore Sottsass), Milton Glaser, Hipgnosis, Sture Johannesson, Moebius, Robert Peak, Yves Tanguy, Art Deco and Art Nouveau (jewelry, posters, textiles, glass work, etc), James Romberger, Maxfield Parrish, Helen Dryden, Thomas Cleland, Coburn Whitmore, Robert McGinnis, Richard Powers, Boris Vallejo, Patrick Nagel, Don Weller, Tony Chen, Mel Odom, Heinz Edelmann, Barbara Brown, Roger Dean, Harry Clarke, Francis Picabia, Rik Griffin, Urs Fischer;

3. Ask Matthew to develop a poster for the show. Don't show him any of the actual images that will be at Deitch but just the references and talk to him about the ideas and other collaborators involved;

4. Work with Gerard on a black and white OP/anamorphosis wall-drawing/wallpaper for the concourse area. Silk-screen some of those A.V.A.F. porn drawings for BUTT magazine on the black sections of it;

5. Develop a haunted house façade for Deitch out of that mushroom wall-drawing on Carnaby street in the 60's. Ask Jim if he would be able to build something like that and how to put it up. Paint the façade in bright white. Have the back of the sign painted in fluo yellow;

6. Research videos #1 (for Los Super Elegantes): Mario Bava's, Dario Argento's, Stan Brakhage's. First idea for a Los Super Elegantes (LSE) video: do a one take Vogue music video (something like a mixture of "Paris in Burning" and the Beastie Boys' "Intergalactic" (camp but straight). Also look at Bava's "Lisa and the Devil" again and work on something that relates to the opening credits (the backwards card deal) and that sequence inside the car with long non-stop zoom ins and outs on everybody's faces. Get contact for Willi Ninja ("Paris is Burning", Malcolm McLaren's video "Deep in Vogue") thru Matthew/Michelle's friend. Also check with him info on current vogue balls. Maybe have Ninja choreograph the LSE video? Pepper LaBeija died today...;

7. Collaborators for project at Deitch: Michael Wetzel, honeygunlabs, action daddy, Slava Mogutin, Matthew Brannon, Los Super Elegantes, Gerard Maynard, Joseph Ari Aloi aka JK5;

8. Possible future A.V.A.F. collaborators: Jeff Davis, Michael Lazarus, Michael Magnan, Shoplifter, Tobias Bernstrup, Annika Larsson, Marco Boggio Sella, Dearraindrop, Christophe Hamaide Pierson, David Humphrey, Aïda Ruilova, Danny Wang, Monica Lynch, asianpunkboy, Phiiliip, Aleksandra Mir, Claudia Brown, Dave Muller, LCD Soundsystem;

9. Research videos #2 (for Deitch Projects - drawing and painting techniques for new wallpaper pieces): Osamu Tezuka's "Metropolis", Hayao Miyazaki's "Spirited Away". Show these references to Micahel (specially "Spirited Away" train sequence) and ask him to develop a garden/fountain painting that we would then scan and turn into a wallpaper for the tattoo area;

10. Other future music videos: Zongamin's "Spiral", Green Velvet's "Stranj", Phiiliip's "Elemental Childe", Alan Parson's Project's "Mammagamma", Simple Minds' "Theme for Great Cities", Machine's "There but for the Grace of God", The One Ensemble of Daniel Padden's "Spiders on Ice", Pink Industry's "What I Wouldn't Give", Rah Brahs' "Fungry", Glass Candy's "If There is Something", Soft Cell's "The Girl with the Patent Leather Face", Secos e Molhados' "Rosa de Hiroshima", Cerrone's "Supernature", Tati Quebra Barraco's "Elas Estão Descontroladas", Beatles' "Across the Universe", Blondie's "Fade Away and Radiate", B-52's "53 Miles West of Venus"; Baby Consuelo's "Menino do Rio", Mutantes' "Panis et Circenses", Afrika Bambaataa's "Planet Rock";

11. Start researching about Sylvester and his life. Work on a documentary project about him. Get in touch with that other guy who's making a documentary on Sylvester as well. Start collecting pictures of him on-line to make drawings of. Add them to new wallpaper and floor sticker pieces;

12. Research videos #3 (for Public Art Fund project and also LSE): "HAIR", "Paris is Burning", "Wigstock", "Breakin'"; "Ciao Manhattan", "Downtown 81", "Pie in the Sky – The Brigid Berlin Story", "Wild Style", Woody Allen's, Spike Lee's and Warhol's movies, "Jubilee", "Blank Generation". Also research Act Up! and Gran Fury. Work with Rama on PAF proposal. Develop a moving dancing homage to people who roller skate in Central Park to house music in that rink on the north east section of the Sheep Meadows. Work on a huge floor sticker piece that people could roller skate on and which would follow the rink's existing parameters. Work with Rama on a new tent structure/sculpture for the DJ. Work on something functional that could even be ultimately permanent. Invite Djs to play there on the weekends, people like Monica Lynch and Danny Wang. Research the history of that community (The Central Park Dance Skaters Association) in the last 5 years thru their on-line newsletters. Buy quads with fluo kryptonics wheels. Use the short clips I've been doing with the cheap digital camera in the proposal together with a 3D presentation of the project (Rama);

13. Buy a second-hand cheap turntable and Edirol's "audio extrator". Get pre-amp DJ mixer to connect the turntable to the sound system. Digitize Brazilian records from the 70's/80's;

14. Develop a tattoo piece for Slava's upper arm and part of his chest. Get some visual references from him. Set up a tattoo shop at the front space at deitch projects. Find a tattoo artist who would be there for the whole duration of the show making tattoos (not just A.V.A.F's but also his own and hopefully mixing them together as well). The tattoo artist should get 100% of his gains. Set up his/her drawings on the walls like in regular tattoo parlors. Try to convince Slava to be wearing just jockstraps or naked at the opening while getting part of his tattoo done. Maybe some surprise performance? Maybe he could read some of his texts too. Develop a transparent adhesive for the windows and doors panes (so the sunlight projects the colors on the gallery floor) with little peepholes so people can watch the tattoo process from the street. Make it a very light, cheerful environment;

15. Plan with Matthew to make a guerilla posting of the show's invite around some places in the city. Have a new version of it printed at Kinko's in three different colors and without the gallery info just the upside down triangle icon. Definitely post them on that wall across the street from the Drawing Center. Ask Javier which kind of paste to use for the posting;

16. Send visual and musical references to LSE. Burn a CD with Rita Lee, Baby Consuelo, Fannypack, funk do Rio, Prog Rock, hip-hop. Also make photocopies of most visual references. Go to L.A. as soon as possible and start working on collaborative project with them for peres projects. Ask LSE to develop a new song out of the musical references sent to them and make a shaped picture disc with it. Maybe also make a music video with that song. Set up a whole environment with wallpaper, floor sticker, stage, neon sign, and outdoor flag that would be a performance/rehearsal space for them at the gallery. Ask them to be there a few days a week so people could visit peres projects while they rehearse. Ask them to vary the performances, sometimes their music concert, sometimes one of their plays (like the one they performed at UCLA?). Maybe customize drums, microphones, guitar. Research acoustic. Also develop poster/invite and t-shirt. Light/laser show?;

17. Finish pages for "Oi" magazine. Have asianpunkboy take pix of me for the mag wearing that Big Bird mask. Do some porn stuff too so he can use it in his upcoming book on 100 men;

18. Find speedy driving lessons before going to L.A. (something like "get your license in 5 days");

19. Ask honeygunlabs to remix video again at the Deitch opening starting at 7pm. Give her new A.V.A.F. elements, line drawings, creatures. Maybe at 8pm have LSE start their concert. Place their instruments right on top of the floor sticker in the main gallery and have people around them during the set. Send Carlo a package on their stuff (press stuff, CD, etc) and come up with a list of other people that could help getting other gigs for LSE (Pianos? Sin-e? Tonic? Luxx? Knitting Factory?). Try to get Glass Candy's contact and suggest LSE to open for them. Get contact for Radical Fairies with Jeff/Bec and invite them for the opening at Deitch;

20. Collect Manchete magazines from the 70s mainly the special Carnival issues. Ask Carlos/Éder to get Iemanjá and Pomba Gira images so they can be incorporated on A.V.A.F.'s project for K48's Kult issue;

21. Make list of people who could get me recommendation letters for green card application

Assume Vivid Astro Focus, ASSUME VIVID ASTRO FOCUS VII, installation view, Deitch Projects, June 26 – Augets 15, 2003.

On Wed, 1 Sept 2004, Kathy Grayson wrote:

>was there a specific moment or event you can remember
>where you got the sense that something new was going on
>in your art/music/lifeworld and you wanted to
>participate? Something coalescing where you felt things
>were awesome and you wanted to be a part of it artwise
>or lifewise?/

seeing Karp; meeting kids from Michigan/Chicago that
were thinking the same thing we were and playing the
most fucked-up music possible and really just being
able to let go and play, be playful and not care and
really care with all your self. trading tapes made
out of goo and finding junk that Fine Americans would
throw away that you could use a billion more times
until it dissolved into doves; seeing the
Need; seeing Harry Pussy; 99 cent Slug Cds, Boredoms,
freezing together; seeing the Scissor Girls; seeing
that the Melvins are on a MTV giveaway CD at the
Extreme Games, breaking the CD in half and then
regretting not listening to the track b4 breaking it;
Lois coming over, K Records, Kill Rock Stars; Vermiform; Bulb;
Load; fake greyhound merit passes; Jerry dying, not
caring then caring then not caring; freezing your ass
off and then getting your cold self yelled at for not
paying the rent. getting your cold self yelled at, then
talking to your Grandma or brother or sister over LOUD
MUSIC. the Make-up the first time; being pissed that you
went to class instead of hanging out with Poo Rag
blowing up shit. Melt Banana; taking in stray cats,
kids, bats, bands, mice. cooking rice with mouse
shit- its boiled: no germs, right? holding up yr
pants with the last bit of thread you stole; stealing
everything you can; stealing the shit out of Kinkos,
steal from your school, steal from the mall; steal yr
groceries.

—JIM DRAIN

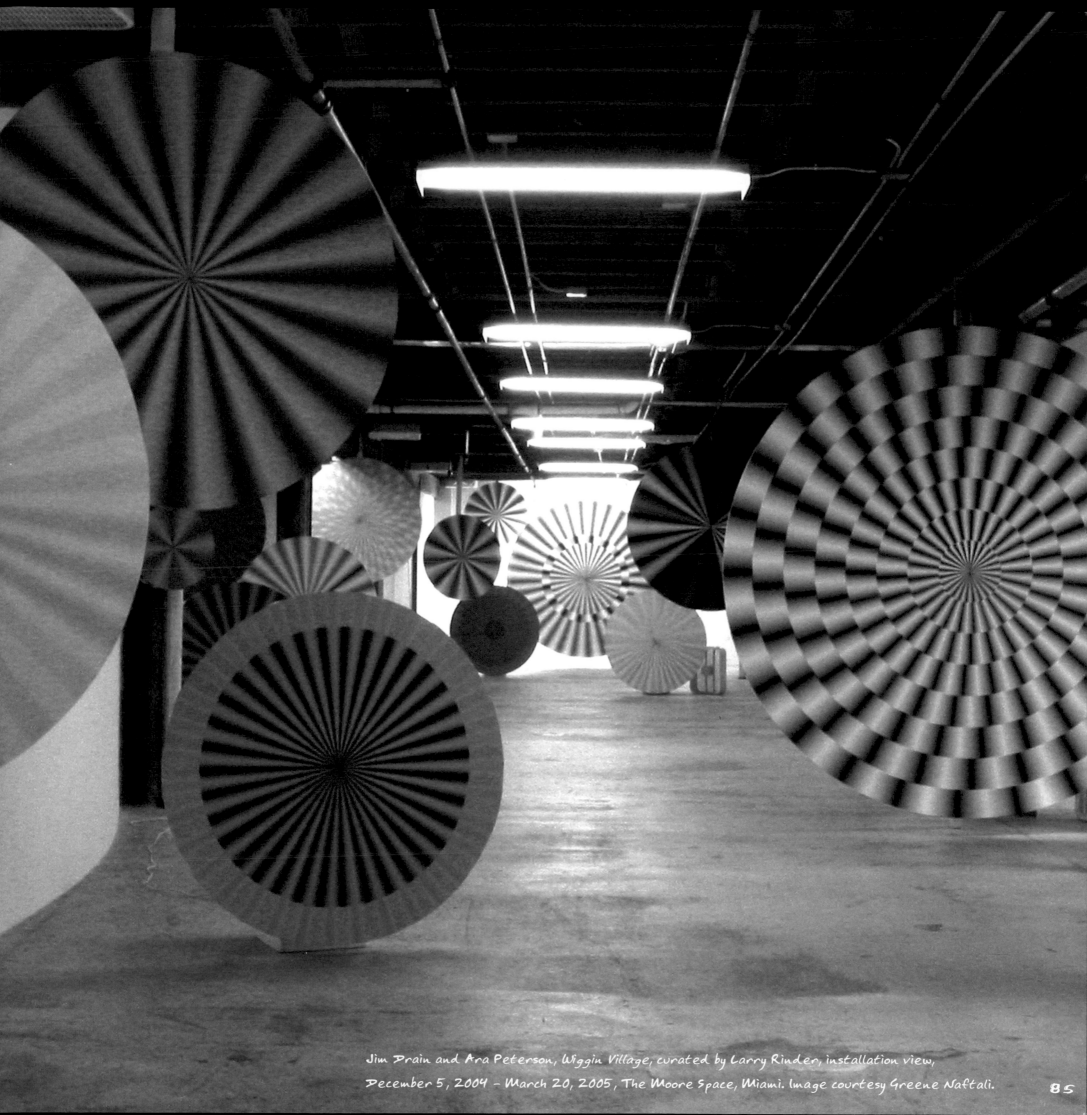

Jim Drain and Ara Peterson, Wiggin Village, curated by Larry Rinder, installation view,
December 5, 2004 – March 20, 2005, The Moore Space, Miami. Image courtesy Greene Naftali.

JIM DRAIN
AND
ARA PETERSON

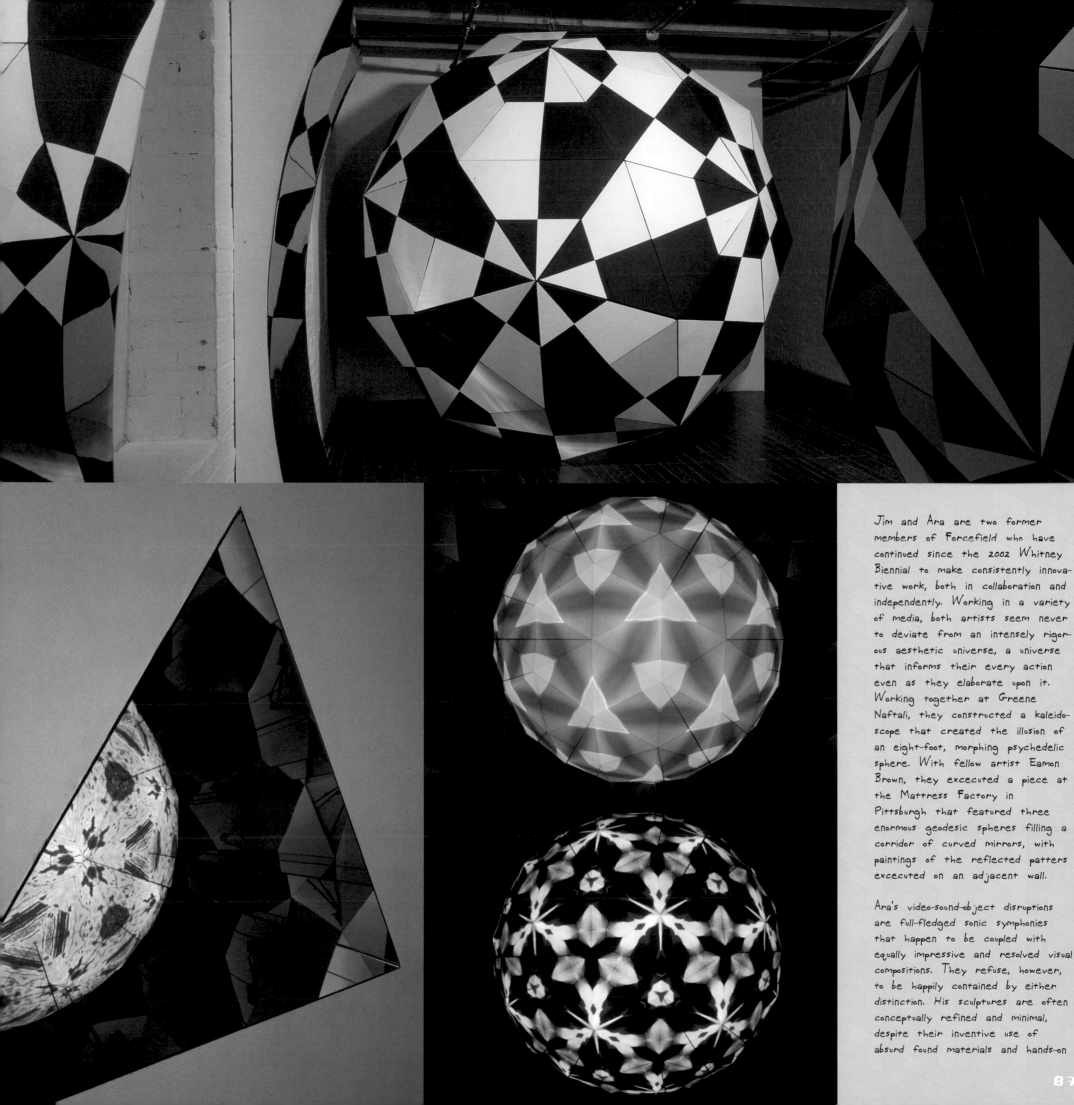

Jim and Ara are two former members of Forcefield who have continued since the 2002 Whitney Biennial to make consistently innovative work, both in collaboration and independently. Working in a variety of media, both artists seem never to deviate from an intensely rigorous aesthetic universe, a universe that informs their every action even as they elaborate upon it. Working together at Greene Naftali, they constructed a kaleidoscope that created the illusion of an eight-foot, morphing psychedelic sphere. With fellow artist Eamon Brown, they executed a piece at the Mattress Factory in Pittsburgh that featured three enormous geodesic spheres filling a corridor of curved mirrors, with paintings of the reflected patters executed on an adjacent wall.

Ara's video-sound-object disruptions are full-fledged sonic symphonies that happen to be coupled with equally impressive and resolved visual compositions. They refuse, however, to be happily contained by either distinction. His sculptures are often conceptually refined and minimal, despite their inventive use of absurd found materials and hands-on

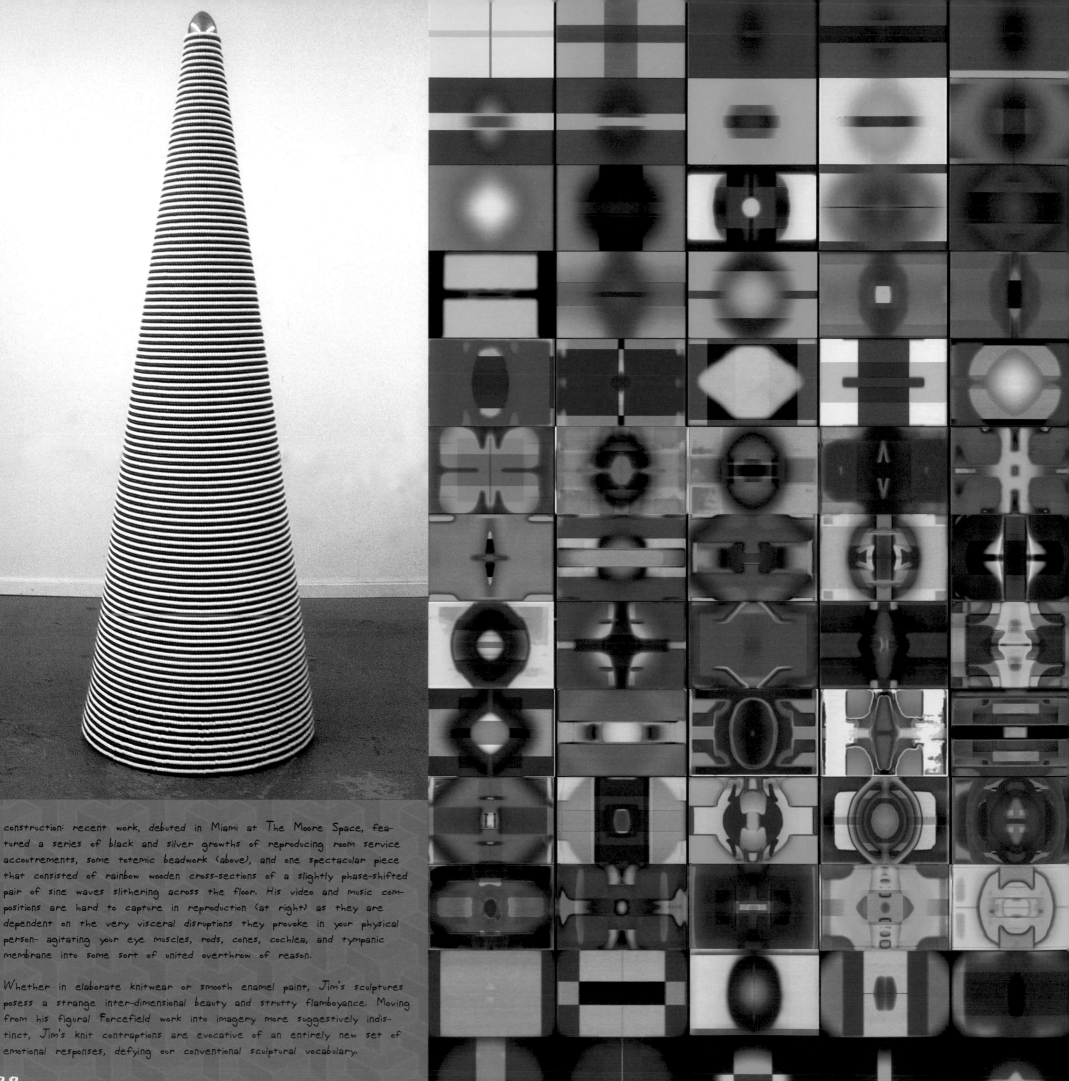

construction: recent work, debuted in Miami at The Moore Space, featured a series of black and silver growths of reproducing room service accoutrements, some totemic beadwork (above), and one spectacular piece that consisted of rainbow wooden cross-sections of a slightly phase-shifted pair of sine waves slithering across the floor. His video and music compositions are hard to capture in reproduction (at right) as they are dependent on the very visceral disruptions they provoke in your physical person— agitating your eye muscles, rods, cones, cochlea, and tympanic membrane into some sort of united overthrow of reason.

Whether in elaborate knitwear or smooth enamel paint, Jim's sculptures posess a strange inter-dimensional beauty and strutty flamboyance. Moving from his figural Forcefield work into imagery more suggestively indistinct, Jim's knit contraptions are evocative of an entirely new set of emotional responses, defying our conventional sculptural vocabulary.

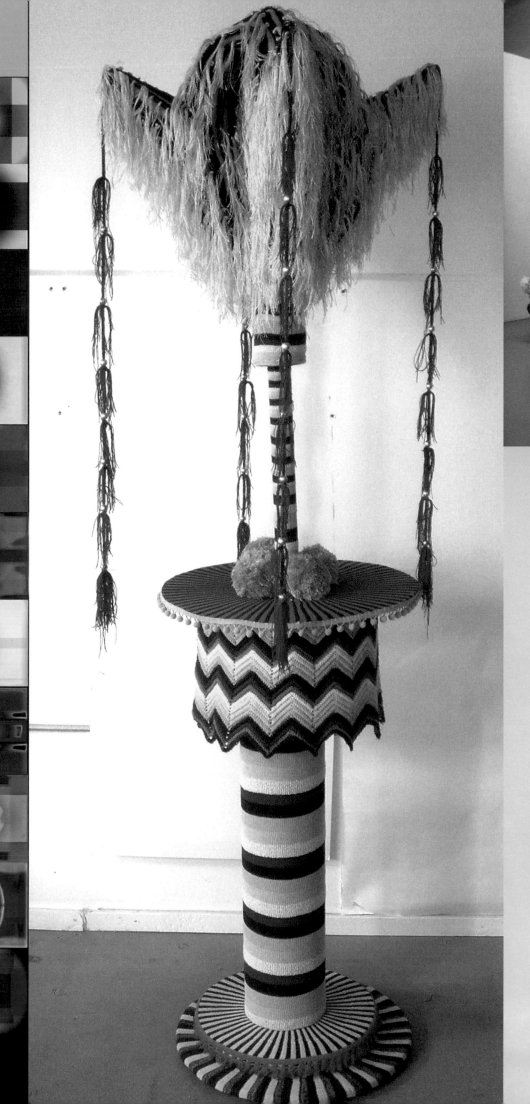

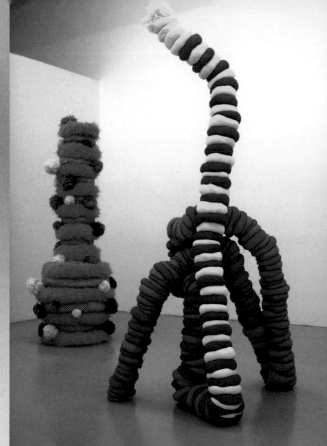

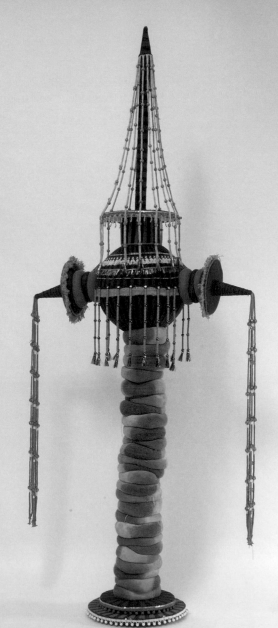

Essentially found object conglomerates decked out with hand-knit encasements, the strange bulges, quasi-familiar geometric forms, and suggestively semi-functional nature of these objects make them read like alien lounge furniture or intergalactic scratching posts— but what you're really looking at is bland modernist sculpture rammed with life and plugged into something fantastic.

Page 86: Ara Peterson, Jim Drain, and Eamon Brown, *Bizarre Love Triangle (Wind Star and Burl Ives)*, 2003. Photo: Michael Olijnyk. Installation view at the Mattress Factory. Page 87: Ara Peterson, Jim Drain, and Eamon Brown, *Bizarre Love Triangle (Burl Ives and Chubby Checker)*, 2003. Photo: Michael Olijnyk. Installation view at the Mattress Factory; Jim Drain and Ara Peterson, *Untitled (Kaleidoscope)* installation view, 2003, kaleidoscope 48 x 48 x 48 x 7", at Greene Naftali Summer, 2003, image courtesy Greene Naftali; Jim Drain and Ara Peterson, *Untitled, (Kaleidoscope)* two video stills, 2003 kaleidoscope 48 x 48 x 48 x 7", courtesy Greene Naftali. Page 88: *Steely Dan I*, mixed media, 3 x 7' aprox., 2004; stills from *UV (Strobe Sequence)*, DV, 2003. This page: *Aurora*, 2004, mixed media, 6 x 3'; *Double Dudes*, 2004, installation view from *Eldorado (1 of 5)*, Drantmann Gallery, curated by Anne Pontegnie, Brussels, Belgium; *Your Highness*, mixed media, 6 x 4' aprox. image courtesy Peres Projects.

HISHAM
Bharocha

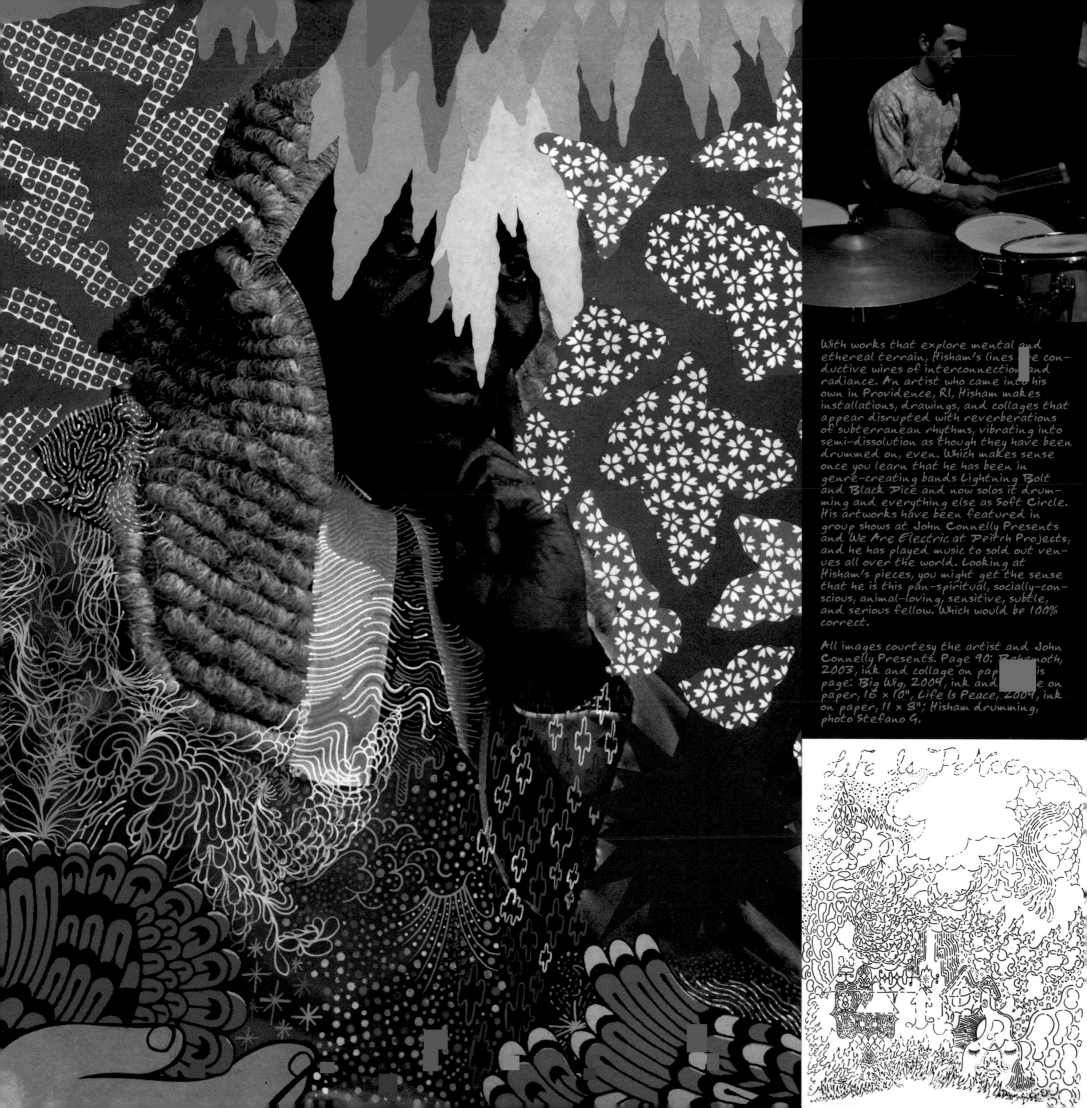

With works that explore mental and ethereal terrain, Hisham's lines the conductive wires of interconnection and radiance. An artist who came into his own in Providence, RI, Hisham makes installations, drawings, and collages that appear disrupted with reverberations of subterranean rhythms, vibrating into semi-dissolution as though they have been drummed on, even. Which makes sense once you learn that he has been in genre-creating bands Lightning Bolt and Black Dice and now solos it drumming and everything else as Soft Circle. His artworks have been featured in group shows at John Connelly Presents and We Are Electric at Deitch Projects, and he has played music to sold out venues all over the world. Looking at Hisham's pieces, you might get the sense that he is this pan-spiritual, socially-conscious, animal-loving, sensitive, subtle, and serious fellow. Which would be 100% correct.

All images courtesy the artist and John Connelly Presents. Page 90: Behemoth, 2003, ink and collage on pap__ __is page: Big Wig, 2009, ink and ____e on paper, 16 x 10", Life Is Peace, 2009, ink on paper, 11 x 8"; Hisham drumming, photo Stefano G.

DEVENDRA BANHART

Devendra is known primarily as a musician whose albums "Oh Me Oh My...", "Rejoicing in the Hands", and "Nino Rojo"— all released in fairly quick succession— earned him rapid notoriety beyond the underground level. With a quivering theramin of a voice and an acoustic guitar, Devendra has managed to move a whole diverse community of people who thought they were too cynical to ever like folk music. In performances known for their wit, generosity, and breadth of emotion, Devendra sings songs that combine fantasy, surrealism, and sobre todo, sincerity. He describes what he does as music made for friends and family, and his 2002 debut "Oh Me Oh My..." was filled with lots of music bits he had left on friends' answering machines as he traveled all over the place.

By his own admission, his songs inspire drawings and his drawings, songs; and anyone perusing his new album might be just as struck by the beautiful illustrations and hand-drawn fonts as by the music it contains. Just like his music, his drawings are unplaceably vintage-feeling, featuring a beautiful painted line in deep reds and blacks covering old book covers and yellowing paper. Circles of teeth, hands, beards, and animals congregate with rhythmic elegance into hybrid forms outlined in positive and negative space. Super sincere, like his music, but with a big dollop of clowning around, his art projects have also included a six-foot painting in the front window of White Box called "Grandpa Curtis Mayfield Releases the Knowledge Through His Vessels of Wisdom" which would only be sold for 1,000,000 flowers. He's been included in group shows at Daniel Reich and Canada and most recently, a solo exhibition uptown at Roth Horowitz.

All images courtesy the artist and Canada Gallery. Page 92: Mother Owl, 2004, ink on paper, 18 × 12". This page: photo credit Alissa Anderson, 2003; Bob Marley, 2004, ink on paper, 4 × 6"; Rejoicing in the Hands cover art, courtesy Young God Records; Untitled (Bird), 2003, ink on paper 4 × 6".

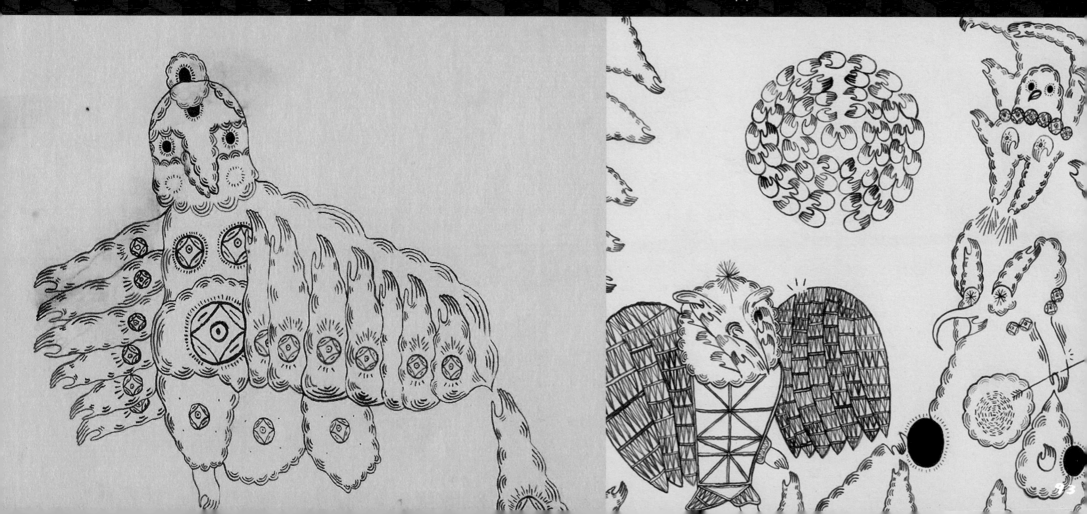

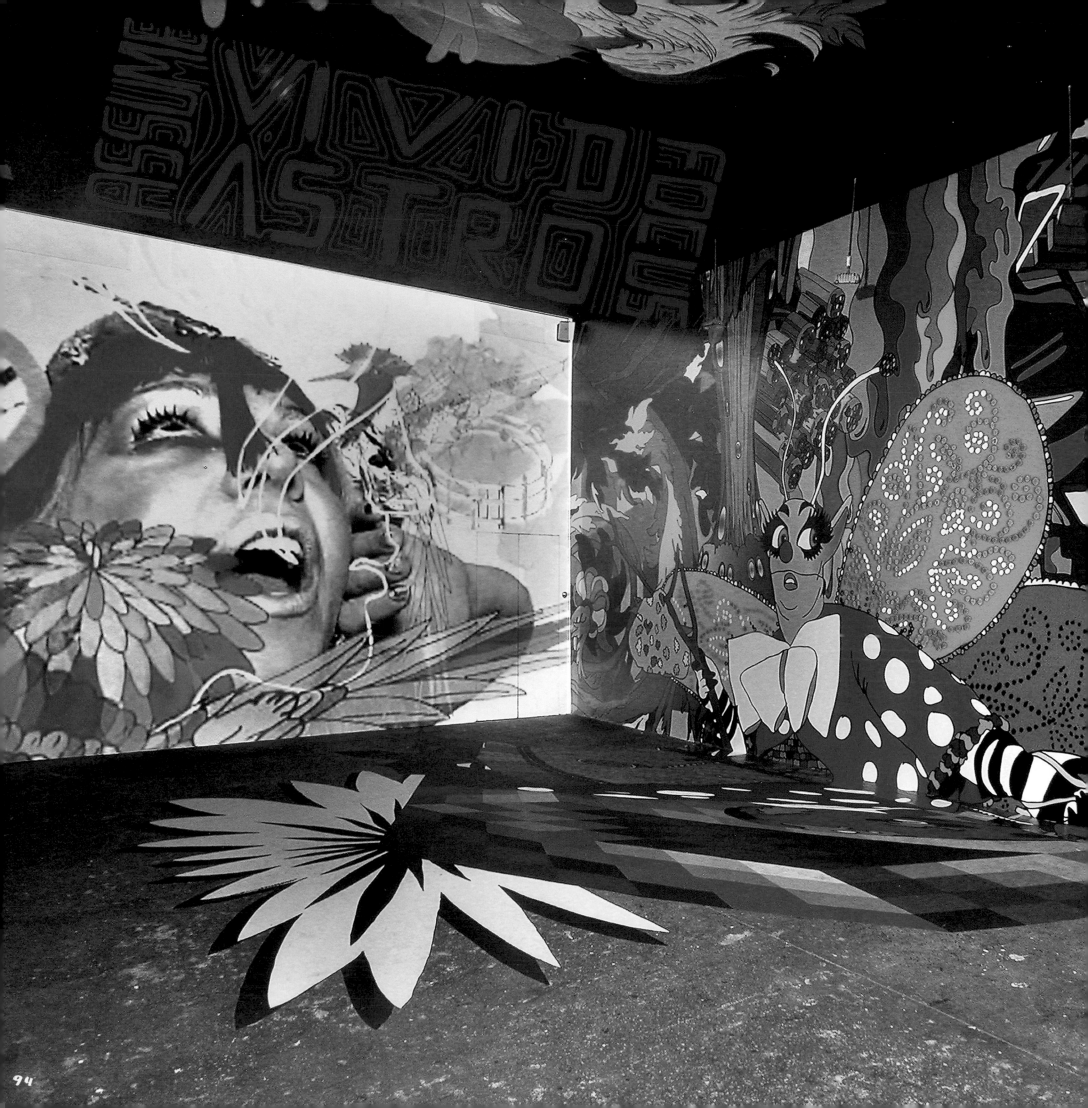

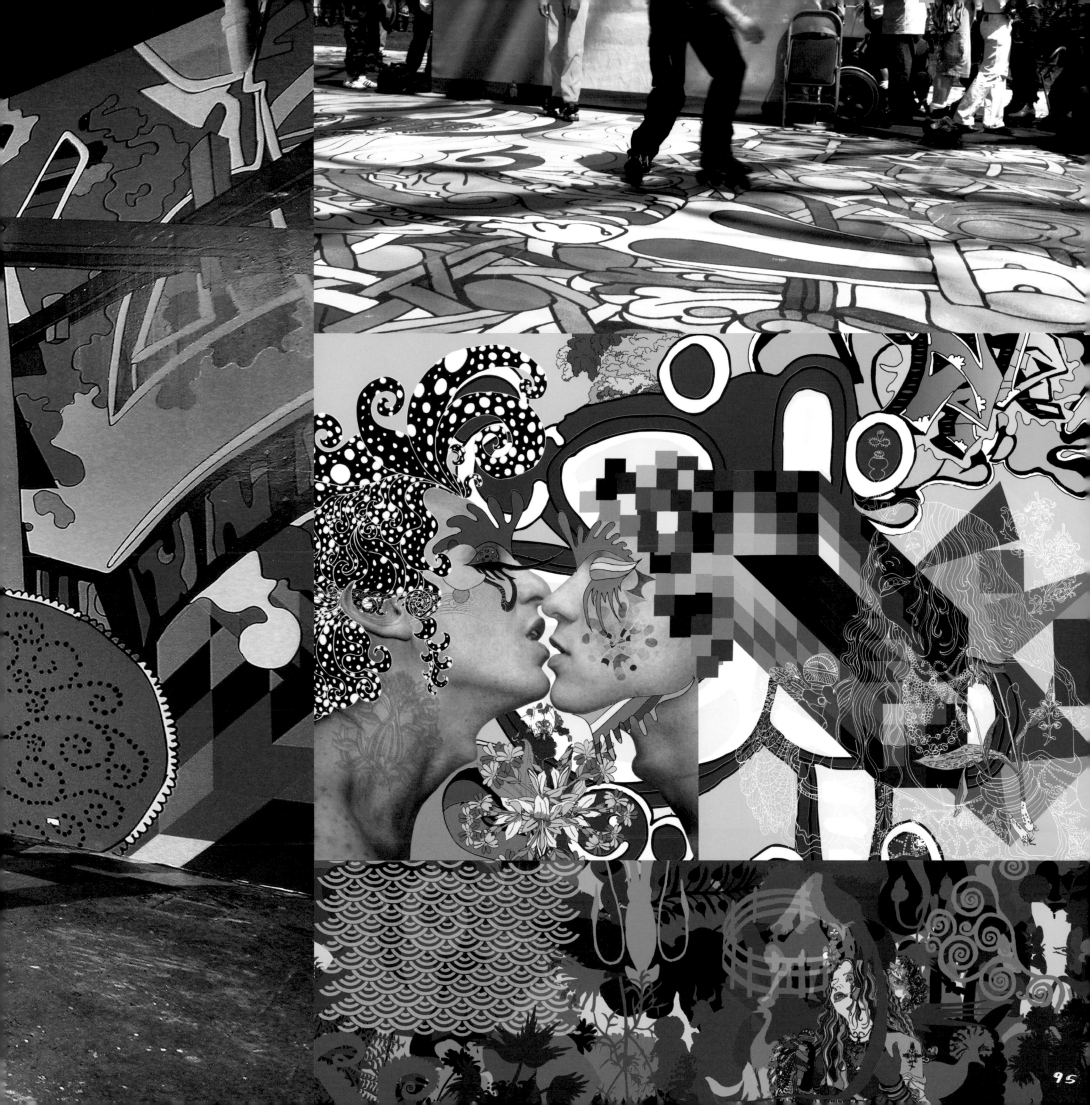

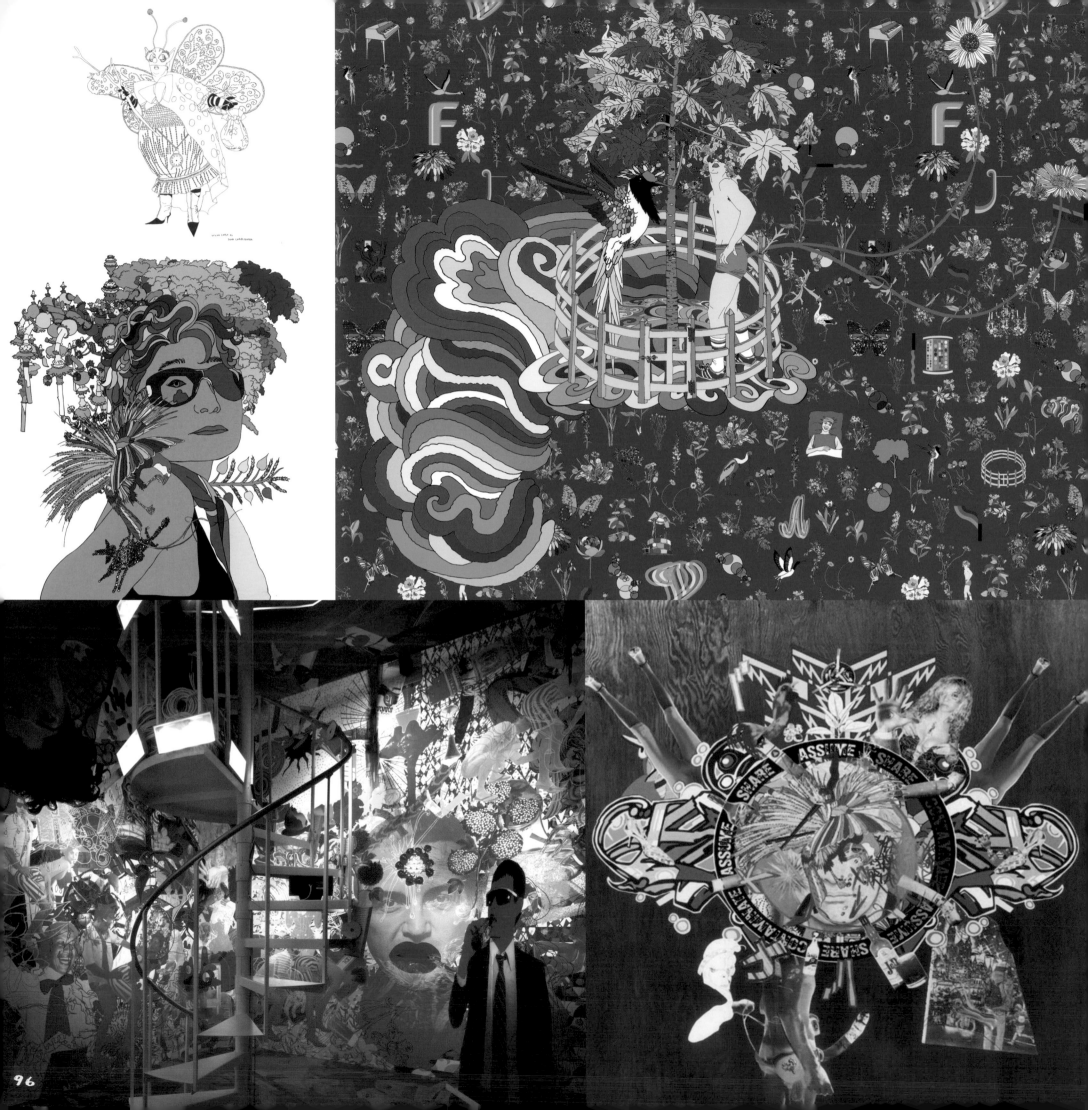

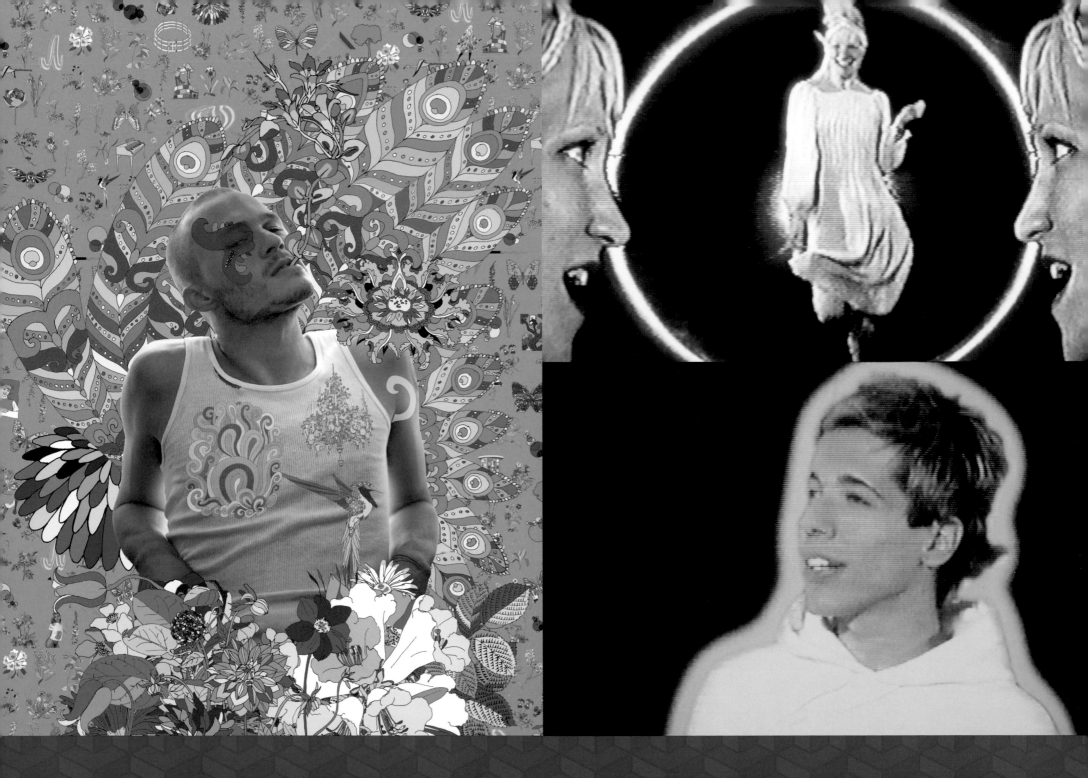

One of the most talked-about artistic forces to have emerged during the past several years, A.V.A.F. is a unique movement with an expansive vision of total sensory input. Pursuing a way to create a visual record of everything that is a part of someone's life and everything that's added to that person's life every day, A.V.A.F. masterfully remixes all strata of these experiences as they collide and mutate, making art that never exists as an original but rather is a continuum of copies and hybrids. Moving through networks of collaboration, A.V.A.F. has executed major projects for the 2004 Whitney Biennial, the Public Art Fund, Deitch Projects, Peres Projects in Los Angeles, and in Rosa de la Cruz's residence during Art Basel Miami 2004.

Sampling tapestry design and softcore porn, coloring books and Tibetan thangka paintings, Pink Floyd and Picabia, A.V.A.F. spins vibrant and outrageous patterns from a very personal simulacrum of images. Part Brazilian Carnival, part Aubrey Beardsley, A.V.A.F.'s own brand of psychedelia washes over one's senses, feeling both familiar and daringly new. It's definitely not sixties nos-

talgia: A.V.A.F. literalizes the thanatos behind that eros by blending both art historical and pop circulation in a way that could best be described as tuning in and nerding out.

All images courtesy Peres Projects, Los Angeles, and John Connelly Presents, NYC. Page 94: installation view of ASSUME VIVID ASTRO FOCUS VII, June, 2003 at Deitch Projects, photo Tom Powel Imaging. Page 95: Public Art Fund installation, the Rollerskating Rink, Central Park, 2004, image courtesy The Public Art Fund; edcr+gerard.JPG, 2003 Hi-Fi print; Garden 4, 2002, wallpaper. Page 96 clockwise from top left: Wilza Carla as Dona Carochinha, 2003, ink on acetate, 12 x 9"; y.o.JPG, 2002, decal; garden.JPG, 2002, wallpaper dimensions vary with installation; untitled, 2004, sticker from Majority Whip, May 2004, White Box; Garden 8, 2004 Whitney Biennial of American Art, installation view. This page: heath.JPG, 2002 (cover for Flaunt magazine, November, 2002) Hi-Fi print; stills from JCP_video_alvinrow.JPG, 2001, videotape, 13 minutes and 5 seconds.

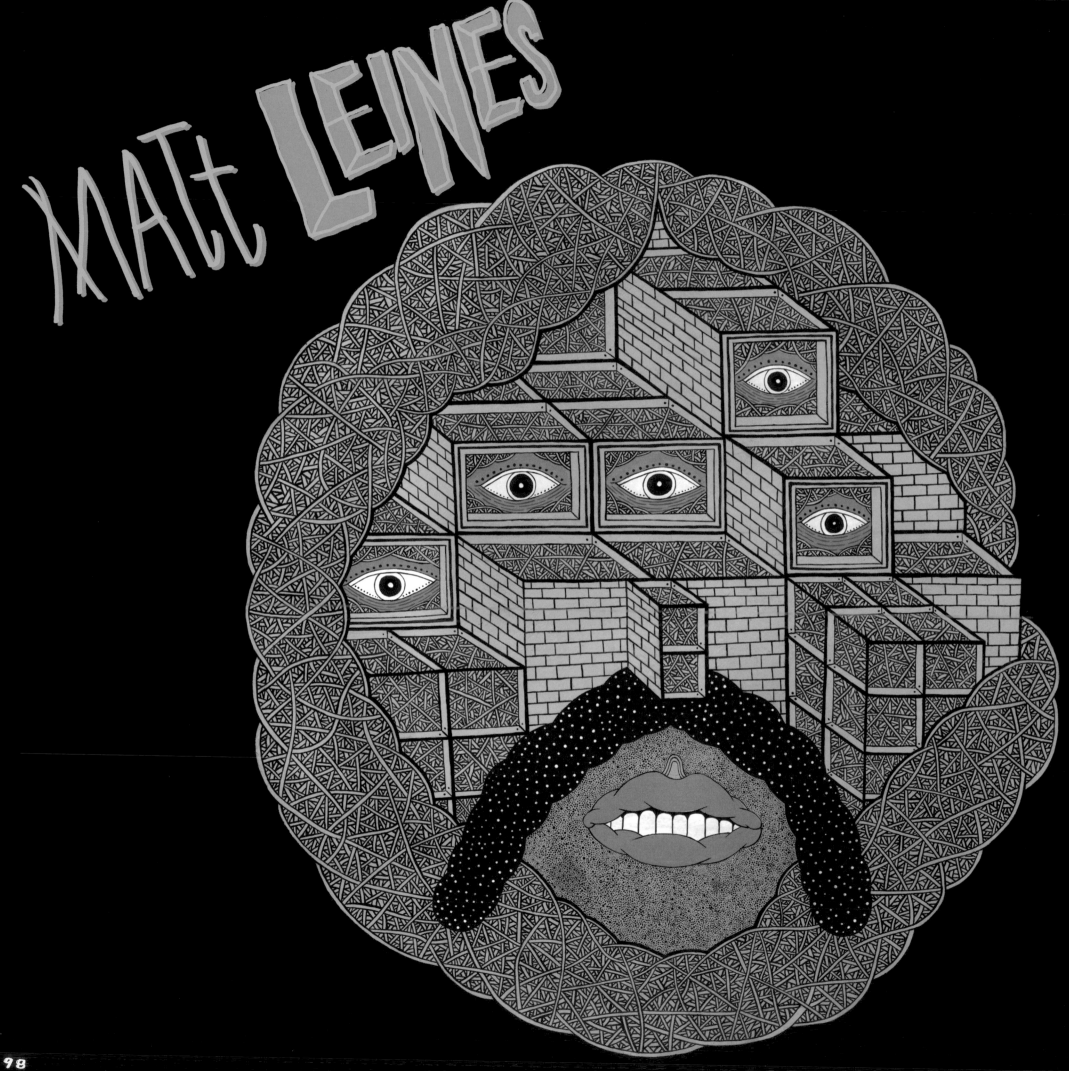

MATT LEINES

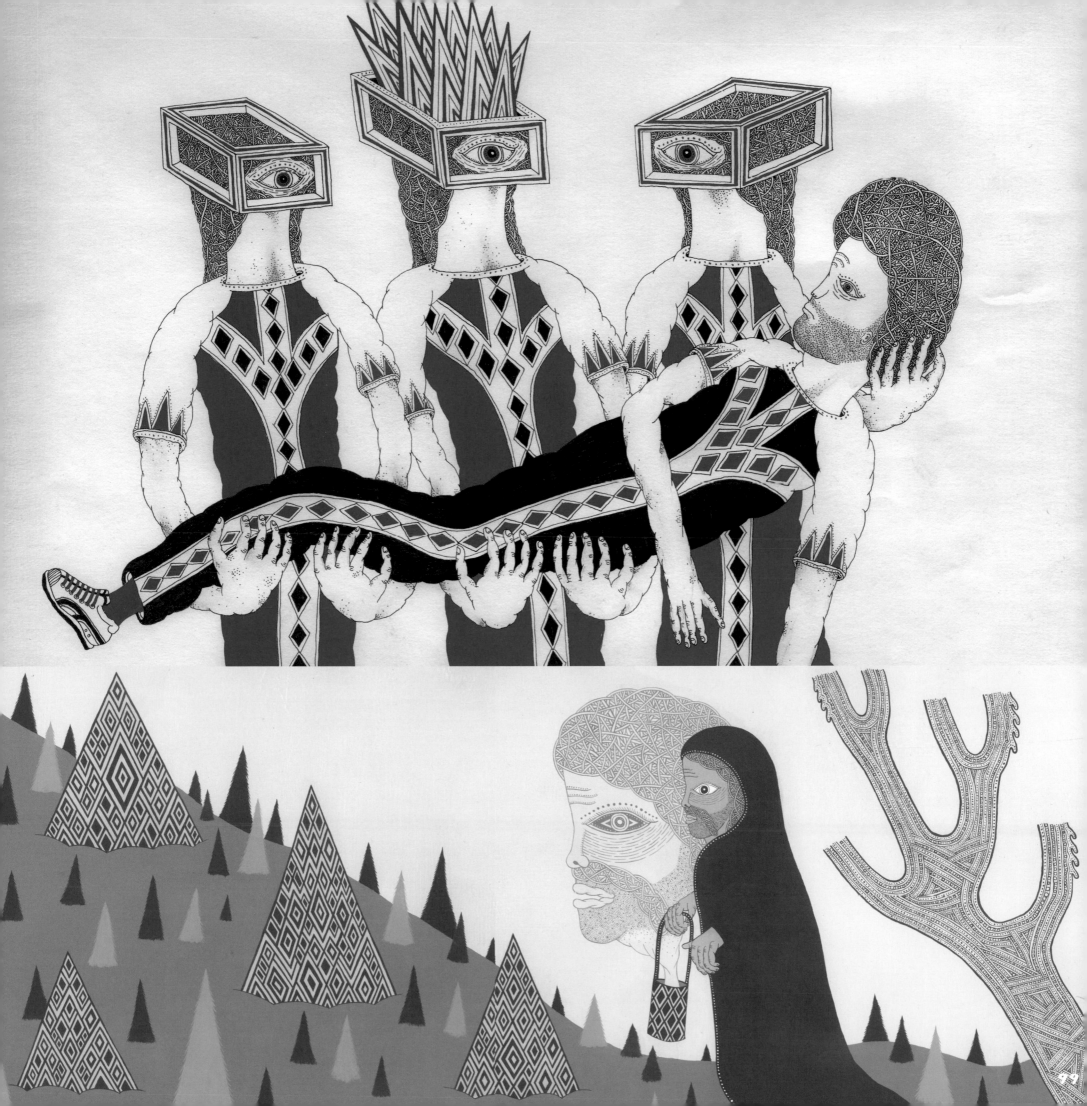

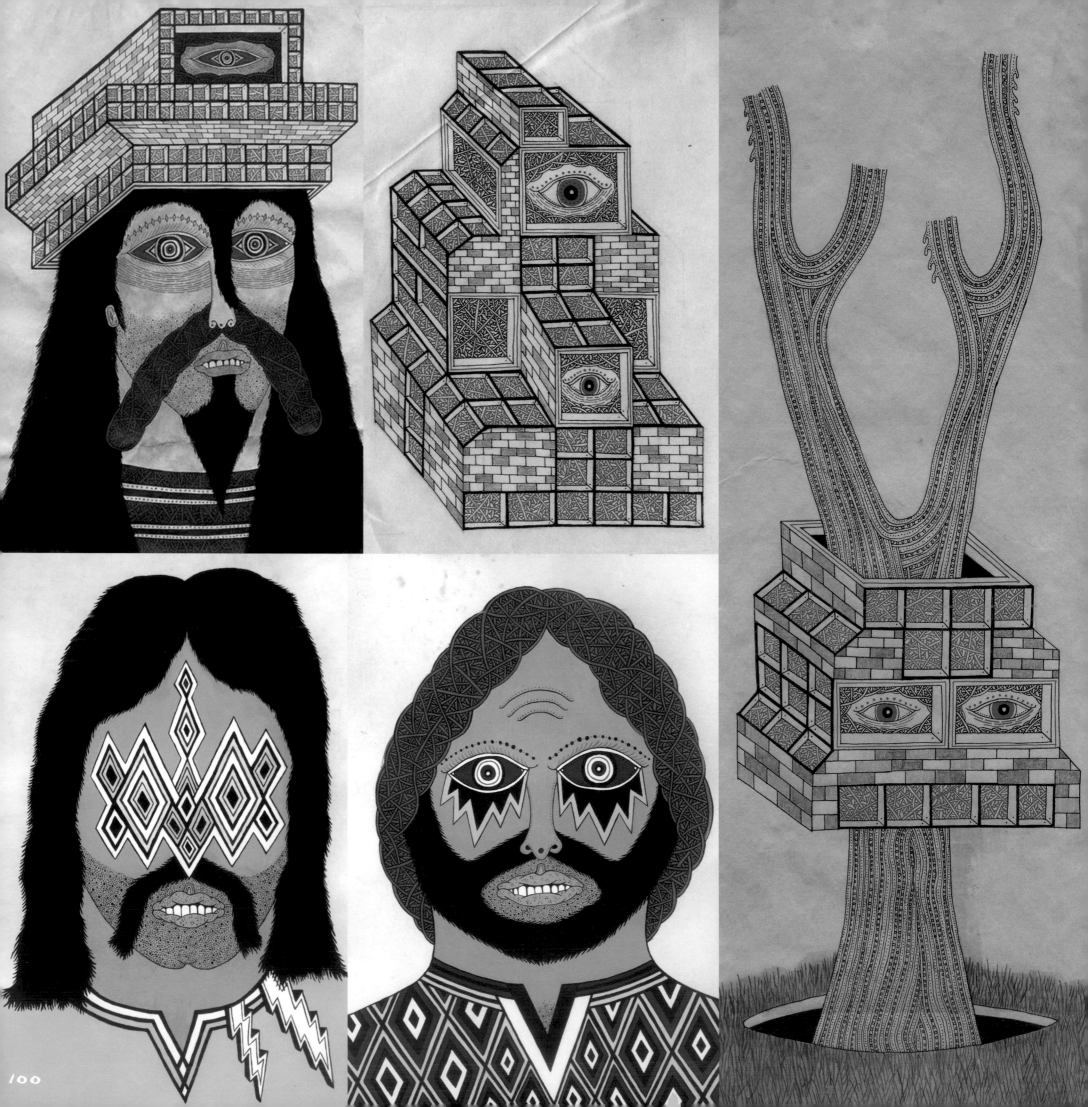

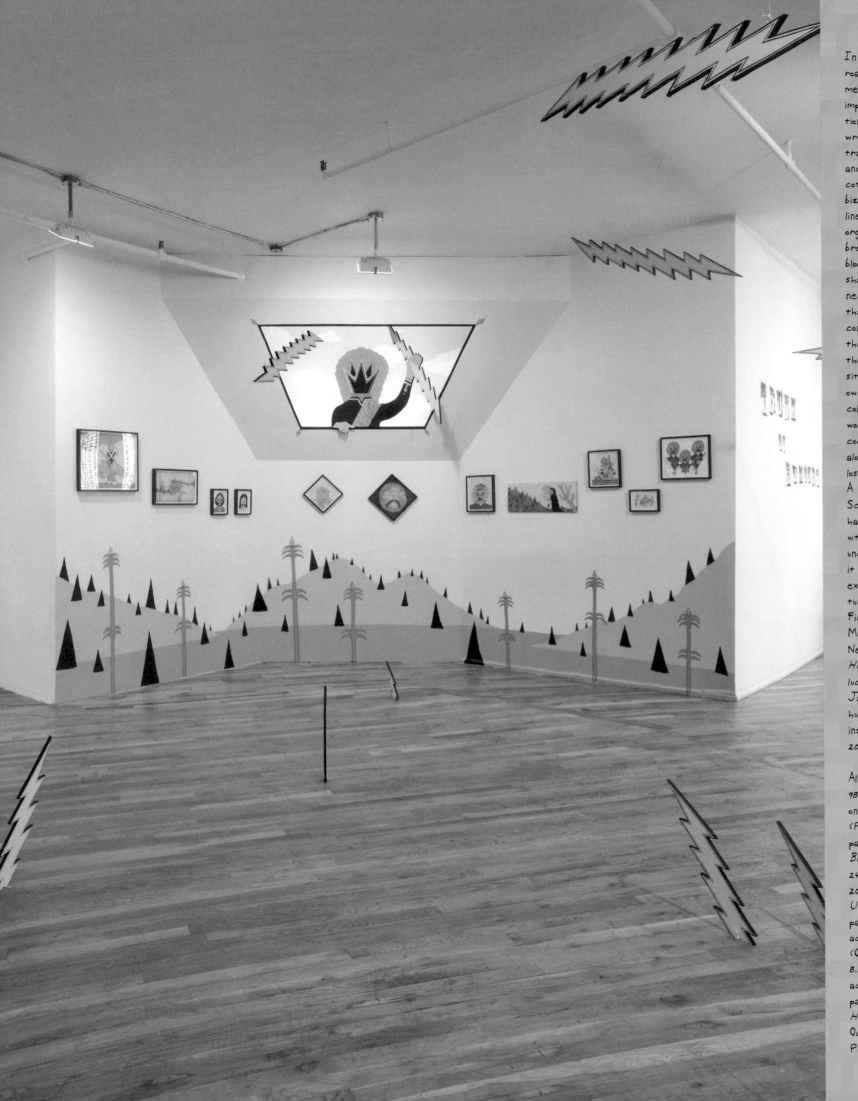

In Matt Leines' work, strange hybrids roam landscapes of intense pattern, meeting in charged confrontations that imply narratives of power and manipulation. Tigers, houses, anteaters, pro-wrestler looking dudes, analog-ish contraptions, Transylvanian count fellows, and land mollusks are amongst the coterie of characters inhabiting Matt's bizarre graphic world. Fine, painted lines spin into quasi-Norse thickets and organic architectural objects with breathtaking precision. Hair, wires, blood, tears and natural objects all share a pulsating circuitry of interconnection, animating an alternative reality that is full of humor and insights into contemporary experience: reconstructing the world of Matt's creatures from the artifacts he leaves us, we infer situations that enlarge and critique our own social world. Working with limited colors and recurring characters, his work reads like an extended cultural codex from a different dimension, cataloguing epic conflicts, flora, fauna, and lost civilizations as they rise and fall. A graduate of The Rhode Island School of Design in illustration, Matt has taken his intricate style (along wtih some influence of Providence underground comic culture) and applied it to larger paintings and sculpture to exciting ends. His work has been featured in *Dirt Wizards* at Brooklyn Fire Proof, *Drone* at Vilma Gold, *KGB Magazine*, John Connelly Presents, New Image Art in LA, and *Trunk of Humours* at Deitch Projects. And some lucky people braved the wicked January temperatures to catch the huge six-foot behemoth painting Matt installed at The Wrong Gallery in 2004.

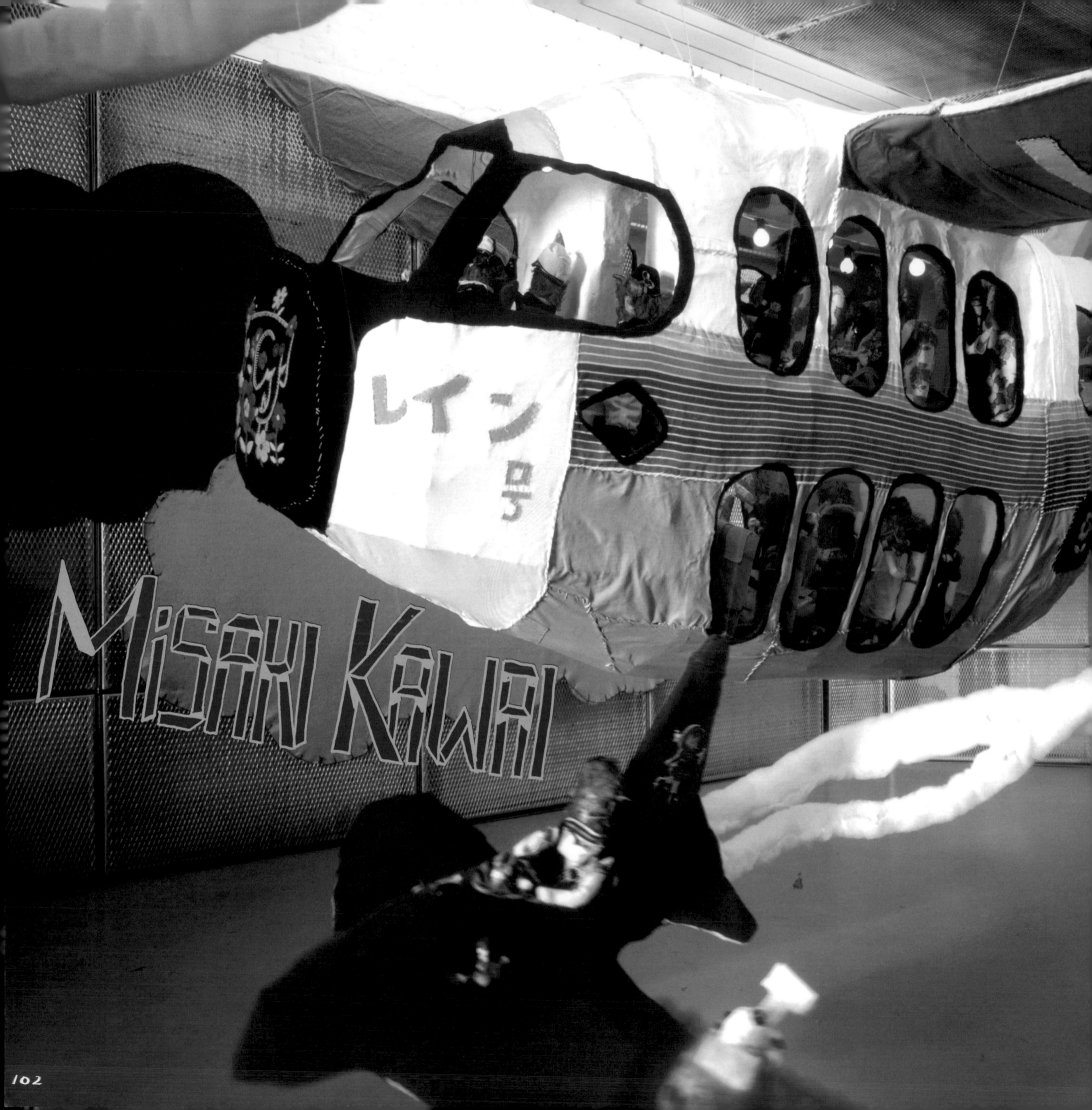

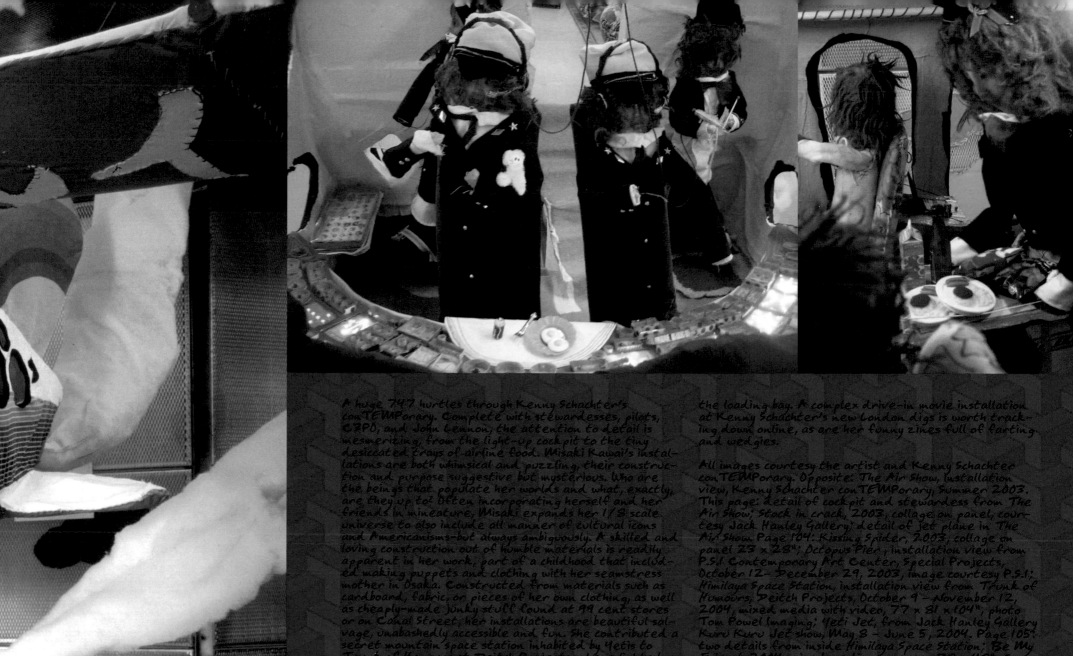

A huge 747 hurtles through Kenny Schachter's conTEMPorary. Complete with stewardesses, pilots, C3PO, and John Lennon, the attention to detail is mesmerizing, from the light-up cockpit to the tiny desiccated trays of airline food. Misaki Kawai's installations are both whimsical and puzzling, their construction and purpose suggestive but mysterious. Who are the beings that populate her worlds and what, exactly, are they up to? Often incorporating herself and her friends in miniature, Misaki expands her 1/8 scale universe to also include all manner of cultural icons and Americanisms-but always ambiguously. A skilled and loving construction out of humble materials is readily apparent in her work, part of a childhood that included making puppets and clothing with her seamstress mother in Osaka. Constructed from materials such as cardboard, fabric, or pieces of her own clothing, as well as cheaply-made junky stuff found at 99 cent stores or on Canal Street, her installations are beautiful salvage, unabashedly accessible and fun. She contributed a secret mountain space station inhabited by Yetis to Trunk of Humours at Deitch Projects, where lighted control panels, a miniature zine rack, three different videos, and a strikingly accurate replica of Brian Belott populated the inside for anyone peering into

the loading bay. A complex drive-in movie installation at Kenny Schachter's new London digs is worth tracking down online, as are her funny zines full of farting and wedgies.

All images courtesy the artist and Kenny Schachter conTEMPorary. Opposite: The Air Show, installation view, Kenny Schachter conTEMPorary, Summer 2003. This page: detail of cockpit and stewardess from The Air Show; Stock in crack, 2003, collage on panel, courtesy Jack Hanley Gallery; detail of jet plane in The Air Show. Page 104: Kissing Spider, 2003, collage on panel 23 x 28"; Octopus Pier, installation view from P.S.1 Contemporary Art Center, Special Projects, October 12 - December 29, 2003, image courtesy P.S.1; Himilaya Space Station, installation view from Trunk of Humours, Deitch Projects, October 9 - November 12, 2004, mixed media with video, 77 x 81 x 104", photo Tom Powel Imaging; Yeti Jet, from Jack Hanley Gallery Kuru Kuru Jet show, May 8 - June 5, 2004. Page 105: two details from inside Himilaya Space Station; Be My Friend, 2004, mixed media on canvas, 38 x 48". Space Jet Team, installation view from Trunk of Humours; Himilaya Space Station control panel detail.

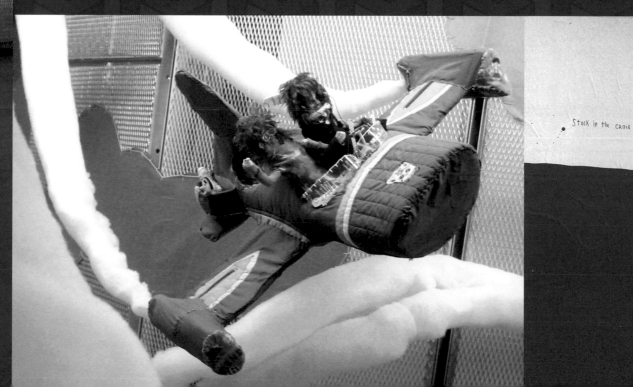

Stock in the crack

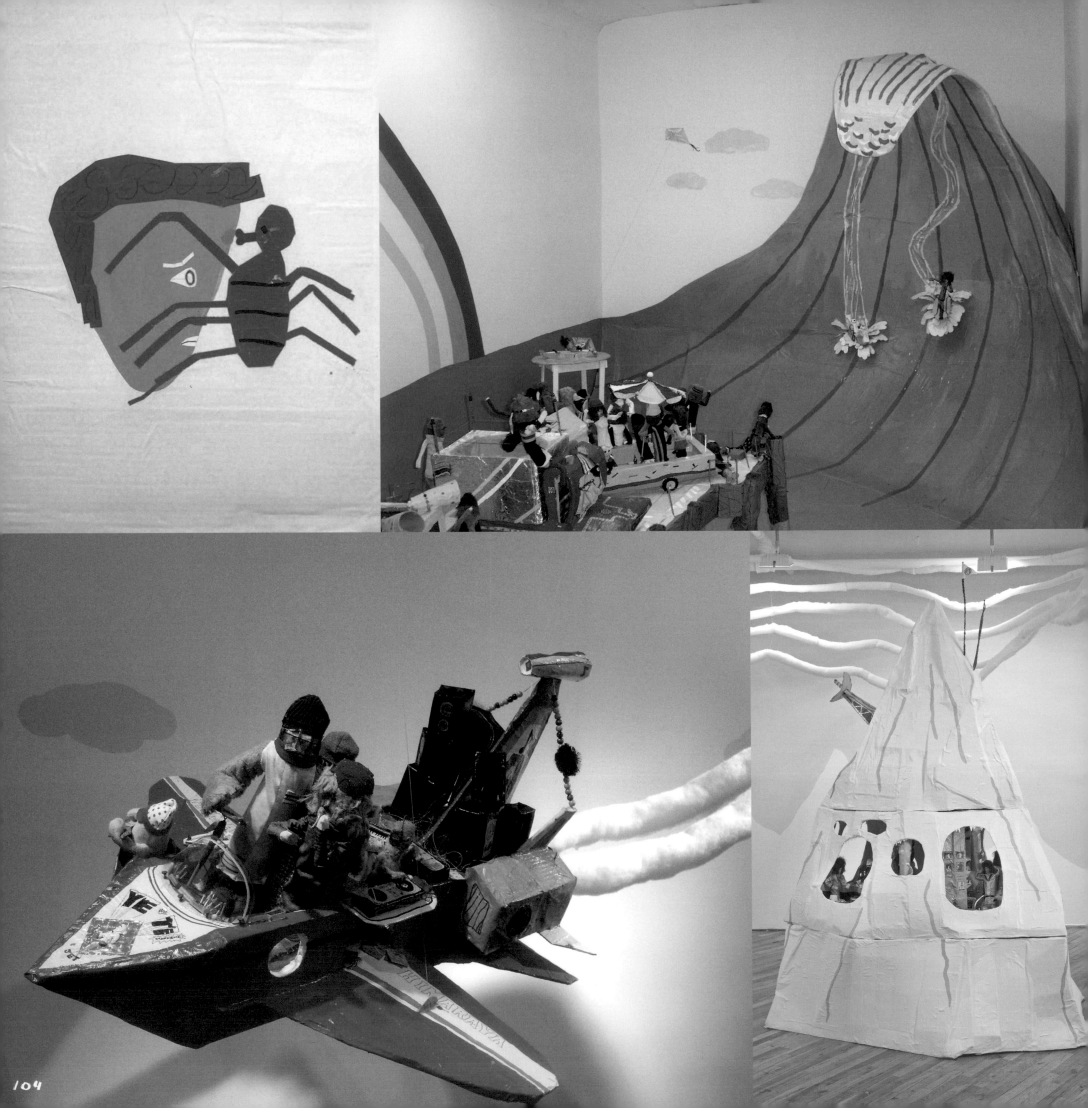

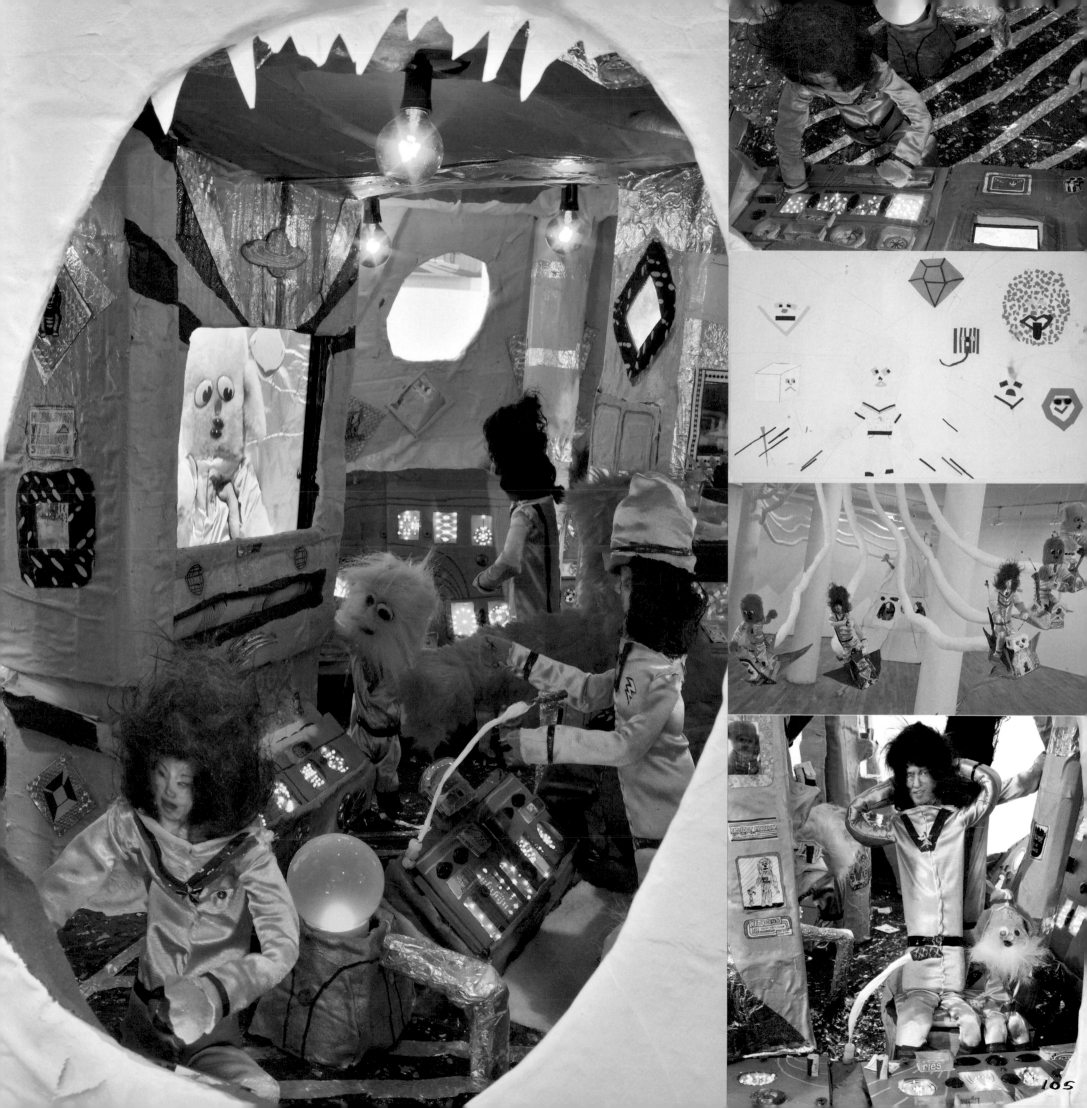

JUSTIN SAMSON

Justin Samson deals in personalized artifacts, creating installations that are not sentimental or narrative per se, but rather ones that explore an eclectic range of cultural references, focusing on the convergence of personal memory and social history. Justin's work describes a mind not only well-versed in an early-80's childhood vernacular, but also strongly influenced by recent excitement coming from Providence, RI. Color and pattern are manipulated with craft and wit, creating ever-reinvented process-oriented installations that recall dens and playrooms from suburban homes. Taking hippie kitsch junk such as macramé, beaded curtains, or psychedelic fabrics, Justin uses the openness and generosity of a child's relationship to objects to test the expressive potential of these nostalgic materials. Crafting a subtly suggestive and unquestionably adult mélange, he is often able to strip this cultural debris of the sentimentality that our present cultural position slathers on it.

Justin debuted his art in *Dirt Wizards*, a group show curated by Kathy Grayson at Brooklyn Fire Proof with Chris Johanson, Phil Frost, Xylor Jane, Maya Hayuk, Matt Leines, and Keegan McHargue. Since then, he has been included in group exhibitions at John Connelly Presents, Peres Projects, Daniel Reich Gallery, Deitch Projects, and Metro Pictures.

All images courtesy John Connelly Presents. Page 106: *Somnambuloid*, 2004, mixed media, installation view Liste Young Art Fair 2004, Basel. This page: *Lords of the North*, 2004, installation view from *Incantations*, July 2004, Metro Pictures, mixed media, 88 x 88 x 144"; four zine covers, 2003-2004; *Untitled*, 2003, mixed media with collage and incense on board, 74 x 26 x 19", image courtesy Peres Projects; installation view from *Dirt Wizards*, group show curated by Kathy Grayson, Brooklyn Fire Proof, July 12 - August 18, 2003; *Obelisk*, 2004, yarn and mixed media, 3 x 3 x 6', installation view from *Majority Whip*, White Box, NYC, curated by Kathy Grayson and Laura Tepper, May 1 - 29, 2004, photo Tom Powel Imaging.

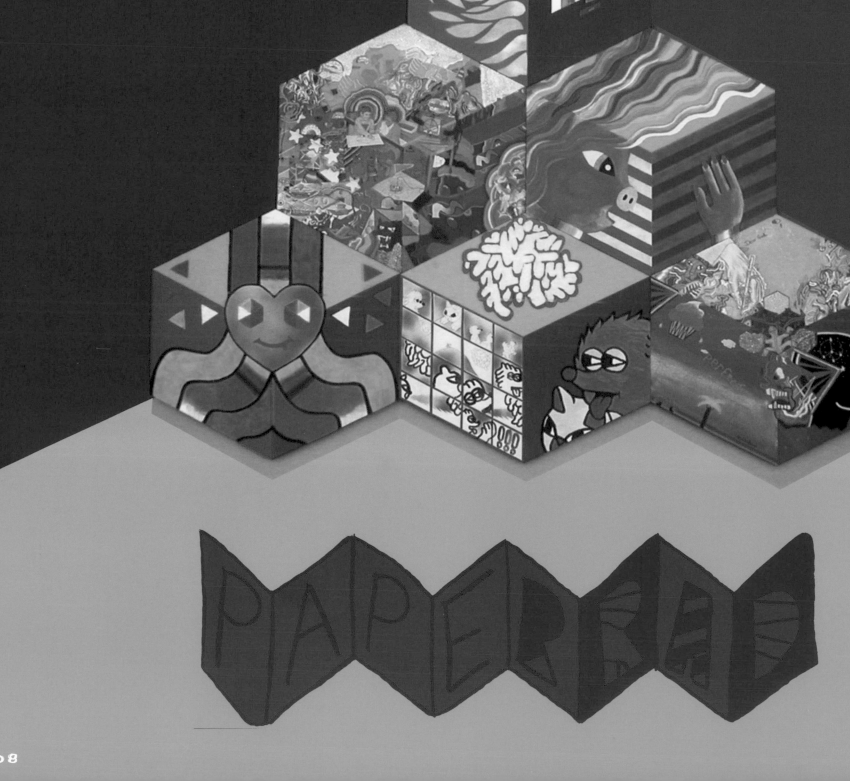

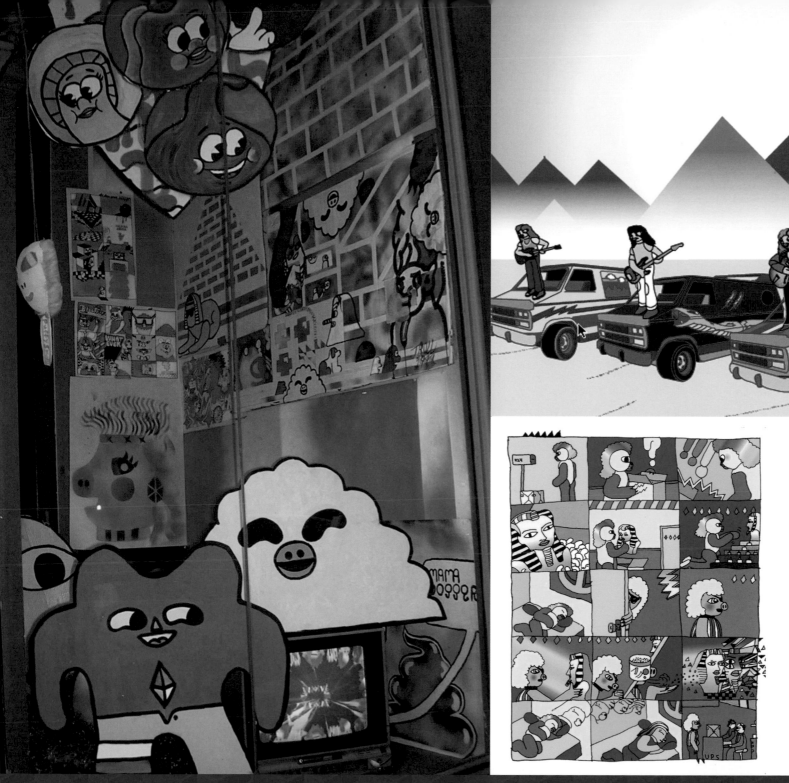

Paper Rad is an art crew composed of Jacob Ciocci, Jessica Ciocci, and Ben Jones. Making paintings, performance, animations, music, comics, web sites, sculpture, clothes, dolls, photos, and video, plus going on tours with it all, Paper Rad is more a thicket of activity than a gallery art thing-- although they do put together amazing shows like 3-D at Foxy Productions (Summer 2004). They've collaborated with Cory Arcangel (BEIGE), Paper Rodeo, Forcefield, Barry McGee, Clare Rojas, Andrew Jeffrey Wright, and many others, and might have been spotted under the monikers Doctor Doo or Extreme Animals on The Summer of HTML Tour with Cory or Totem Tour with Kites, Neon Hunk, and Barkley's Barnyard Critters.

The group is perhaps best known for its amazing comics: some of them just like scanned sharpie doodles with shitty computer coloring or effects, some with oh-so-cheesy rainbow gradients everywhere, trolls, gay nerds, dogz, Popples, Tux Dog, Garfield-- and the dialogue all in this early AOL chat room slang or something-- whatEVA. The group also performs this no-rules-type morphing repertoire of weird, making music with instruments and computers, performing in front of bad iMovie effected pre-made videos, each

different performance having a bizarre internal logic or concept-- and outfit. Their videos range from amazing to amazinger-- one called Gum-B definitely rules, and this video comic Troll Patrol in Foxy was six channels of rad. You can see them on their website and in fact, visiting the site might help explain everything: paperrad.org, which Cory once described as: "a mess of a site: there are one million different colors, table art, animated background gifs, garbage color blue links, and pictures floating around in places only poorly-coded HTML would know about. It is all at once a combination of Rammellzee, jodi.org, form art, Fort Thunder, pure go4it Geocities homepages, and pyramids. Like as if the 1990s, extreme sports, and My Little Pony finally decided to have a party for peace."

All images courtesy the artists and Foxy Production. Page 108: 3D, 2004, acrylic and collage on hexagonal panels, 58 x 72". This page: installation in Pittsburgh store front; still from Bubble Puppy video, 2004; Untitled, 2004, acrylic and spraypaint on paper; excerpt from never-ending comic- paperrad.org.

PHILLIP AVENUE D GRANT WORTH

The name "Phillip" was born in the fall of 2000 at the suggestion of Momus (Nick Currie) so that Philip Guichard might stand out better on Google. He released his first album Per Cancer in October 2001 on Momus' new label American Patchwork, and it rapidly became an underground hit with the debut single "(Inside the) Sleep Pavilion". For his new album, Divided By Lightning, Phillip did much more than just release music; activating his expanded community of artists, friends, fans, and fellow musicians, he released himself in elaborated form. Rather than letting a publicity machine sculpt him in accordance with the strict dictates of the pre-fab pop market, Phillip gently entrusted himself to the masterfully-crafty hands of over fifty friends and admirers at Deitch Projects Brooklyn space this winter. Playing everywhere to be played across New York, including scores of Manhattan clubs and a virtual residency at Williamsburg's notorious Luxx, he has thrown down and rolled over the stages of Dior Homme parties in Paris, punk squats in Germany, New York art galleries, Salt Lake City youth centers, and all three Electroclash festivals.

Debbie D. and Daphne D. together form the volatile, hilarious ghetto booty group Avenue D that totally have this awesome presence— and not just because they're wearing only duct tape. Their strange hybrid vibe, part 2 Live Crew and Cyndi Lauper, part Debbie Deb and CRASS, succeeds at being both wildly provocative and aggressive— which is to say it fully brings out the drunk slut in everyone. The music videos Grant Worth makes for both Phillip and Avenue D— plus his polaroids, great web design, and epic parties— put this all together in a way that makes these roommates and collaborators an exciting hive of collaborative creativity. One of their group creations is Panty Party, this awesome controlled chaos they threw at Opaline last summer and took this March to Miami. The always-decked-out, thematic debauchery gets everyone in their underwear in a way that isn't creepy— a feat in itself. Phillip is djing, a room full of people is going bananas, and absolutely everyone of every size, shape, and affiliation is welcomed with open arms (and legs).

All images courtesy the artists. Above: still from Summer Collection video by Grant Worth featuring Phillip. Below: polaroids by Grant Worth. Page 111: Panty Party invitation by Magicland; still from Avenue D, The Punk Rock Song, video Grant Worth, 2003; Avenue D performance, photo Grnat Worth; Debbie Attias collage; Phillip Wiith Explodiing Piils, design by Michael Magnan, 2004.

Ryan McGinley

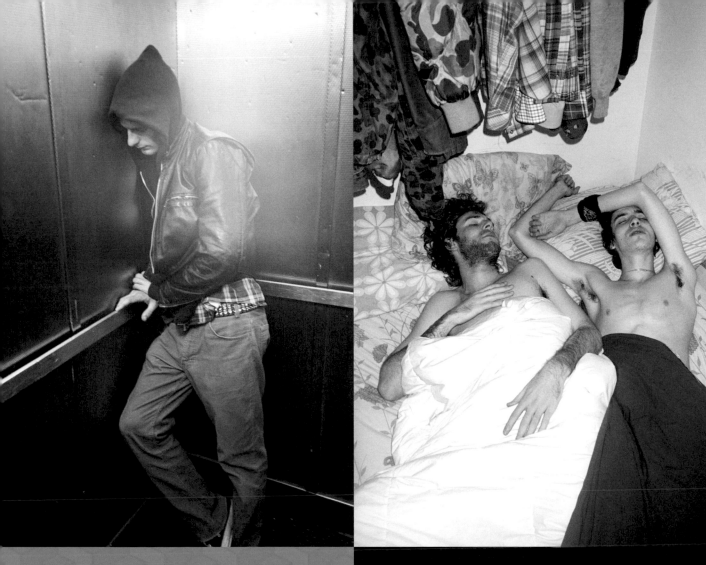

Ryan McGinley's public career began with a self-published zine that he sent to his 100 favorite people: the subjects of his pictures, photographers he admired, and the editors of art and culture magazines he read. After numerous magazine spreads and a 2003 solo exhibition at the Whitney Museum, his distinctive vision of his friends and his scene now define the look of the Lower East Side aesthetic. His work energizes the genre of documentary photography with the seemingly-unstudied directness and immediacy that Ryan is able to maintain even as he becomes more sophisticated in his staging and manipulation of his photographs. The subjects of Ryan's photos-- skaters, graffiti kids, musicians, scenesters, friends, lovers, and family members-- are all drawn from his life, performing for the camera and exposing themselves with a frank self-awareness that is distinctly now. Many photographs play with the conventions and accidents that accompany snapshot photography, manipulating flash and focus in unexpected ways to make the familiar feel seriously uncanny. His work also walks an interesting line of documentary objectivity-- sometimes the subjects seem presciently hip to the entire publicity machine they are getting themselves into, hip already to the scene they are about to be used to represent. His new work, exhibited at P.S.1 in the summer of 2004, took these subjects out of the city and found expressive potential in a natural environment. An elegant series of photographs of Olympic swimmers and an intense series of European hacker kids were featured recently in The New York Times Magazine.

All images courtesy the artist. At left: Tree #1, c-print, 2003. This page: Elevator, c-print, 1999; Dan and Eric, c-print, 2001; Lizzy, c-print, 2002; Jake (golden), c-print, 2003. Page 114: Eric, c-print, 2004; Jake and Dakota, c-print, 2004; Crash, c-print, 2002. Page 115: Dash Bombing, c-print, 2000; Danny, c-print, 2003.

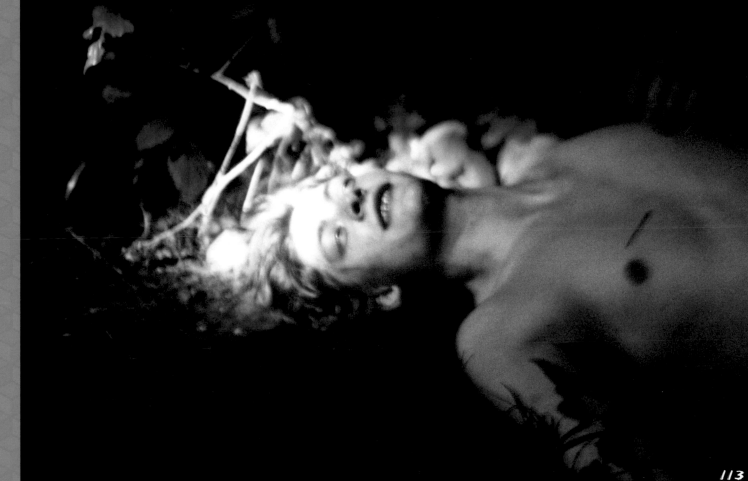

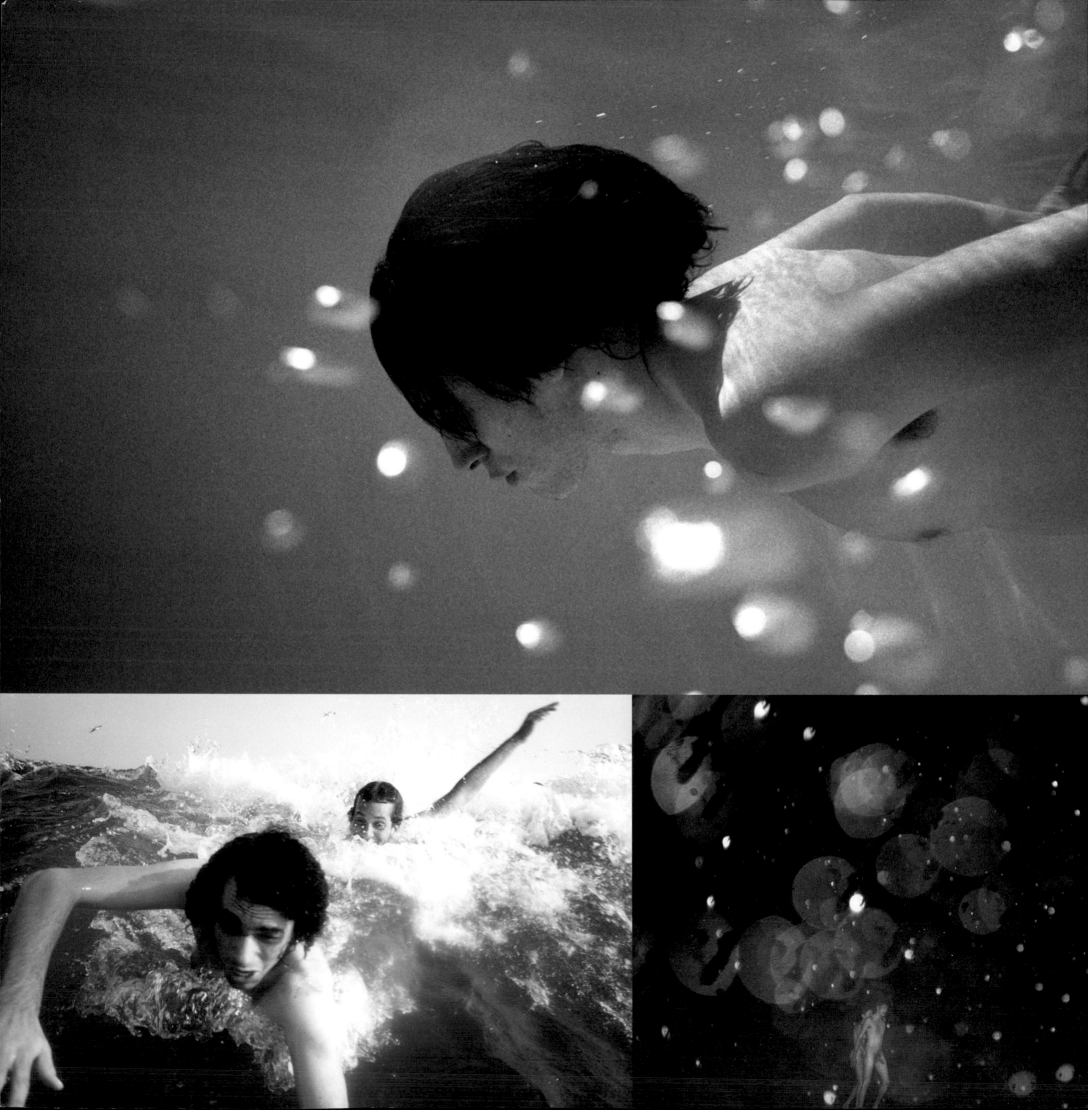

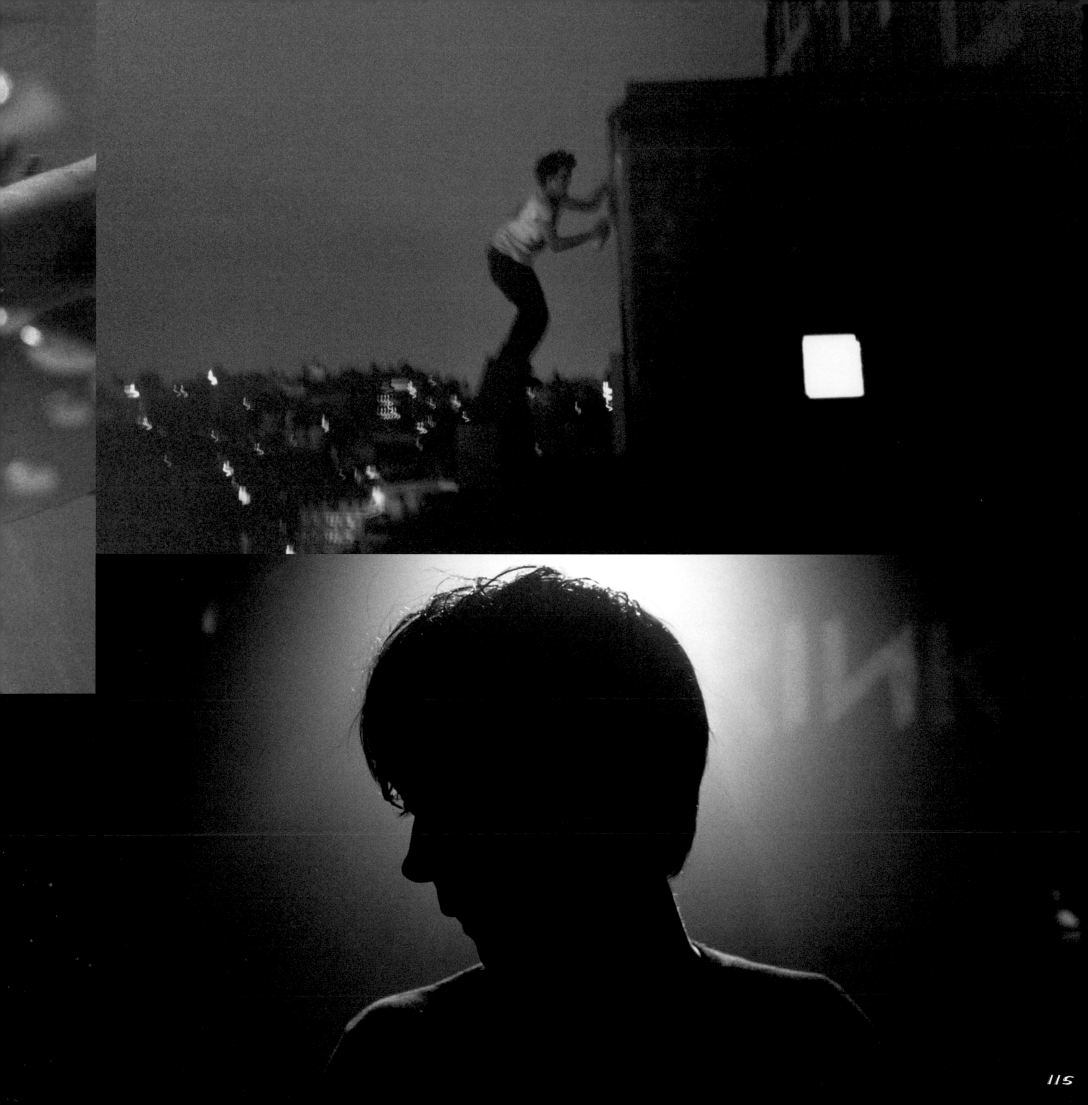

K48

K48

STOP

2

$9.99

SCOTT HUG

Scott Hug started K48 in 2000 while at school and has since turned what was an indy graphic design project into the biggest watershed of underground creative energy in New York. His punk rock, hands-on, collaboration-minded talents inte- grate a community of artists, writers, and musicians, fashion people, freaks, geeks, and dirtbags, in the pages of each new issue and also at his parties. K48 always includes awesome and off-kilter articles, fine art from all up and down the notoriety

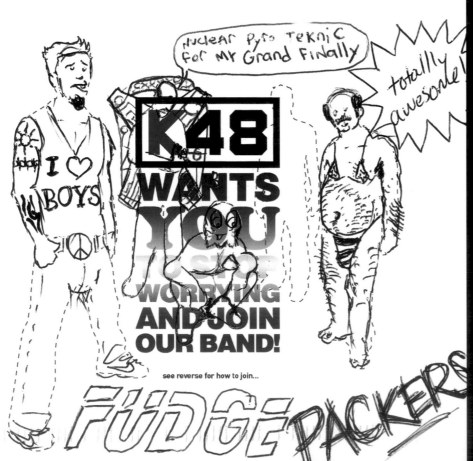

NUCLEAR PYRO TEKNIC FOR MY GRAND FINALLY

totally awesome!

I ♥ BOYS

K48

WANTS YOU

TO STOP WORRYING AND JOIN OUR BAND!

see reverse for how to join...

FUDGE PACKERS

116

Find strength and encouragement in your walk with...

K48

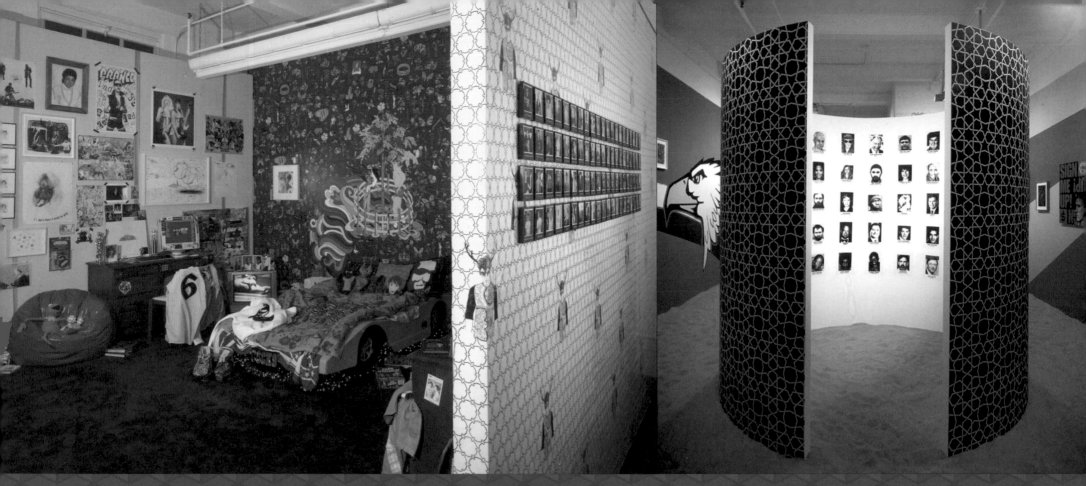

ladder, cool pictures, and a presciently curated CD of underground music that has included, among others, Avenue D, Matmos, Animal Collective, Gravy Train!!!, Devendra Banhart, Phiiliip, Wolf Eyes, BARR, and Deerhoof. Each issue manifests itself in three dimensions as an art show and a series of events: Issue #3, the Teenage Rebel issue, became *The Teenage Bedroom Show* at John Connelly Presents, Summer 2003, and changed everyone's idea of what a truly integrated group art installation could look like; Issue #4 sprang up as a crazy Kult Klubhouse at the Deitch Brooklyn space, where an entire rundown house was built in the gallery, dried leaves swirling around the floor and parties almost every night offering some of the freshest up and coming music and performance. Scott also collaborates with Michael Magnan on their own art and zines, as seen in Hug & Magnan's Summer 2004 show *Boys Gone Wild* at John Connelly Presents. It's the force of a truly

generous spirit and fierce industriousness that can take a bunch of diverse artists and get them all working together to build huge shows, throw huge parties, and to make something that is much larger than merely its constituent parts.

All images courtesy the artist and John Connelly Presents. Page 116, clockwise: K48 issues 1,2,4,3. This page: *K48 Teenage Rebel: The Bedroom Show,* curated by Scott Hug, John Connelly Presents, December 3, 2002 - February 15, 2003; Scott Hug/ Michael Magnan: *Boys Gone Wild,* June 29 - July 30, 2004, installation view, John Connelly Presents, NYC; *K48 Klubhouse,* installation view, November 21 - December 20, 2003, Deitch Projects Brooklyn; *K48 Klubhouse,* installation view, November 21 - December 20, 2003, Deitch Brooklyn.

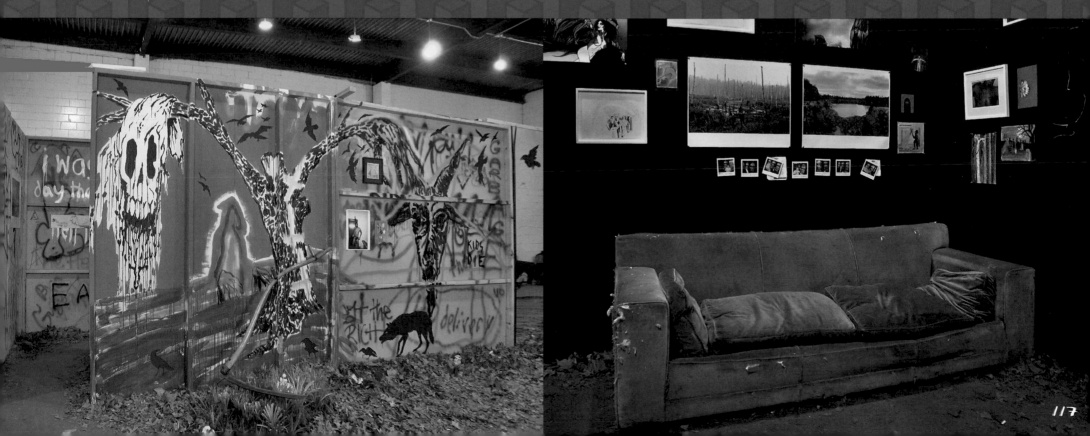

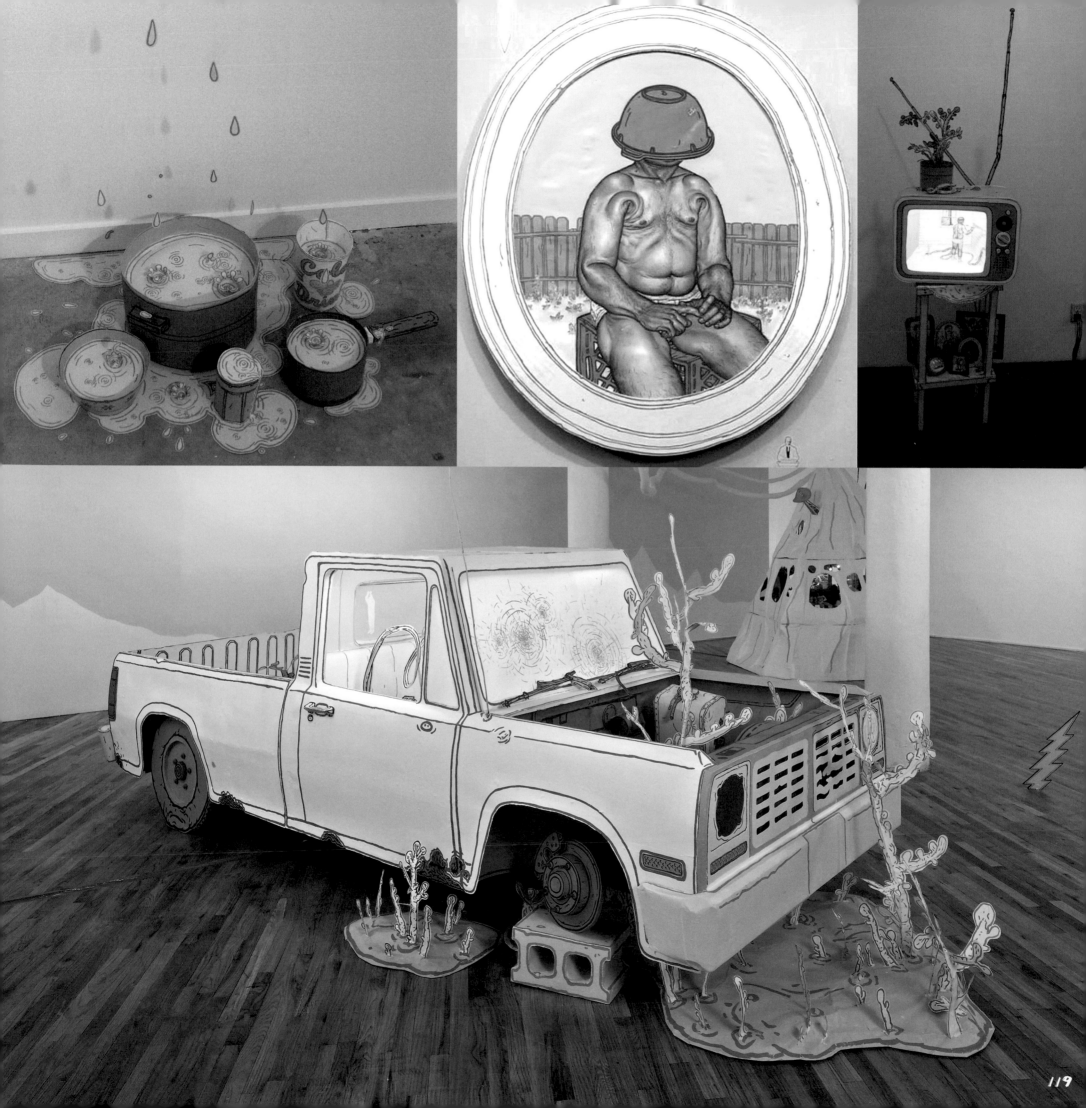

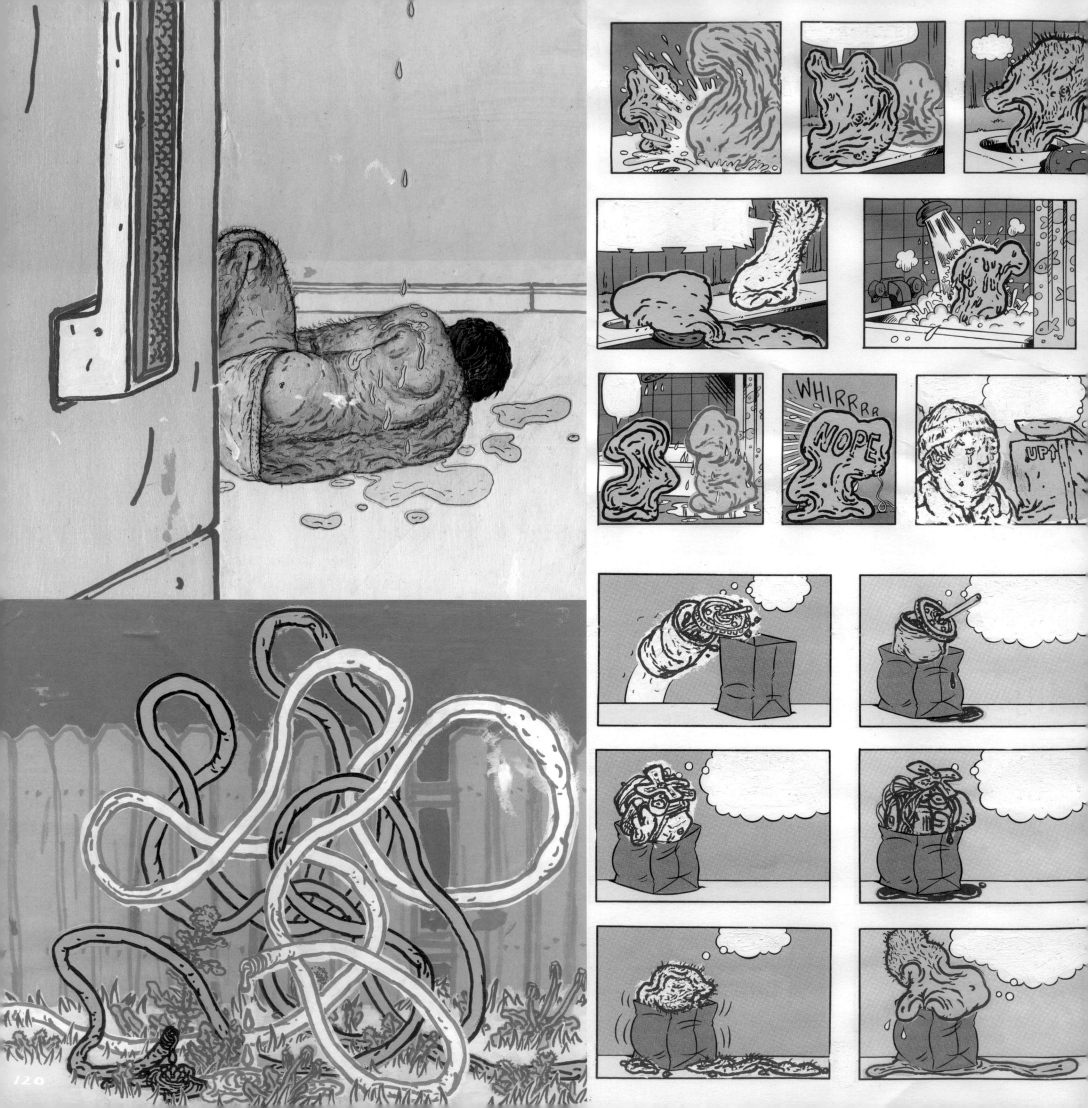

Taylor McKimens' paintings and installations blur the line between drawing and sculpture, taking a graphic sensibility and expanding it into clever and subtle environments. Deadbeats and derelicts roam sparse, harshly-lit worlds of soggy bread and Band-Aids, bologna and knotted garden hose. The palette is a dulled Fixin's Bar of mustardy yellows, greying tomatoes, and limpid greens-- pastels have never looked quite so sinister. Taylor has this predilection for the entropic-- splatters, drips, tangles, messes and decay, rust and ruin-- exploring all the corners where disorder begins to reclaim our fabricated environment and our bodies. No one is smiling and everyone is somehow sweaty. Strong comic book influences and a childhood in the L.A. outskirts lend an edge to the tragico-comic energy of his pieces, and moments of elegant painterliness can invest even his ugliest image with a complex beauty.

A stand-out solo show at Clementine Gallery (November 2003), entitled "Day Old Bread" introduced New York to work that had been garnering attention for the past two years at New Image Art in L.A. Taylor was also included in Trunk of Humours, a group exhibition at Deitch Projects curated by Kathy Grayson for which he displayed a phenomenal life-sized broken-down pick-up truck sculpture (page 119).

All images courtesy the artist and Clementine Gallery, NYC. Page 118: Baloney Sandwich, 2003, acrylic and vinyl paint on muslin on paper, 105 x 116". Page 119: Leak, installation view, Annet Gelink Gallery, Amsterdam, January 2005, mixed media, dimensions variable; Portrait with Plastic Bowl, 2004, acrylic on paper on wood, 4 x 3'; Boob Tube, 2004, mixed media, 3 x 4 x 7 'aprox.; Truck, installation view from Trunk of Humours, Deitch Projects, October 9 – November 12, 2004, mixed media, 7 x 4 x 5' aprox. Page 120: Kitchen Leak, 2003, mixed media on wood, 18 x 24"; VP, drawing on found comic strip, 2003; Deja Vu, drawing on found comic strip, 2003; Hoses and Weeds, 2005, gouache and opaque pen on paper, 14 x 12". This page: Man with Wet Paper Bag, 2003, acrylic and opaque pen on paper, 40 x 11.5"; Thank You, 2003, acrylic gouache and opaque pen on paper, 16.5 x 19.5"; Art Club Beer Cozy, 2003, acrylic gouache and opaque pen on paper, 11.5 x 6"; Table with Gum, 2003, acrylic, gouache and opaque pen on paper, 32 x 31.5"; Green Hose with Upside Down Sprinkler, 2003, acrylic and opaque pen on paper, 36 x 33".

Terrence KOH

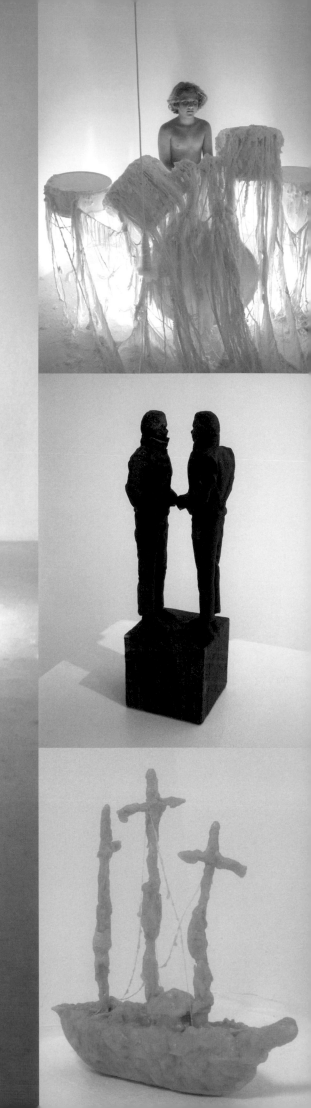

Terrence Koh was until recently best known for his cult website asianpunkboy.com and his Asianpunkboy magazine, which are, in his own words, "filled with an infusion of gentle surfaces, dissident eruptions, haikus, mapped pictures, dirty illustrations, moist cum, decadent artificial words, love and all manners of faggy filth". Though now occupied with sculpture, performance, and drawing, Koh's work is still entrenched in self-exploration led by personal sensitivities; his are statements that speak of fragility, aesthetically poised between brittle beauty and banal kitsch. Part thief, part provocateur, Koh is an originator of new ideas who invites us to come along on a narrative journey. His 2004 show at Peres Projects featured two mossy, ghost-like drum sets decomposing into a beard of beads and thread that were "activated" during Koh's performance the 50 most beautiful boy by two half-naked boys beating furiously on them. Austere, quirky, touching, and ballsy installations at the 2004 Whitney Biennial of American Art and Extra City in Antwerp (evocatively titled Temple of the Golden Piss) transformed Koh's unique aesthetic into a total sensory environment.

All images courtesy Peres Projects and the artist. Page 122: the 50 most beautiful boy, performance view, Peres Projects, July 17, 2004; Michael Jackson, mixed media sculpture, 3' aprox.; America The Ship, mixed media sculpture, 2' aprox. This page: Asianpunkboy, Whole Family, installation view, 2004 Whitney Biennial of American Art; the 50 most beautiful boy, Peres Projects, performance view, September 2004. Page 124-125: two installation views from Temple of the Golden Piss, Extra City, Antwerp, Belgium. November 20, 2004-February 20, 2005; (along bottom) photographs from asianpunkboy.com.

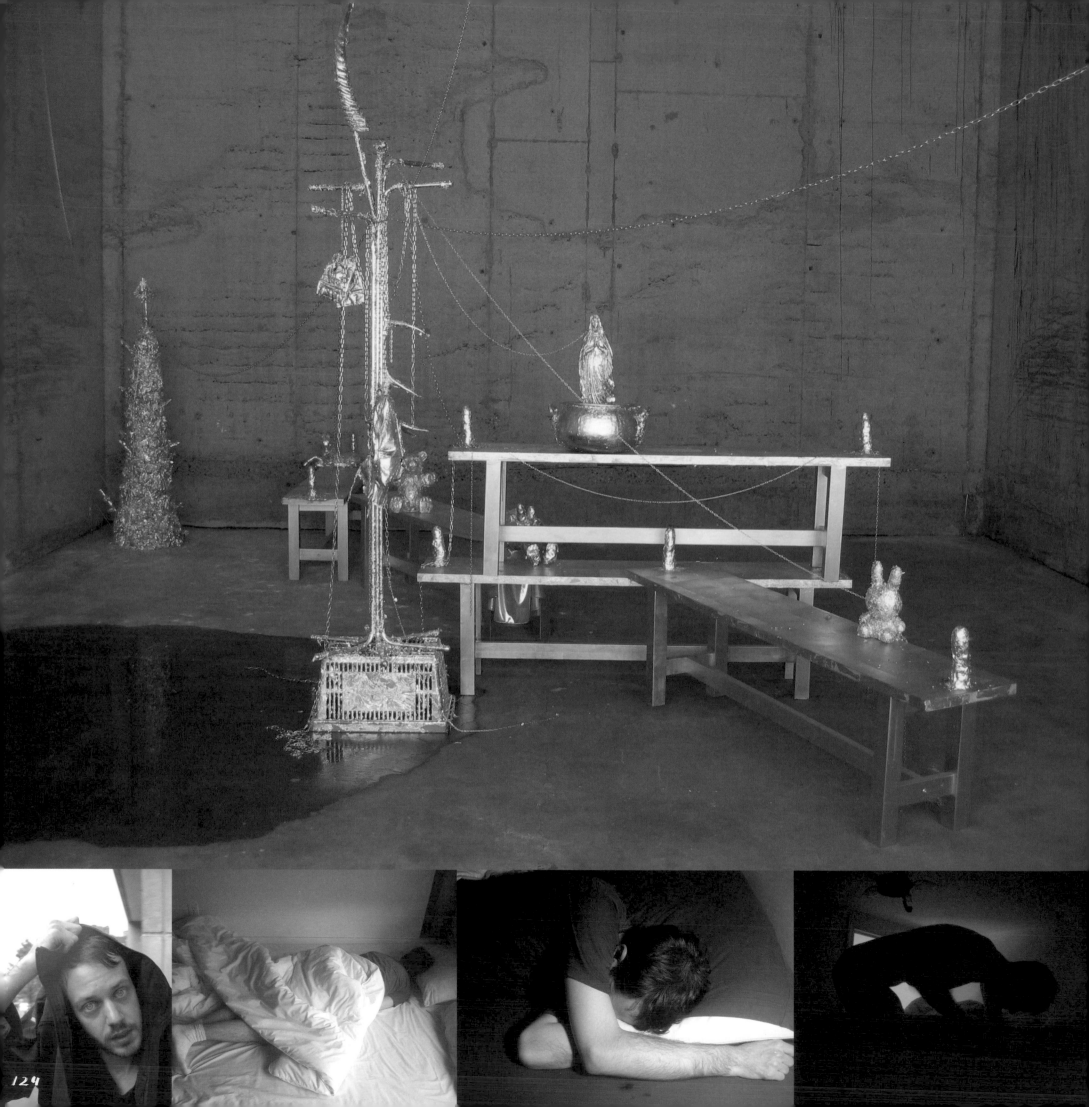

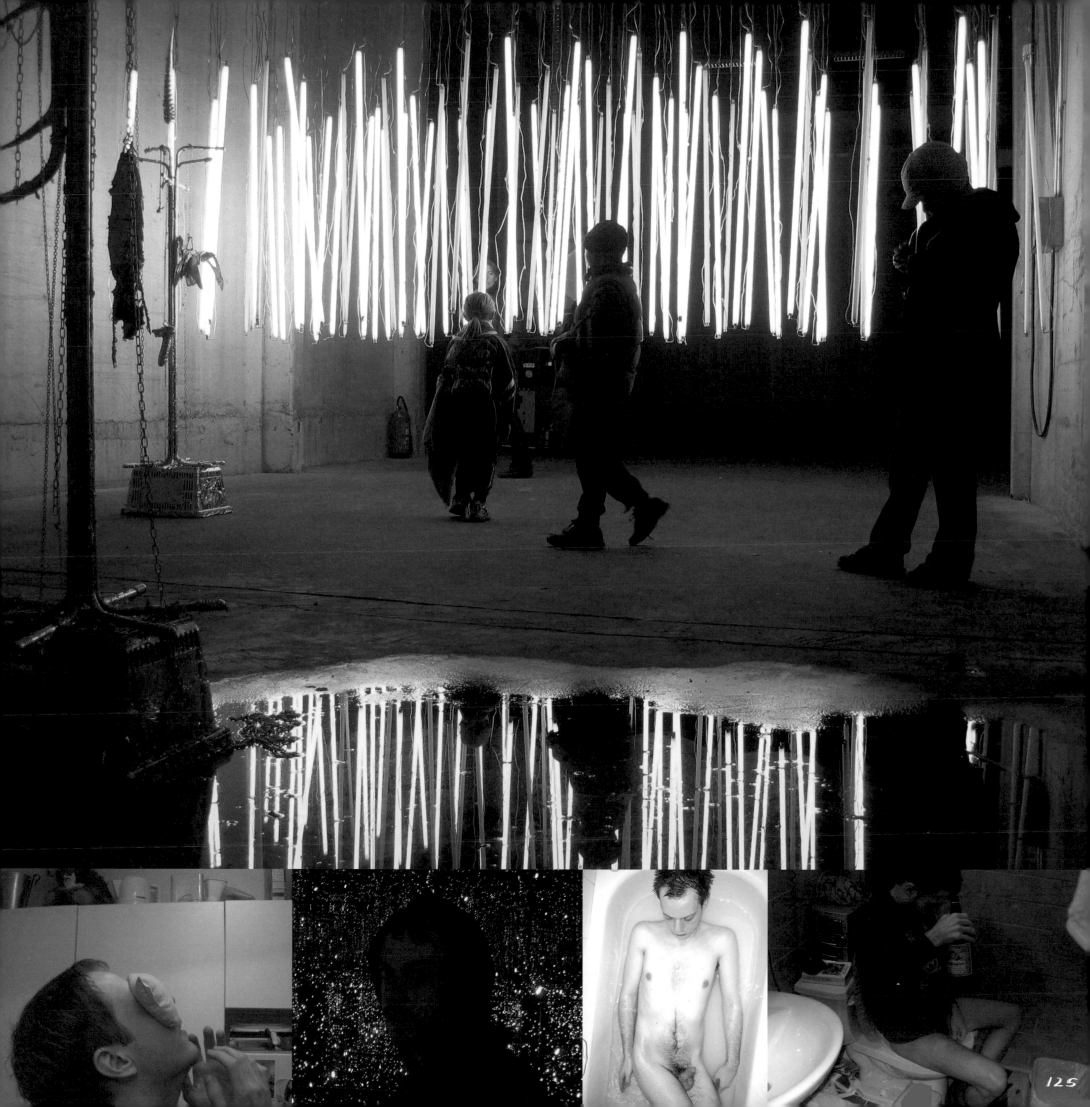

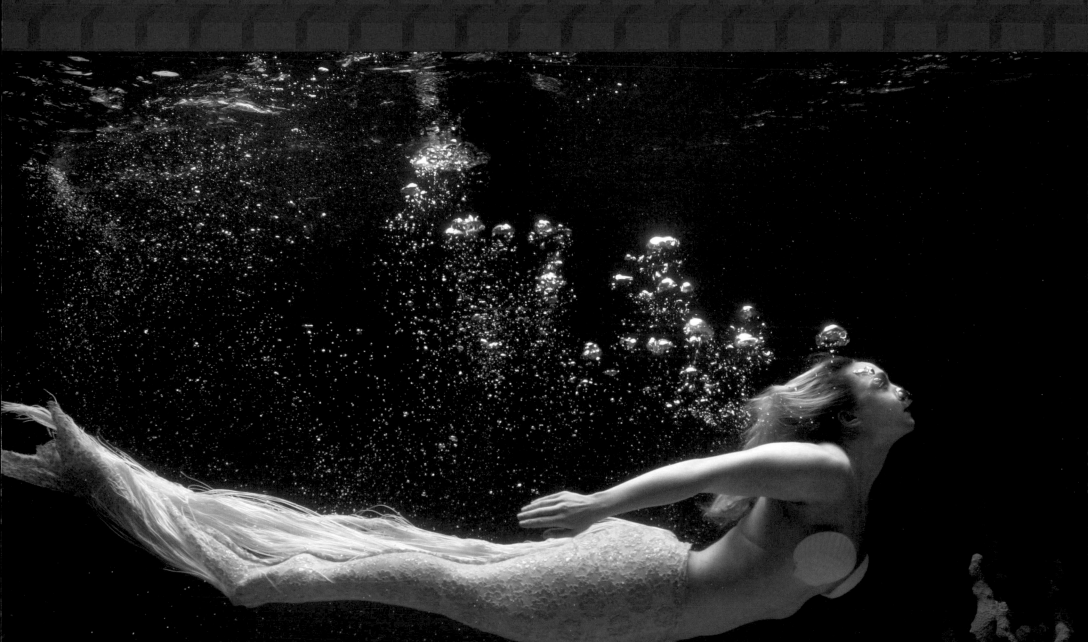

Maybe you saw Julie at the 2004 Whitney Biennial opening wearing only a pair of red pumps, or maybe you've caught her more regular performances in the big swim tank at The Coral Room, but any way you've seen her is likely to be unforgettable. Coming out of the explosion of neo-burlesque and underground performance art that includes Miss Dirty Martini, The Wau Wau Sisters, The World Famous Bob, Scotty the Blue Bunny and many, many others, Julie and her peers are reviving the forms and conventions of this vintage entertainment to address very contemporary concerns. Often presenting her work in a fine art context, Julie has performed at all types of venues including The Kitchen and the Whitney Museum of American Art. Using arousal to invigorate and manipulate, Julie encourages an intellectualized interpretation that she simultaneously, um, problematizes. Her piece included at the Whitney, The Rite of Spring-- transposing Stravinsky's orchestral masterpiece onto guitars, bass, and drums-- featured sex flowers, death metal, stilts, glitter, and sweat. The political I Am the Moon and You Are the Man on Me (November 2004), in which a purple sparkle-clad Julie pulls an American flag out of her bum, left audiences in awe, but also laughing their asses off-- her bawdy, brainy humour keeps dance in close contact with the absurd. You can see Julie perform regulary in New York at the VavaVoom Room, Joe's Pub, Galapagos, The Slipper Room, The Coral Room, the Marquis, and a host of other places easily accessible on her web site julieatlasmuz.com.

All images courtesy the artist. Page 126: Julie Flying, from The Coral Room performances, 2004. This page: photograph from Elle Magazine; Escape, performance 2003; The Thing, front view, performance 2004.

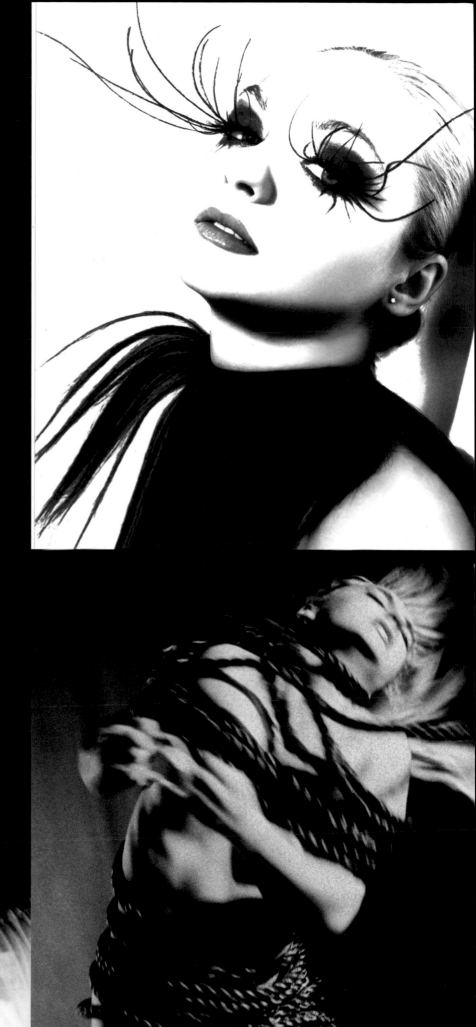

127

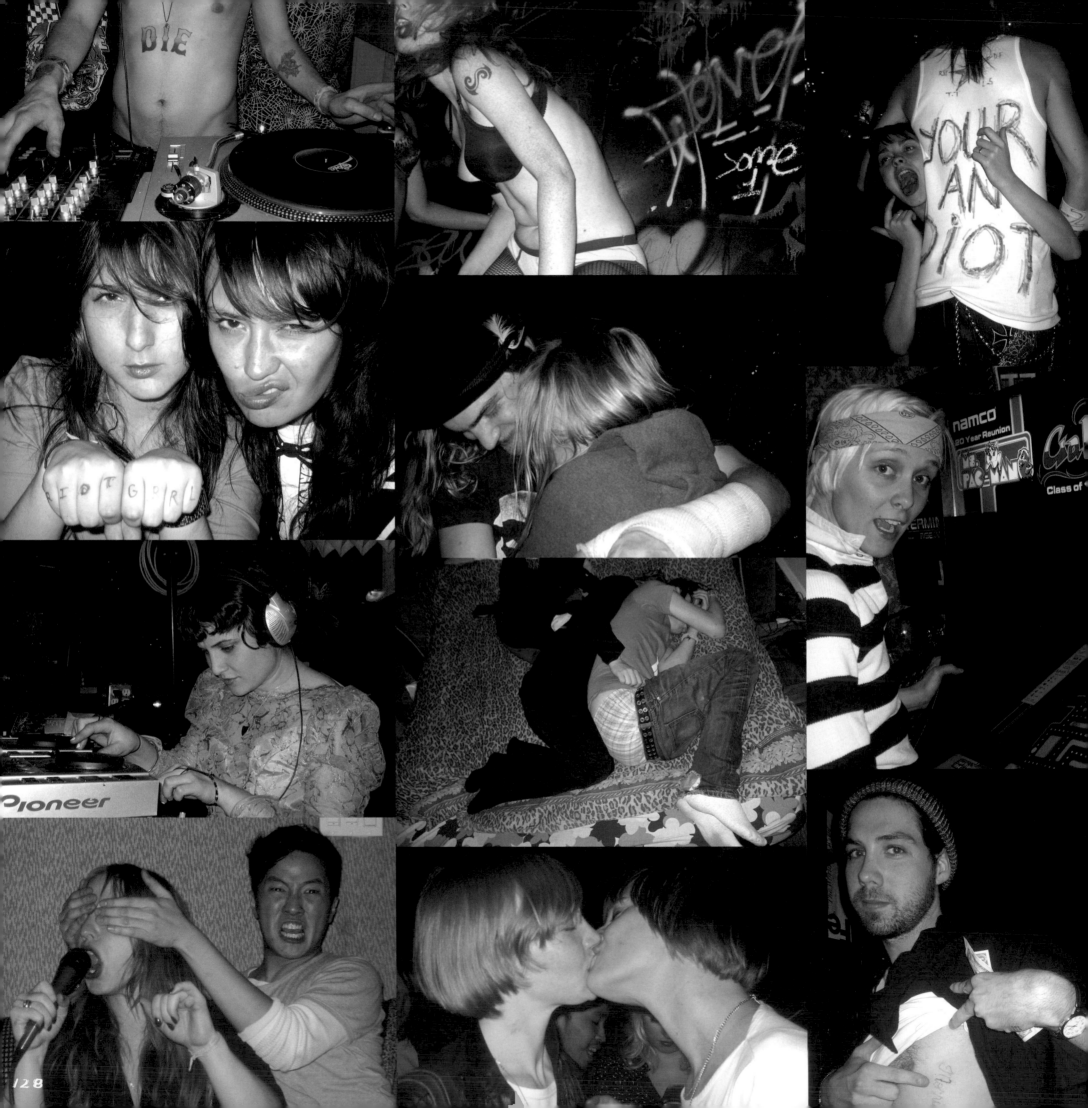

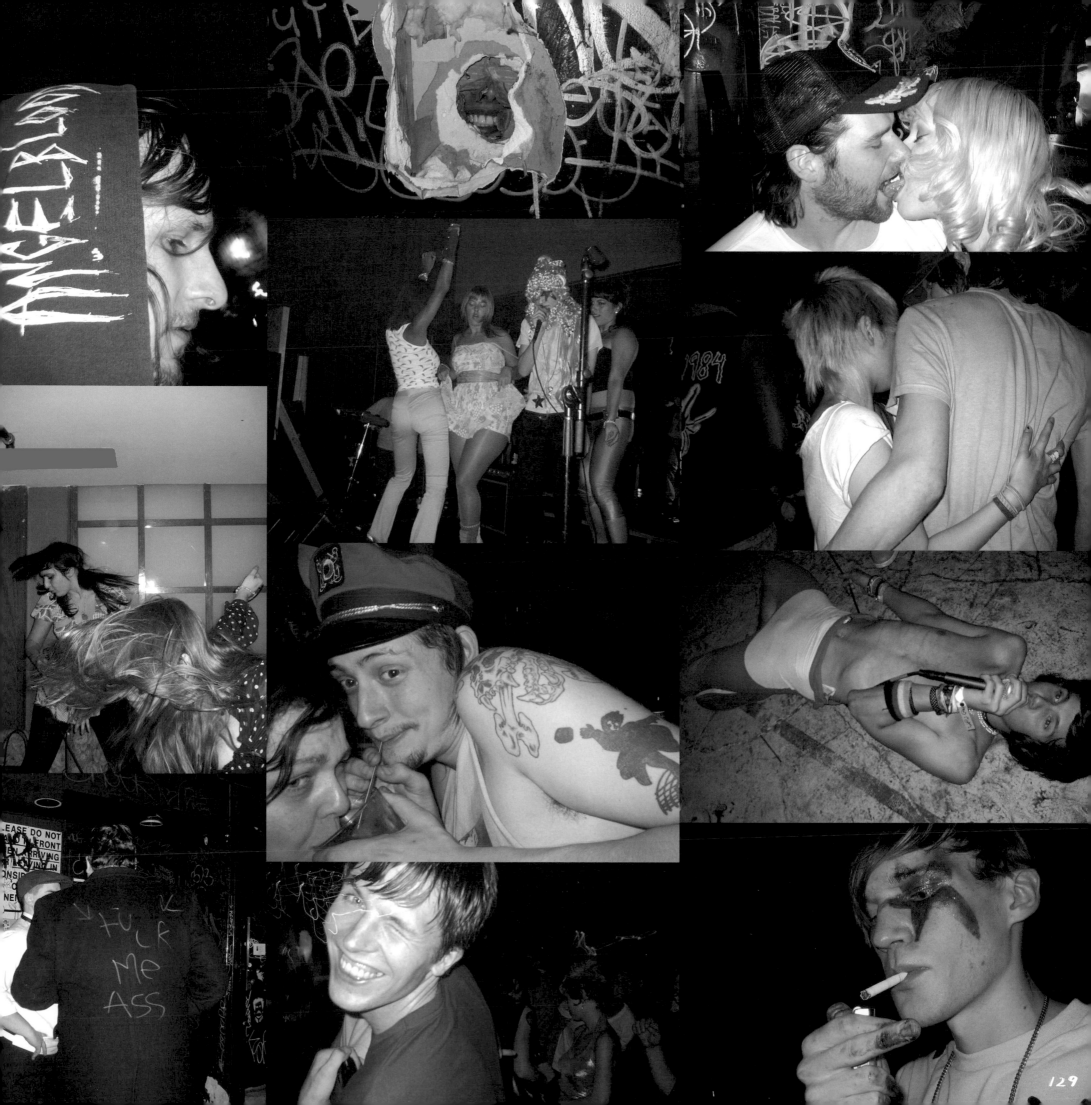

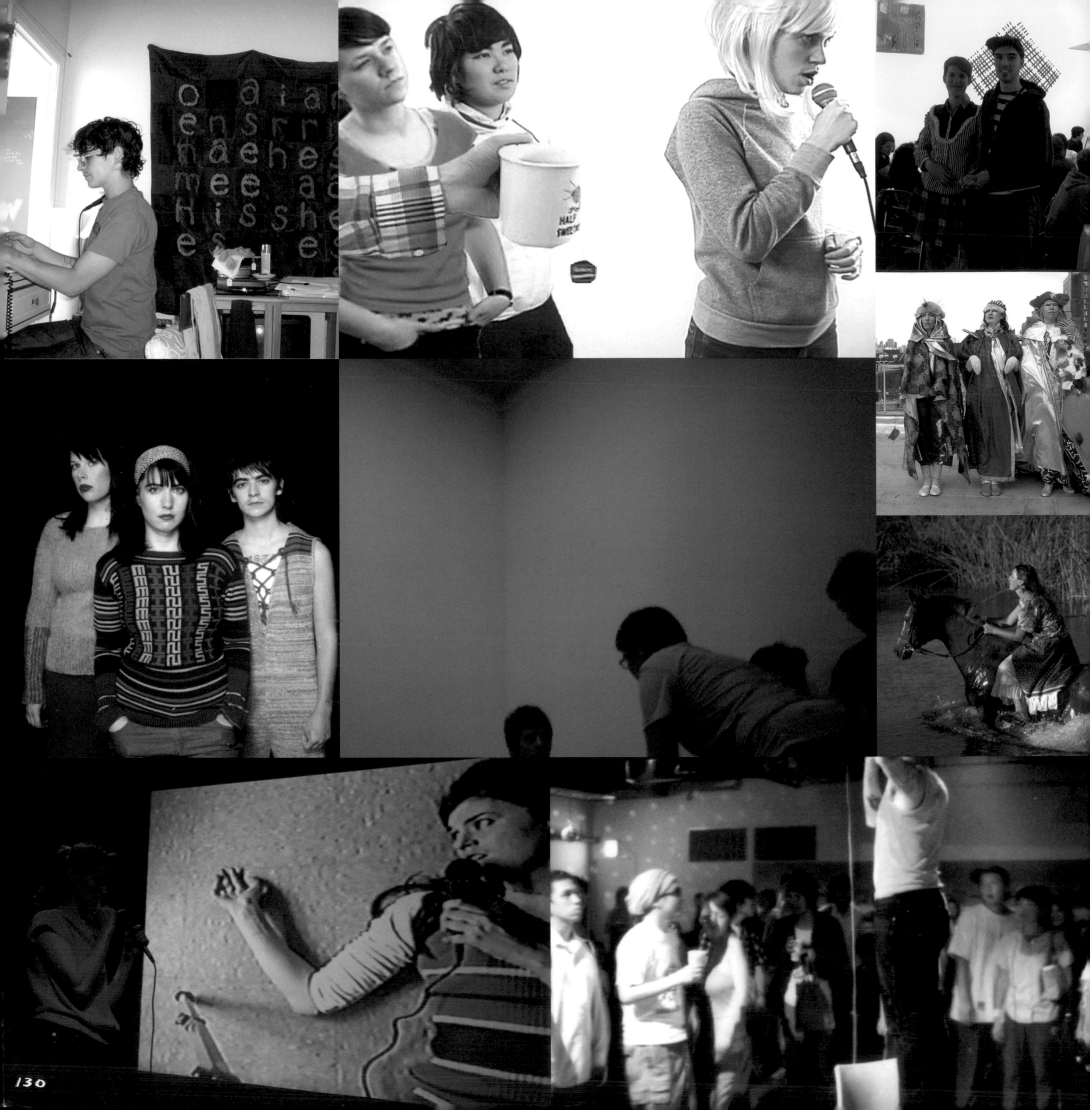

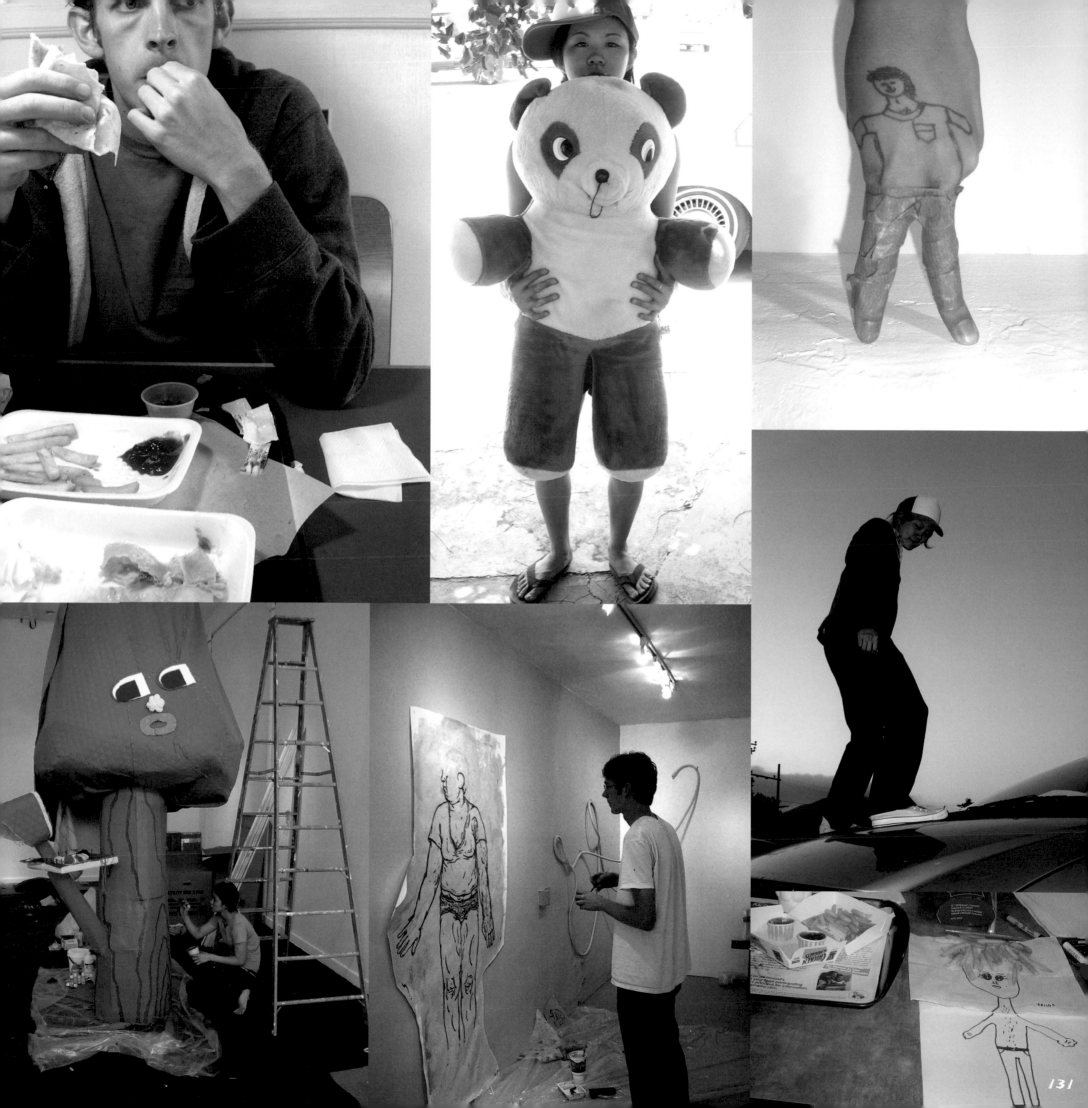

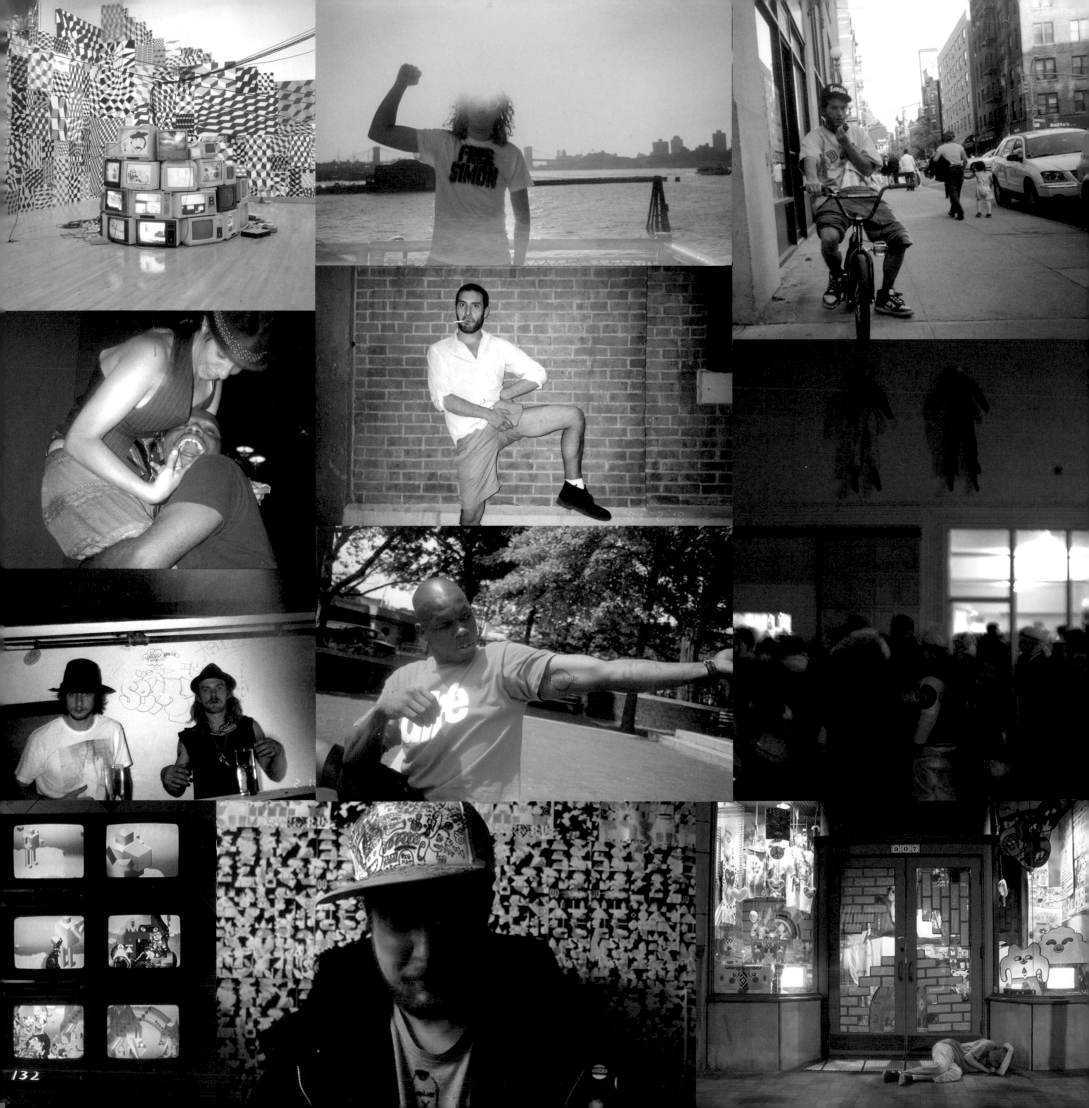

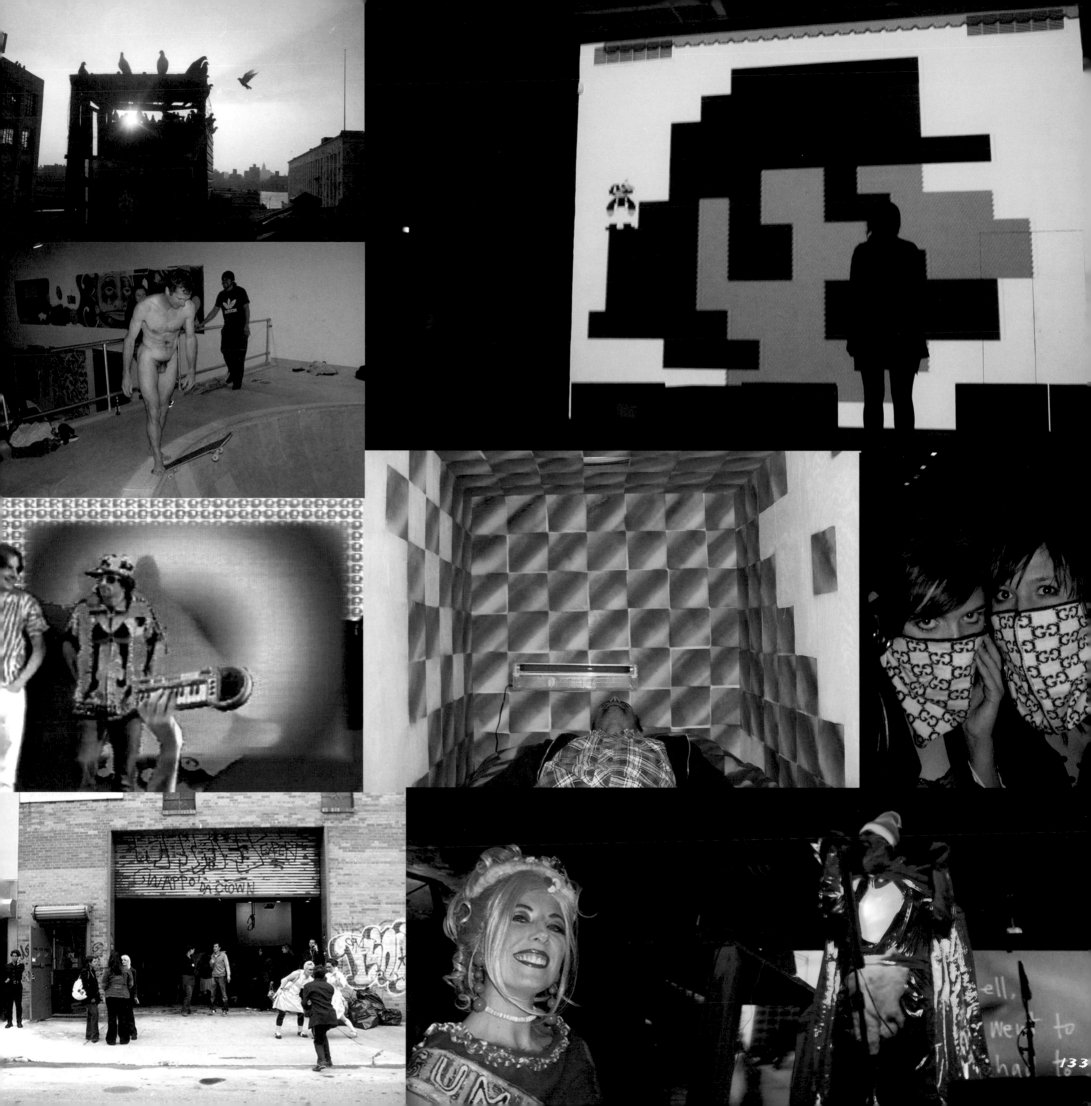

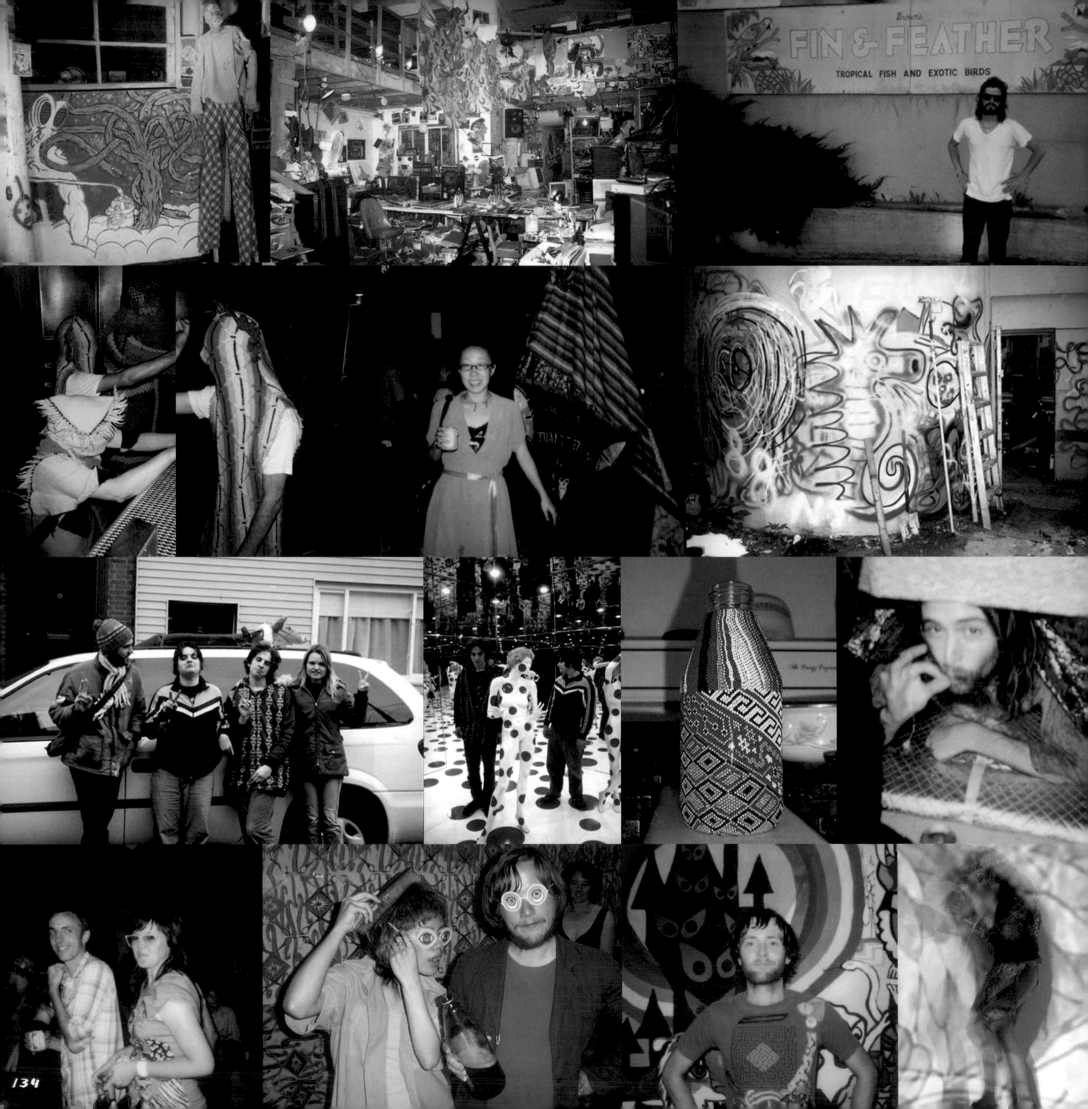

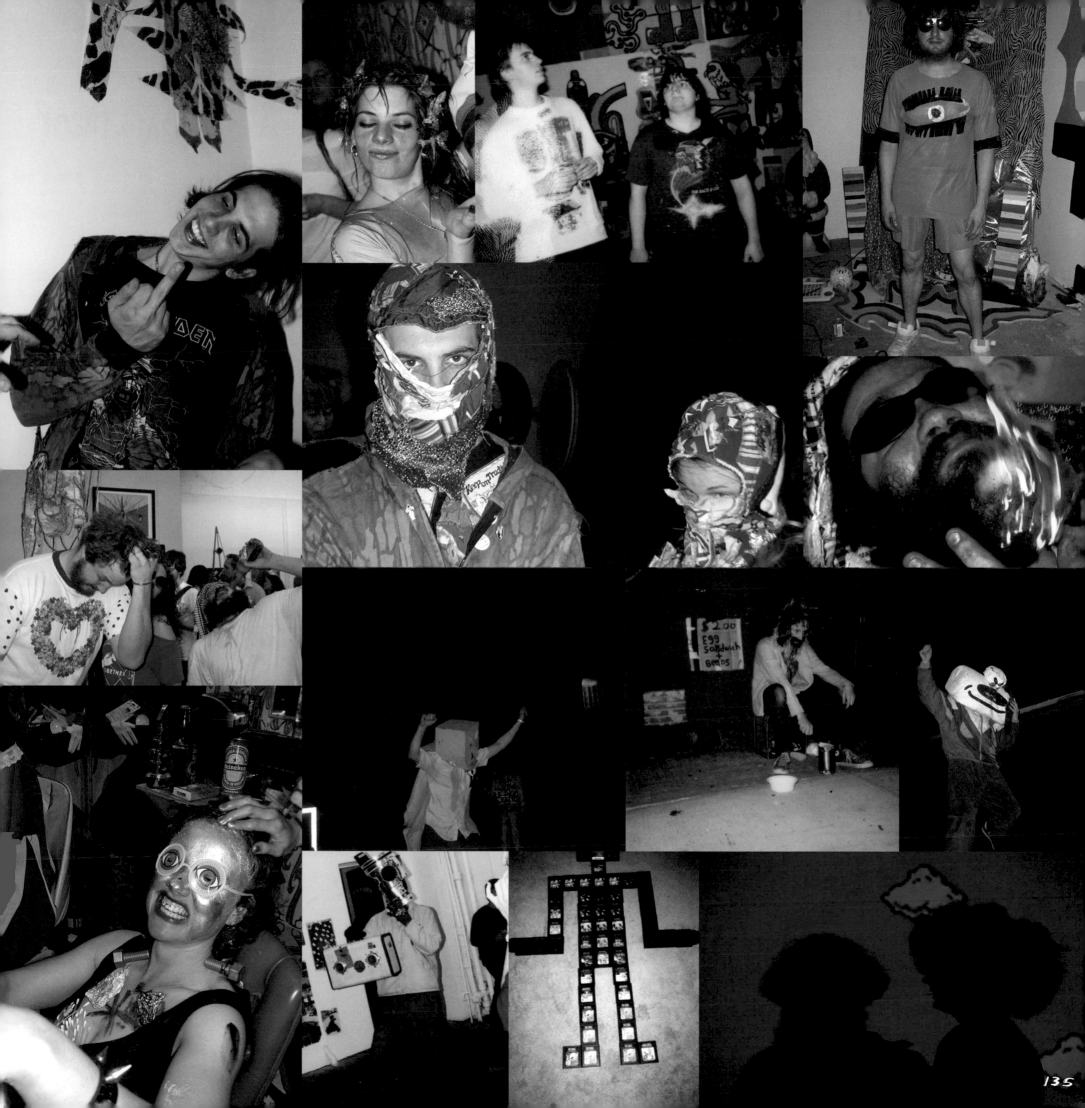

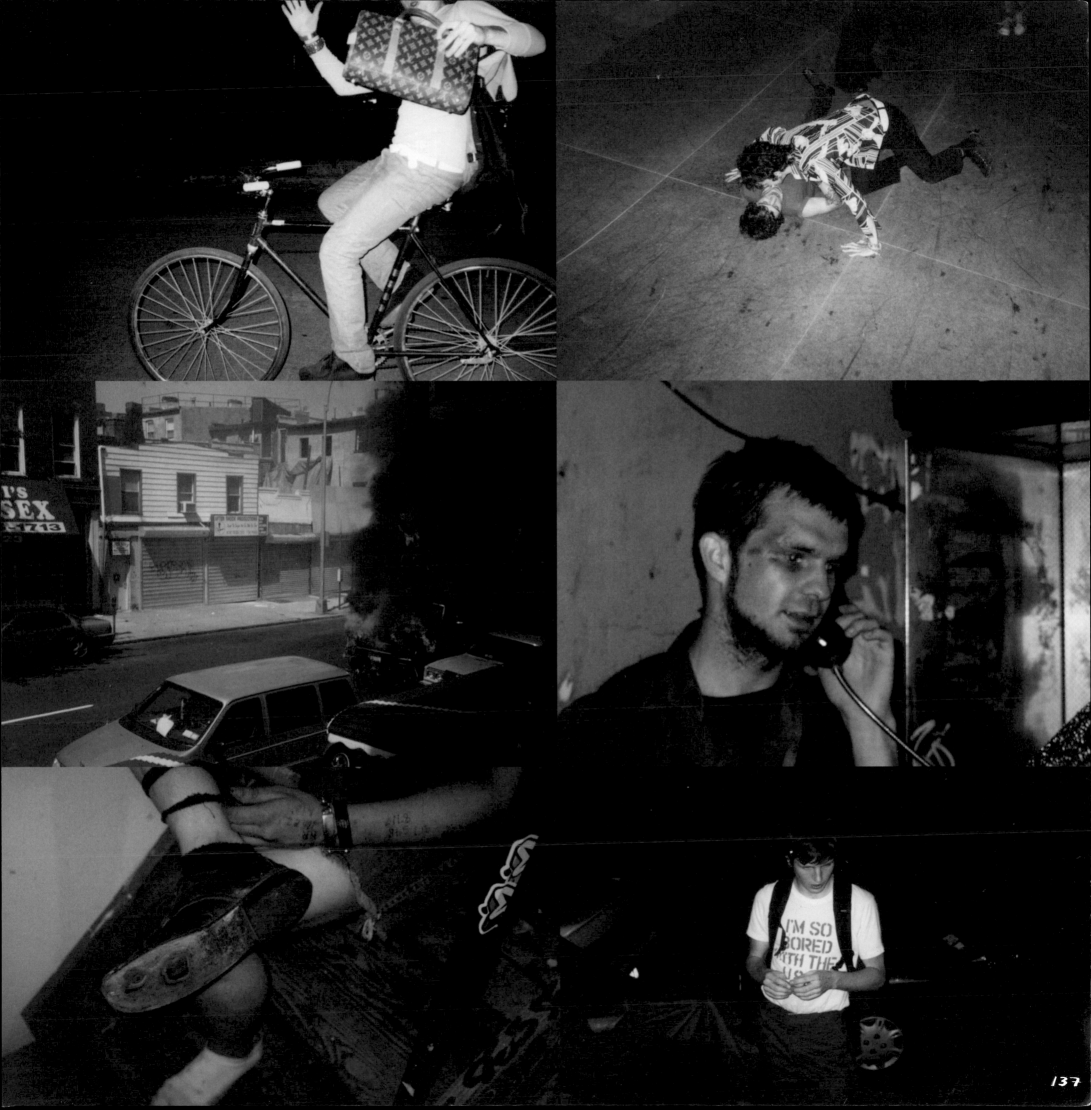

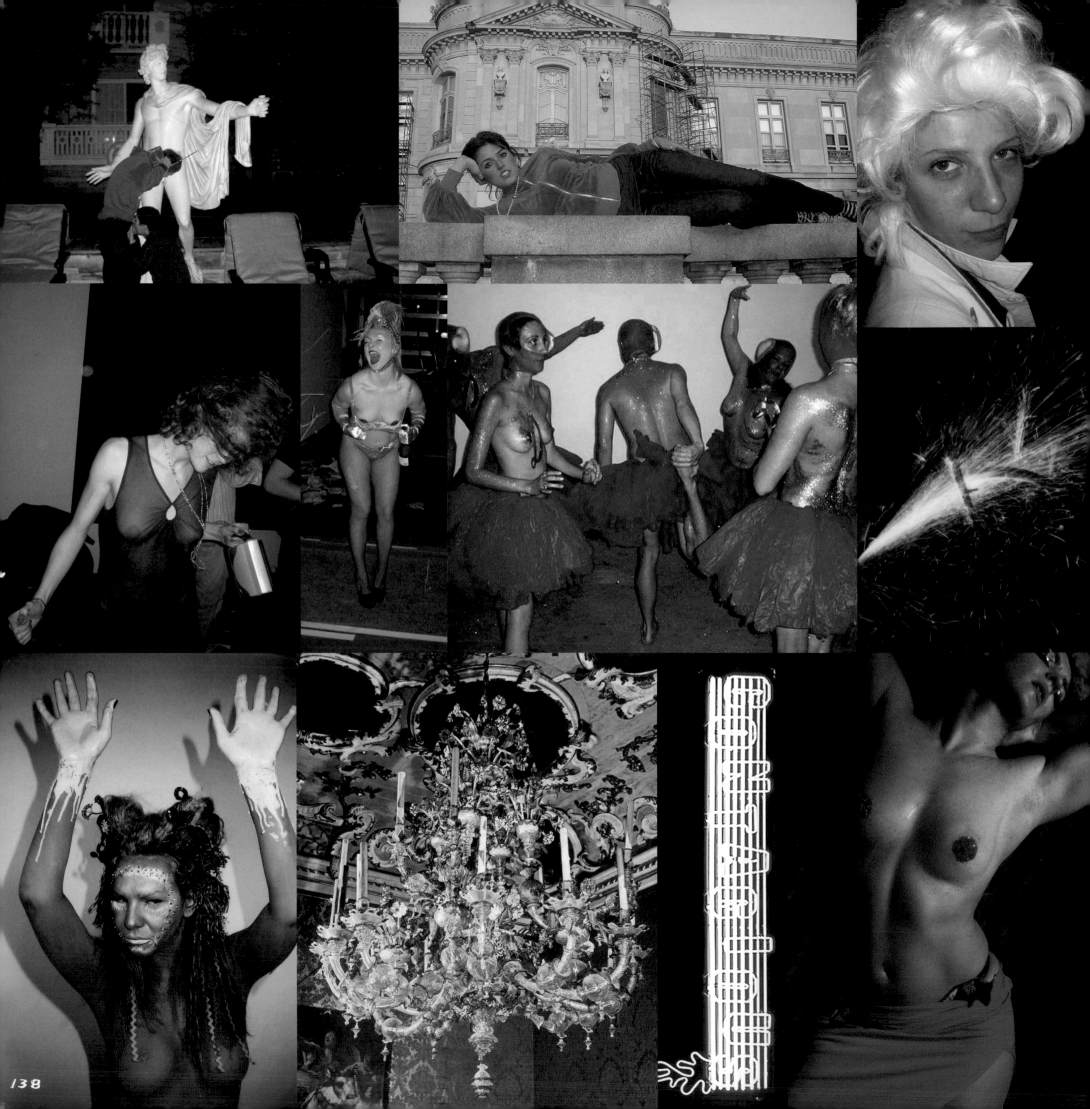

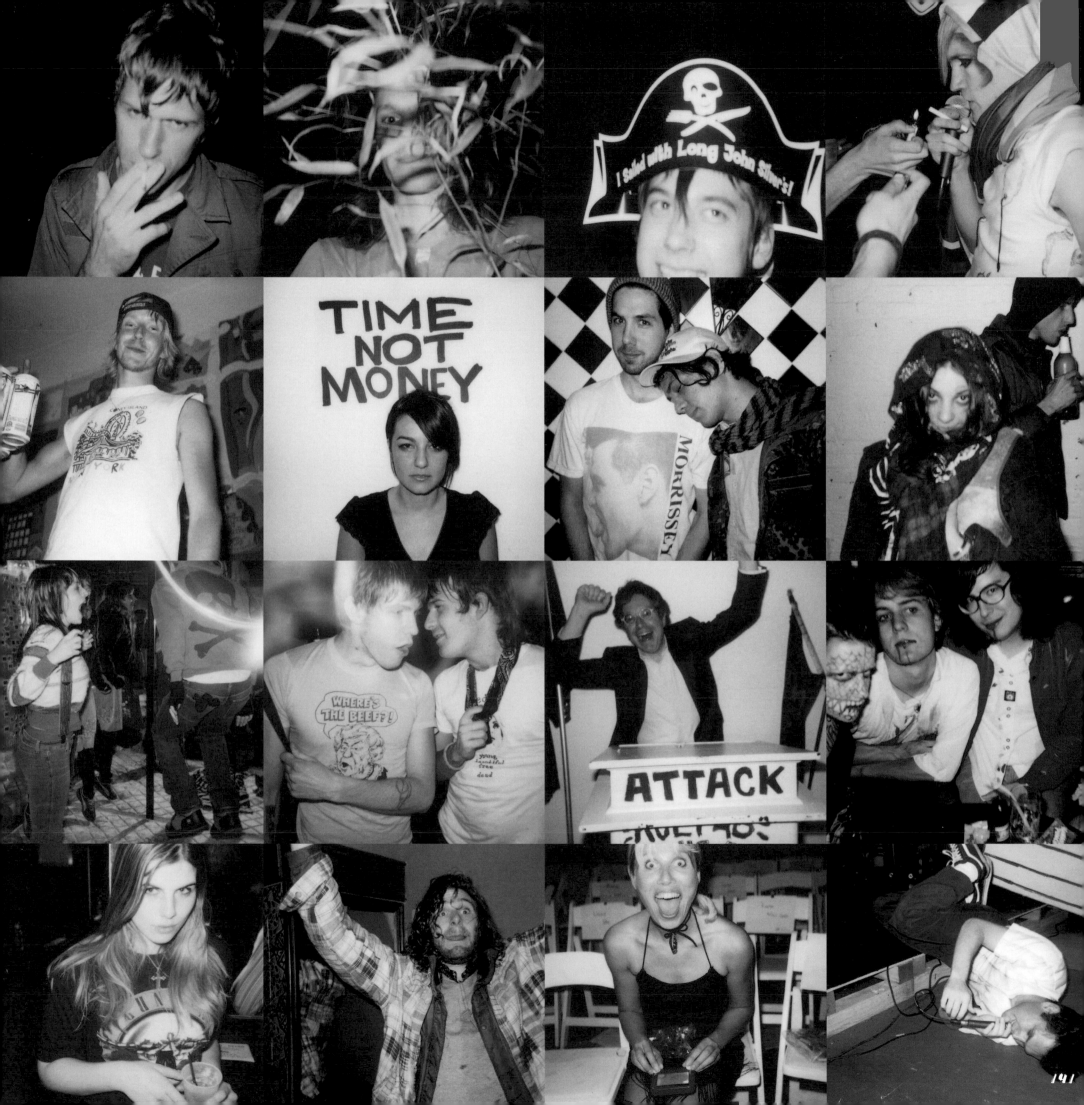

CONTRIBUTORS

PHOTO

Conrad Ventur

Conrad Ventur, a photographer based in Brooklyn, NY, has been documenting the underground art and music scene since his arrival in 2000. His first book entitled Electrodiskopunks! compiles almost five years of these photographs. Ventur's publication, Useless, features profiles of people who are hot right now; people who are doing things. "Here today – gone tomorrow – truly useless moments in art, music and fashion that we love." Ventur's photographs have been published in Rollingstone, SPIN, V Magazine, and others. The pull-out poster for Peaches' Father Fucker album was shot by Ventur. He continues documenting the New York art world and building on his collection of personal portraits.

Ry Fyan

Ry Fyan is an artist featured in this book who had this stash of amazing superdark superrad photos in a shoebox. The photo at left is one of Dash's.

Scott Hug

Scott Hug is also in this book and rules!!! A phenomenal mover of peoples and constant inspiration, he is also a diligent archivist and photographer whose Polaroids herein contained are an irreplaceable look at all the people his long arms bring in. His are the first two and the last two photo pages included.

Justin Samson

Justin Samson's art is featured in this book. Some of the photos he contributed to the project can be found in his handmade zines and art books, which you can rustle up at John Connelly Presents.

Ryan McGinley

Ryan McGinley is featured in this book and also contributed many off-duty photos to our photo pages. He wanted me to note that the photo of Jake lying in the gutter with the THIS IS YOUR BRAIN ON DRUGS shirt was shot after Ryan kicked his ass.

Chris Perez

Chris Perez contributed lots of great photos from the various shows and events he's done around the world. He is the owner/director of Ratio 3, an access point for contemporary art based in San Francisco. He previously worked as the curatorial assistant for contemporary art at the Whitney Museum of American Art, helping organize BitStreams and the 2002 Biennial Exhibition.

Hisham Bharoocha

Hisham Bharoocha contributed the phenomenal treasure chest of awesome Fort photos. He's been in many groundbreaking, genre-creating, phenomenal bands including Lightning Bolt and Black Dice and will thank goodness continue to do things that improve our ear lives, as well as making the arts. This photo: Mark Borthwick.

Amy Kellner

Amy Kellner is a writer from New York City. She's not sure why she started keeping an internet photo-diary, but she did. You can see it at teenageunicorn.com if you are into things that are awesome.

Kayrock Wolfy

Kayrock and Wolfy designed this awesome thing in your hands. They made the fonts, designed the cover and title pages, kept everyone entertained and encouraged, and made the cool patterns scattered about. Together, they are these very well-known Brooklyn screen printer fellows Kayrock Screen Printing who have done a bazillion and one amazing projects, in comparison to which this is just, like, a drop in the bucket. Speaking of which: FUCK BUSH.

David Janik

David Janik made this pile of images and text into an awesome, readable, dynamic, book. He does a lot of work for Soft Skull Press and is a very patient and precise dude.

Kathy Grayson

Kathy Grayson put this book together, along with the inimitable Jeffrey Deitch. She is a young curator and writer living in New York whose recent curatorial projects include the cult-favorite Dirt Wizards show at Brooklyn Fire Proof, a two-door installation at the Wrong Gallery, and a celebrated group show, Majority Whip, this May 2004 at White Box raising money for voter registration. She likes to organize Žižek lectures and huge, huge parties. Graduating from Dartmouth College in 2002, Kathy has worked at the Hood Museum of Art, The Kreeger Museum, and the Whitney Museum of American Art.

Produced by Deitch Projects

76 Grand Street, New York, NY 10013

(212) 343 7300 | www.deitch.com

Edited by Jeffrey Deitch and Kathy Grayson

Design by Kayrock Screenprinting, New York

Layout by David Janik

Printed by Shapco Printing

©2005 Deitch Projects

Distributed by DAP

ISBN: 0-9753243-3-0

Cover: Walking on Thin Ice video still, Bec Stupak

New!

deitch projects

PHOTO CREDITS (all clockwise from top left of page):
Page 2 and 3: all images courtesy Scott Hug. Page 4: Ryan McGinley, Ry Fyan, Ryan McGinley, Ryan McGinley, Ry Fyan, Kathy Grayson, Ry Fyan, Ryan McGinley, Chris Perez, Ryan McGinley, Todd Cole. Page 5: Daphne Gomez-Mana, Kathy Grayson, Amy Kellner, Piera Lu, John Andrew, Amy Kellner, Scott Hug, Scott Hug, Piera Lu. Page 6: Taylor McKimens, Terrence Koh, Kathy Grayson, Paul Laster, Chris Perez, Bec Stupak, Debbie Attias, Marsea Goldberg. Page 7: Bec Stupak, The Public Art Fund, Chris Perez, Bec Stupak, Justin Samson, Bec Stupak, Bec Stupak, Kathy Grayson, Bec Stupak, Bec Stupak. Page 8: Conrad Ventur, Conrad Ventur, Conrad Ventur, Conrad Ventur, Conrad Ventur, Conrad Ventur, Justin Samson, Conrad Ventur, Kathy Grayson, Conrad Ventur, Paper Rad. Page 9: Kathy Grayson, Kathy Grayson, Marsea Goldberg, Andrea Cashman, Andrea Cashman, Andrea Cashman, BARR, Justin Samson, Paul Laster, Kathy Grayson. Page 10: Bec Stupak, David Henry Brown, Bec Stupak, David Henry Brown, Bec Stupak, Bec Stupak, Dearraindrop, Bec Stupak, Kathy Grayson, Bec Stupak. Page 11: Bec Stupak, John Andrew, Chris Perez, Kathy Grayson, Kathy Grayson, Misaki Kawai, Kathy Grayson, Ry Fyan, John Andrew, Kathy Grayson. Page 128-129: all photos courtesy Amy Kellner. Page 130: BARR, Wynne Greenwood, BARR, Chicks On Speed, Sarah Shapiro, BARR, Wynne Greenwood, Danielle Levitt, Isaac Ramos. Page 131: all photos courtesy Taylor McKimens and Misaki Kawai. Page 132: Barry McGee at the Rose Art Museum, Dash Snow, Dash Snow, Hikari Yokoyama, Paper Rad, Hikari Yokoyama, Paper Rad, Dash Snow, Dash Snow, Dash Snow, Dash Snow. Page 133: Dash Snow, Cory Arcangel, Rosson Crow, Andrea Cashman, Andrea Cashman, Andrea Cashman, Paper Rad, Paper Rad. Page 134: Hisham Bharoocha, Justin Samson, Devendra Banhart, Justin Samson, Justin Samson, Kathy Grayson, Justin Samson, Justin Samson, Justin Samson, Dearraindrop, Justin Samson, Justin Samson, Dearraindrop, "bluckabluck", Joseph Beuckman (BEIGE). Page 135: Nancy Smith, Nancy Smith, Justin Samson, Justin Samson, Brian Belott, Hanna Fushihara, Cory Arcangel, Dearraindrop, Nancy Smith, Justin Samson, Kathy Grayson, Dearraindrop, Kathy Grayson, Hanna Fushihara. Page 136-137: all photos courtesy Ry Fyan. Page 138: Terrence Koh, Rosson Crow, Pia Dehne, John Andrew, Julie Atlas Muz, Tom Powel, AVAF, AVAF, Andrea Cashman, Andrea Cashman, Paul Laster. Page 139: Daphne Gomez-Mana, Scott Hug, Debbie Attias, Piera Lu, Scott Hug, Piera Lu, Debbie Attias, Debbie Attias, Scott Hug, Lucien Samaha, Paul Laster. Page 140-141: all photos courtesy Scott Hug.

We would like to thank:
Jasmine Levett
Javier Peres
Andrea Cherkerzian
Kenny Schachter
Carol Greene
John Connelly Presents
The Mattress Factory
David Henry Brown
Danielle Levitt
Sylvia Karman Cubina
Jack Hanley Gallery
Creative Time
The Public Art Fund
The Whitney Museum of American Art
P.S.1 Contemporary Art Center
Matthew Marks
Rivington Arms
Team Gallery
Clementine Gallery
Ben Davis
Todd Cole
Sasha Yanow
Andrea Cashman
Foxy Production
Burr Dodd and Pearl Son
Laura Tepper
Katie A Davis
Juan Puntes
Zach Feuer Gallery (LFL)
Canada Gallery
Hikari Yokoyama
John Andrew
Nancy Smith
Paul Laster
Marsea Goldberg
Paulsen Press
Kelly Kuvo